THE ORILLIA SPIRIT

Second Edition

An Illustrated History of Orillia

RANDY RICHMOND

Foreword by James A. "Pete" McGarvey

DUNDURN
TORONTO

Cover image: Wikimedia Commons
Printer: Webcom

Library and Archives Canada Cataloguing in Publication

Richmond, Randy, 1958-, author
 The Orillia spirit / Randy Richmond ; foreword by James A. "Pete" McGarvey. -- Second edition.

Includes bibliographical references and index.
Issued in print and electronic formats.
ISBN 978-1-4597-3960-4 (softcover).--ISBN 978-1-4597-3961-1 (PDF).--ISBN 978-1-4597-3962-8 (EPUB)

1. Orillia (Ont.)--History. 2. Orillia (Ont.)--History--Pictorial works. I. Title.

FC3099.O74R52 2017 971.3'17 C2017-902145-1
 C2017-902146-X

1 2 3 4 5 21 20 19 18 17

We acknowledge the support of the **Canada Council for the Arts**, which last year invested $153 million to bring the arts to Canadians throughout the country, and the **Ontario Arts Council** for our publishing program. We also acknowledge the financial support of the **Government of Ontario**, through the **Ontario Book Publishing Tax Credit** and the **Ontario Media Development Corporation**, and the **Government of Canada**.

Nous remercions le **Conseil des arts du Canada** de son soutien. L'an dernier, le Conseil a investi 153 millions de dollars pour mettre de l'art dans la vie des Canadiennes et des Canadiens de tout le pays.

Care has been taken to trace the ownership of copyright material used in this book. The author and the publisher welcome any information enabling them to rectify any references or credits in subsequent editions.

— *J. Kirk Howard, President*

The publisher is not responsible for websites or their content unless they are owned by the publisher.

Printed and bound in Canada.

VISIT US AT

 dundurn.com | @dundurnpress | dundurnpress | dundurnpress

Dundurn
3 Church Street, Suite 500
Toronto, Ontario, Canada
M5E 1M2

CONTENTS

FOREWORD

James A. "Pete" McGarvey died March 10, 2014, at eighty-six.

In the years after the first edition of this book was published, McGarvey's stature in Canada and Orillia continued to grow. The man who saved the Stephen Leacock home in the 1950s and helped create the first Mariposa Folk Festival in the 1960s lived to see the Stephen Leacock Museum's lifelong learning centre named after him in July 2002. McGarvey received a Lifetime Achievement Award from the Radio-Television News Directors Association of Canada in May 2004, and was nominated for the Order of Canada in 2006. He received an honorary doctorate of Humanities from Lakehead University in 2012. It remains an honour to have his name grace a book with a title that reflects his own energy: The Orillia Spirit.

Randy Richmond
March 2017

A week after I arrived in Orillia in April 1947, I picked up a booklet at the Board of Trade Office. It bore the title, "Orillia, the Town on Two Lakes!"

As Randy Richmond makes so brilliantly clear in the pages of *The Orillia Spirit*, it could have been titled *The Town with Two Personalities*, with equal accuracy.

With candour, a keen journalistic eye, and even keener editorial perception, the author has chronicled three centuries of Orillia's ambivalent existence, carefully separating fact from myth and assigning each the value it deserves. It's a prodigious performance; what results is a work that will endure far longer than any "official" municipal history. This is authentic communal lore, social analysis, economic profile, all in one, and much more. The rich anecdotal overlay alone assures its permanence.

Orillia's true identity has been a matter of debate since at least the turn of the century. Are we the place much of the world thinks we are, the mythical "Mariposa," basking in Leacock's perpetual sunshine? A place of innocence, historic lore, civic boosterism, bucolic charm? Or are we the "town ahead" (to use the boast adopted in the town's pioneering push for Daylight Savings Time) — a bustling industrial/commercial centre elevated by homegrown hydro from lumber-village obscurity to Golden Age prosperity in a single generation?

Who better exemplifies the Orillia "Spirit" — industrial and civic mogul James Brockett Tudhope, or the bemused professor from Montreal, Stephen Butler Leacock, creator of Mariposa? Oddly, *Sunshine Sketches of a Little Town*, published in 1912, contains no hint of the existence of a major automobile manufacturing plant within the borders of the mythical municipality. A strange omission in a book that borrows freely from all of Orillia's leading institutions (churches, lodges, banks, stores) and engaging characters. Police Magistrate/Mayor John McCosh is the fictional Judge Pepperleigh; Canon Richard Greene is Dean Drone. Barber Jeff Shortt is barber Jeff Thorpe, and Josh Smith, proprietor of the Mariposa House, is the real life proprietor of Orillia's most popular watering place of 1912, whose surname was also Smith. But where was James Brockett Tudhope, at the time of writing the most eminent and powerful Orillian of all?

Like Leacock's cast of characters there's always more than meets the eye to Orillia's prime movers and shakers. Champlain, the noble figure atop a block of granite in Couchiching Park, had a vision of a common nationhood for Europeans and aboriginal Canadians. But he blew it in a shabby expedition against the Iroquois, plotted in Orillia in 1615. When the Iroquois took their vengeance a generation later, the dream went a glimmering and a long dark night descended on the land. The lumber barons of Orillia's mid-nineteenth century brought employment to the masses, but little social conscience to the community. Drunkenness and debauchery flourished. The architects of Orillia's Golden Age — Charles Harold Hale, Erastus Long, the aforementioned James Brockett Tudhope among them, combined extraordinary vision, communal pride and personal generosity to fashion visible declarations of Orillia's uniqueness (the YMCA, Opera House, Soldiers' Memorial Hospital, Champlain Monument), but also subscribed to a feudal code of low wages, no unions, and a social/ruling order reserved to the corporate, professional and political elite of the little town on the two lakes. Those celebrated demagogues, Ben Johnston in the thirties, Wilbur Cramp in the fifties defied the establishment and successfully rallied the left-outs and have-nots, but in the end betrayed their constituencies through greed and personal weaknesses.

The nose-thumbing of authority and the flouting of convention have been features of Orillia's public life from the very start. A few weeks after the village council convened for the first time in 1867, a meeting of the local literary society was disrupted by "Doc" Slaven, the village pharmacist, pouring scorn

on both the speaker's research (he was discussing some aspect of a Shakespearean play) and the air of intellectual superiority assumed by the membership. The story in the *Northern Expositor* doesn't relate if strong drink figured in Slaven's outburst. We're only told he brought proceedings to a crashing conclusion and no one knew how to deal with him.

It's been that way ever since. We've never been sure how to deal with rebel spirits and populists. I was among the Orillia aldermen in the 1950s who spent much of their time frustrating the outrageous schemes of Wilbur M. Cramp. In most showdowns, it was seven members of council against the mayor. But they were hollow victories. At election time, the wily Cramp would turn it all around — simply including council as a co-conspirator in the plot of the "ginger group" to destroy the community. The folks lapped it up. He spoke their language.

In more recent times Mayor John Palmer enjoyed much the same communion with voters, but unlike Cramp, he was an honest broker, if often judgmental and bombastic. He sought no material reward from his office.

Contrary characters abound in Richmond's history. Scoundrels as well as swashbucklers, schemers as much as dreamers, have played roles in Orillia's checkered saga. As a good reporter Richmond relishes their stories. Each proves that Orillia, like most communities, is a mix of good and band, of humbug and humility, bunkum and heroism, inspiration and depression.

Charles Harold Hale gets a lot of space in this book and deserves it. More than any other person of his time he moulded the Orillia we know today. The long-time editor of the *Packet*, a friend of Stephen Leacock's for fifty years, my friend and mentor for fourteen years, understood Orillia's split personality perfectly. He sold the merits of the Orillia Hydro scheme to his townspeople in the pages of the *Packet* before the turn of the century and led most of the crusades for Orillia's betterment over the next fifty years. He was responsible for the Public Library, the Champlain monument, Soldiers' Memorial Hospital, the Board of Trade, the Canadian Club, the Historical Society, the Leacock Associates, and, in the last years of his life, the movement to persuade the town to acquire and restore the Leacock home. If there were controversies, scandals or blunders in any of the great schemes of the past, they were well-kept secrets with C.H. Hale. In my many conversations with him, he spoke only of super achievements of selfless citizens — the universe unfolding as it ought. He moralized in print on the evils of alcohol, but never once criticized (in my company at least) the celebrated imbibing of Stephen Leacock. As a seasoned reporter and editor, no one knew the grim social and economic realities of his community better. Or managed to conceal them more. In the enticing literature that drew summer visitors to Orillia in the 1930s, all of it composed by the *Packet*'s editor, there's no suggestion that this centre of recreational delights — blue skies, crystal clear waters, fishing, swimming, sailing, cottaging — was also home to a score of foundry industries,

substandard wages and widespread unemployment. Far more than Stephen Leacock, Hale created the myth of Mariposa. But in truth he was the champion of both Orillias — the community of bustling enterprise as well as the centre of vacation fun. And he was far more of a hustler than he knew — accenting the positive and eliminating the negative in the pitches he contrived for both factions. Naysaying was unproductive. It was a slogan he lived by.

The Orillia Spirit manifests itself not only in the lives and deeds of past movers and shakers, but as a kind of Element "X" in the very air and water of the community. How else to explain the astonishing list of achievers who have departed this place and gone on to national and international acclaim? Franklin Carmichael, an original of the Group of Seven; Gordon Lightfoot, Canadian troubadour to the whole world; Leslie Frost, "Old Man Ontario"; Floyd Chalmers, the greatest single benefactor Canadian music and drama have known; Sculptor Elizabeth Wyn Wood; the Jake Gaudaurs, Senior and Junior; and in our present generation, Donald Tapscott, author and guru/futurist to corporate giants, Peter Baillie, president of the Toronto Dominion Bank, Tayler "Hap" Parnaby, News and Public Affairs Director of CFRB, the nation's most listened-to radio station. It infects those who stay behind just as much. I think of Gordon A. "Skid" Watson, father figure to generations of young Orillians at the YMCA, Archibald "Mac" Carter, who led the movement to build our own community centre, Jim Dykes and Jim Storey, heroes of the Leacock Boathouse project, Doug Little, the creator of pageants to keep Orillia on the map. There are hundreds of latter day heroes on my list — volunteers of every stripe, the promoters and pursuers of good causes from literacy instruction to the Sharing Place. And good and decent people — to be found in every church and service club, in the corridors of Soldiers Memorial, at the Legion, and in every lodge hall in town, doing their bit to build a healthier, happier, more caring community.

Element "X" has yet to be isolated, but it's there, still infecting ordinary people and moving them towards the extraordinary. While the Leacock Boathouse project of 1995 is cited as the latest example, the author errs. The latest example is this very volume. Randy Richmond has given his adopted community a gift for the ages — a mature and humorous (as any book about Orillia should be) account of its storied past, and with it a reminder that what once was can be again.

The Spirit moved him.

Pete McGarvey
May 1996

CHAPTER ONE

A Meeting

The story of Orillia begins with the meeting. The meeting of water. The meeting of peoples. The meeting of a grand vision and a horrible reality.

Where deep and wide Lake Simcoe meets shallow and narrow Lake Couchiching, the water rushes north through a reach called The Narrows. About 3300 BCE, people began to build weirs, lines of stakes, to funnel and catch the fish. With food plentiful, The Narrows became a traditional place for gathering, a crossroads where people could rest and share food, shelter, and stories. The Narrows became the meeting place.

At or near The Narrows, two peoples met — the French, represented by Samuel de Champlain, and the Huron. Champlain had already met Huron before, but when he travelled through the lands in 1615 around what is now Orillia, he truly saw the richness of the 30,000-strong Huron nation.

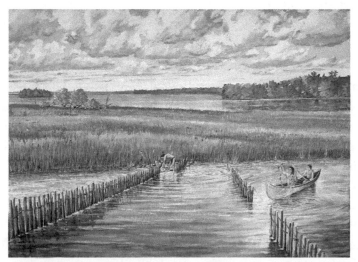

The Narrows between lakes Simcoe and Couchiching were a natural meeting place and ideal for catching fish through a series of weirs, imagined in this mural in Orillia by painter Andrew Miles.

"This country is so fine and fertile that it is a pleasure to travel about in it," he wrote in his journals. "And this small extent of territory I have observed to be well peopled with a countless number of souls, without reckoning the other districts which I did not visit, which by common report are as thickly settled as those above mentioned, or more so...."

Thirty-five years later, the powerful Huron nation was reduced to 300 people so hungry they dug bodies out of graves to get something to eat. Jesuit priest Paul Ragueneau, who lived with the survivors, wrote: "Mothers fed upon their children; brothers on their brothers; while children recognized no longer, him whom, while he lived, they had called their Father."

Famine had crept in behind the armies of the Huron's fierce enemy, the Iroquois. The two great nations had come from the same stock. Centuries earlier, the tribes that eventually made up the Huron had spread north from Iroquois country, south of the Great Lakes, to a territory bordered by present-day Orillia in the east and Georgian Bay in the west. Even before European explorers reached the New World, the Huron and Iroquois had battled. It is unclear why, and historians can see whatever they want in the nature of the conflict. Writing in the late 1800s after the destructive U.S. Civil War, American historian Francis Parkman saw the Iroquois as the "good Indians." These American-born Indians were democratic, yet nationalistic, just like the victorious Northern states. The Huron were a loose confederation of tribes, much like the South, and obviously weaker for it. During the Cold War in the 1950s, the Huron made

What's in a Name? In Orillia, Confusion

No one is really sure how Orillia gained its name, although the most likely theory has as the source the Spanish word *orilla*, meaning the lesser shore. *Oro* means the greater shore. Many of the soldiers who settled in the area on half-pay retirements had served with Wellington in the Peninsular War and knew some Spanish. They or soldiers still in service might have given the area around Lake Simcoe the name Oro, and the area around smaller Lake Couchiching the name Orillia.

Orillia was used officially as early as 1820. That seems to rule out another theory, that early settler Gerald Alley named the place after his sister Aurelia. She had given him the money he needed to buy land west of the Indian Village, which he sold to other settlers. Alley was an ambitious man and it would not be out of character for him to take it upon himself to name the community.

Natives called a red berry growing in the area Orelia, and some claim that as the ancestor of the name. Another theory credits the name to Jean Orillat, a Montreal fur trader who worked in the area in the 1700s. Others argue the name is a corruption of *aureula*, the Latin term for beautiful rose. The city could be named after Orillion, a technical military term for a waterfront fortification. An even stranger claim has Orillia named after a mythical robber, magician, and son of an imp, Orillo. Apparently Orillo could replace his limbs or head if they were cut off, which at least offers hope that, no matter what, Orillia will always survive.

a bit of a public relations comeback. The Canadian Huron were the good Indians, according to former Ontario premier and historian E.C. Drury. The Huron were peaceful and democratic, like the West in the 1950s. The Iroquois were totalitarian and war-like, like the Soviet Union and the Eastern Bloc. The clash between the Iroquois and the Huron was started, as usual, by the totalitarian tribe trying to overrun the peaceful freedom lovers, said Drury.

Whatever the reasons for the initial rivalry between the Huron and Iroquois, the coming of whites to North America and the growth of the fur trade intensified the conflict. Whichever tribe controlled the fur trade earned the most of the Europeans' guns and other goods. The Huron occupied a key position: they were at peace and trading with the agricultural tribes of Petuns and Neutrals to the south, and the hunting Algonquin tribes to the north. As middlemen, they controlled the fur trade that moved pelts from Georgian Bay up the French River to Lake Nipissing, then down to the Ottawa River to the St. Lawrence and Quebec. The Huron's rudimentary tools and belief in a spirit world were enough to convince the French the Natives were inferior savages. But Champlain saw more than savages in the Huron. After all, they were generally peaceful, and organized into clans and villages with clear forms of government. They cleared land and farmed corn, beans, and squash. And they understood commerce. Champlain intended not to destroy or enslave the Huron, but to forge a new nation of French settlers and converted, educated Natives.

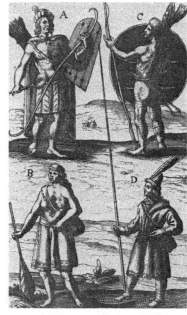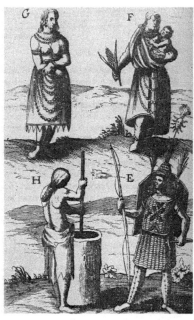

Samuel de Champlain included these sketches of Huron men and women in his journals. Figures A and C show men getting ready for battle.

Before Champlain fixed that vision on the Huron nation near present-day Orillia, he helped the Huron in a battle against the Iroquois in 1608. He tried to persuade the Huron to let him visit their home territory, but the Huron were reluctant. By 1615, they were not so reluctant. Iroquois raiding parties were making it difficult for the Huron fur traders to reach the French. Huron meeting

him at Lachine Rapids that year asked for Champlain's help against the Iroquois and invited him to visit their villages. Champlain agreed to help, explaining in his journal that he did so:

> … both to engage them the more to love us, and also to provide the means of furthering my enterprises and explorations which apparently could only be carried out with their help, and also because this would be to them a kind of pathway and preparation for embracing Christianity. For which reason I resolved to go and examine their territory, and to help them in their wars, in order to induce them to let me see what they had so often promised me.

That summer, Champlain, two other Frenchmen, and ten Natives in two canoes travelled the French River route to Lake Huron and Matchedash Bay, arriving at Carhagouha, a palisaded town near Nottawasaga Bay in August 1615. For the next three weeks, Champlain travelled from village to village, working his way from Georgian Bay to Lake Simcoe.

Not knowing what to expect, Champlain was pleased with the fertility and size of the Huron nation, which must have further strengthened his vision of a great alliance. The greatest village of all was Cahiague, with 200 large longhouses and 5,000 people protected behind a triple palisade. Champlain arrived at the village, a few miles from present-day Orillia, on August 17. The Huron prepared feasts and dances to celebrate Champlain's safe arrival and the march against the Iroquois. Champlain stayed in Cahiague until the main body of warriors was assembled, then, on the first day of September, made the short trip to The Narrows between lakes Couchiching and Simcoe.

> When the most part of our people were assembled, we set out from the village on the first day of September and passed along the shore of a small lake [Couchiching], distant from the said village three leagues, where they make great catches of fish which they preserve for the winter. There is another lake immediately adjoining [Simcoe], which is 26 leagues in circumference, draining into the small one by a strait, where the great catch of fish takes place by means of a number of weirs which almost close the strait, leaving only small openings where they set their nets in which the fish are caught.

The small army stayed at The Narrows for a few days, waiting for the rest of the Huron. When they had arrived, two canoes with twelve Huron and French interpreter Étienne Brûlé set out to sneak through Iroquois country to reach about 500 allies of the Huron

Samuel de Champlain and Étienne Brûlé parted ways at The Narrows in 1615: Champlain and an army of Huron to do battle; and Brûlé to reach about 500 allies of the Huron.

who had promised help. Champlain and the army made their way along the lakes and rivers of the Trent Valley to Lake Ontario. Once they crossed Lake Ontario, they were in Iroquois country, so they hid their canoes on shore and walked through the forest to an Iroquois stronghold near or on Lake Onondaga.

Champlain quickly realized it would be no simple task to overwhelm the Iroquois. Thirty-foot-high palisades enclosed the village. A nearby pond gave the Iroquois fresh water for drinking and to put out any fires. The battle was a disaster for the Huron and the French. Arrows fell down on them like hail. Champlain wrote that the Huron promised to obey him in the battle. But from the start, the Huron's less organized style of fighting frustrated the French. The Huron and French managed to build a cavalier, a ten- to twelve-foot tower on which the French shooters could stand to fire their guns over the Iroquois palisades. The allies also built a mantelet — a large, movable shelter that could shield a group of warriors from Iroquois arrows as they moved in and laid siege to the fort. But the Huron broke ranks, setting small and useless fires, wrote Champlain. The first attack ended in a stalemate, with several wounded and killed on both sides. Champlain received two arrow wounds, one in the knee and one in the leg, yet tried to convince the Huron to attack again, in an organized fashion. The Huron would agree only to wait a few days for reinforcements. In the skirmishes that followed over the next few days, the Iroquois shouted at the French that they should not interfere in Iroquois and Huron battles — a prophetic warning.

The reinforcements did not arrive, so the Huron and French left. Champlain begged the Huron to take him back to the settlement at Quebec, but the Huron said they could not spare the canoe. Champlain wrote, "I perceived that their plan was to detain me with my comrades in their country, both for their own safety and out of fear of their enemies, and that I might hear what took place in their councils and meetings…." This Champlain did, spending the winter visiting Huron and Algonquin villages, such as Cahiague, cementing the alliance.

Despite superior weapons and a shooting tower, the French and their Huron allies could not seize a strong Iroquois fort in what is now New York state.

That alliance turned out to be deadly to the Huron. Thanks in part to Champlain's efforts, French Jesuits eventually set up missions throughout Huron country. The Iroquois grew increasingly frustrated at French interference in their affairs, the pressure of white settlement on their territory, and the Huron's stranglehold of the fur trade. The French feared that a Huron–Iroquois alliance would free the Huron to send furs to the rival Dutch, so they broke up any moves by the two Native nations to establish a peace treaty between themselves.

Disease gave the Iroquois an advantage over the Huron. Smallpox, brought by the French, raged through Huron country in 1637, killing thousands and reducing the population from 30,000 to about 12,000. Shaken, the Huron gathered north into their strongholds, which stretched from Lake Couchiching to Georgian Bay. The missionary work continued, and fur brigades of canoes laden with pelts still travelled down the Ottawa and up the St. Lawrence Rivers to the French. Iroquois attacks on the brigades intensified in the 1640s. In 1642, the Iroquois slipped into Huron country itself, burning the village of Contarrea, a few miles south-west of Orillia, and killing all the inhabitants. (Cahiague, the capitol village Champlain had visited earlier, was abandoned sometime before 1624, either because nearby resources had been depleted or the two clans that made up the village had gone their separate ways.) Over the next few years, the Iroquois began isolating the Huron by destroying their allies — the Petuns, Neutrals, and Algonquins.

The final destruction of the once-proud Huron nation began July 4, 1648, with an attack on Teanaostaiae, called St. Joseph by the French, a mission town of about 2,000 in what is now Medonte Township. About 700 Huron were killed. The Iroquois slipped

A Forgotten Village

The misfortune that followed Samuel de Champlain's stay in Cahiague in the 1600s cast a shadow on the village itself in the twentieth century. Debate about the location of the chief Huron village appeared settled in 1947, when the remains of a huge Native settlement were found near Warminster, a few miles outside Orillia. For the next twenty years, students and archaeologists, mainly from the University of Toronto, dug at the site. Professor Norman Emerson, chief of the archaeology department of the University of Toronto, suggested the village was indeed Cahiague, one of the largest Native villages in North America.

Orillians dreamed of a unique tourist attraction, a reconstruction of that village. In 1964, Premier John Robarts announced the province would spend $1 million on the first part of a multi-million-dollar project to rebuild Fort Ste. Marie, near Midland, and not Cahiague. Professor Emerson received the usual $4,000 summer grant to pay for student research. Orillians pointed the finger at the petty politics of academia. Midland-based archaeologist Wilfrid Jury and researchers with the University of Western Ontario had developed the Ste. Marie site. They were rivals to the University of Toronto, which had developed the Cahiague site, and had more influence with the provincial government. Premier Robarts himself was a Western graduate. Midland received money to rebuild an historic site, while Orillia had to struggle on a pittance.

Interest in Cahiague sputtered on for another decade, and in 1974 the province promised to help make the site a tourist attraction. But researchers gave up on the site and Professor Emerson died before completing a report establishing the site as Cahiague. A Metis and non-status Native association tried to develop the site in the early 1980s, but that effort too failed. Today the site is a field, a silent memorial to the fate of the Huron nation.

back home, apparently satisfied with their success. That fall and winter, hundreds of Iroquois began moving into the forests of eastern Ontario. The French and Huron had no idea their enemy was marching quietly toward them. A thousand warriors suddenly attacked St. Ignace, near present-day Waubaushene, on March 16, 1649, killing most inside. Only three men escaped, fleeing half-naked over snowy fields to nearby villages. Next, the Iroquois took St. Louis, one more village on the road to the main mission village, Ste. Marie. For some reason, the Iroquois fell into a strange panic and left a few days later, torturing prisoners on the way home. The Jesuits had no explanation for the sudden fear among the Iroquois, other than the fact that it was St. Joseph's Day.

Over the summer of 1649, with fifteen of their villages destroyed, the surviving Huron fled to Ste. Marie on the Wye River near present-day Midland. But no one felt safe there anymore, and, on June 14, the surviving Jesuits and Huron burned the mission and headed across Georgian Bay to St. Joseph Island, now called Christian Island. The island had little food to support the 8,000 survivors and the Iroquois hunted down any Huron

who tried to come to the mainland. It was a horrifying winter, as Father Ragueneau reported to his superiors:

> Another mother, perceiving that she would be the first to die, left — with the same peace as if she were falling into a sweet slumber — upon her bosom two poor orphans, who continued to suck from her after her death, and who died upon their mothers as quietly as formerly that had slept there, when they drew from her both milk and life.

About 4,000 Huron died of famine that winter, Ragueneau reported. Hundreds more died of exposure and starvation. The Iroquois killed many Huron the next spring as the starving survivors braved the thin ice of Georgian Bay to reach the mainland. Those who survived fled to find shelter with other tribes. In the spring of 1650, a straggling band of French and Huron fled this area for Quebec. Out of the 30,000-strong nation that would have been the foundation of Champlain's new world, only 300 remained.

The Iroquois victory destroyed one nation, the Huron, and weakened another, the French. If Champlain had left the Iroquois alone, or succeeded in beating them, the face of North America would be different today. Canada might be a French-speaking nation. The Huron might have thrived. But one cannot blame Champlain for trying, and his dream of a peaceful alliance stands in marked contrast to the violent methods Europeans often used to deal with indigenous peoples. At least Champlain tried. About 300 years before anyone coined the phrase, his vision can stand as the first recorded version of the "Orillia Spirit" — the desire to take a risk and do something different.

CHAPTER TWO
An Inevitable Clash

The diaries of Captain John Thomson, who settled at The Narrows in 1832, provide a succinct description of pioneer life. For example, "12th June, 1835, Friday. Mrs. Thomson presented me with a second daughter at a quarter past five this afternoon. Men at the potatoes."

Today, most people likely wouldn't include a grocery list in the same entry as the birth of a child. But for the first white settlers at The Narrows and in the bush around Orillia, raising a family depended on raising the crops. Life wasn't easy in the 1830s for retired military officers like Thomson, the tradesmen, or even the government employees drawn to fledgling communities at The Narrows, the channel between Lakes Simcoe and Couchiching. They came and stayed in the area to teach, to preach, to farm — some even came for love. Through their spirit, politics, eccentricities, strengths, and weaknesses, they set the foundation for life in Orillia.

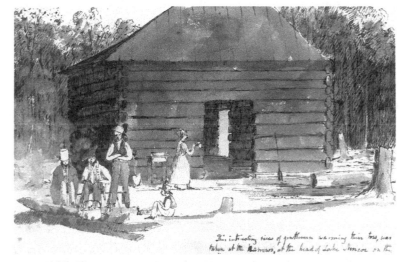

Henry Byam Martin, working in pen and brown ink, captured these "Gentlemen warming their toes, The Narrows, at the head of Lake Simcoe on the 26th day of September A.D. 1832."

Few whites even saw the area for the 200 years after the Huron left. Some white historians say a dark age fell over the area after the destruction of the Huron, with no Natives daring to cross the land. Others argue more convincingly that the Iroquois, using the former Huron territory for hunting, clashed with the Chippewa there, just as they did in other areas of Ontario. A story passed down for generations tells how the Chippewa, while driving out the Iroquois, stopped at The Narrows to get food, wait for reinforcements, and get ready for the rest of their march. One warrior, perhaps a medicine man, made a painting on a rock near Lake Couchiching that predicted the defeat of the Iroquois. A version of that painting, in wampum (beads made from white and purple mollusk shells), is in the collection of the Royal Ontario Museum.

Chippewa storytellers say the connection with The Narrows stretches back even further than the painting. Long before the coming of white men, on a great migration down the St. Lawrence and into Ontario, the Chippewa came across the Huron living and fishing at The Narrows. The Chippewa and Huron became friends. When the Huron clashed with the Iroquois years later, the Chippewa came to their aid. Some of the Huron who did not flee to Quebec in 1650 were adopted into the Martin clan of the Chippewa. The Chippewa pushed the Iroquois out of the area. At The Narrows, the Chippewa flourished and became renowned as the people of the fish fence, or Mnjikaning. The Narrows became a healing centre, where different, even rival, tribes could rest on their

Resting at The Narrows on a march against the Iroquois, a Chippewa made a rock painting that predicted a victory for his people. A wampum version of this painting on a basket is held by the Royal Ontario Museum.

journeys. Many tribes helped to mend the fish weirs (fish fences) that guided fish through The Narrows into Huron nets. According to Chippewa tradition, the language of the Mnjikaning people took on the singsong rhythm of the water flowing between the two lakes. The Chippewa at The Narrows gained the admiration of all tribes for their healing powers.

It appears most of the battles between the Iroquois and Chippewa took place northwest and southeast of present-day Orillia. The Chippewa had driven the Iroquois out of the area by 1701, and were

settled in the area when the first fur traders, soldiers, and explorers came through The Narrows — the junction of two north/south routes from Lake Ontario and the Huron's main/east overland route, the Coldwater Trail. One north/south route took travellers from Lake Ontario through the Trent Valley, the way Champlain and his Huron allies had travelled on their expedition against the Iroquois. The other took travellers along the ancient Taronto Portage, from Lake Ontario up the Humber River and overland to the Holland River, which flows into Lake Simcoe. Through The Narrows, traders and soldiers alike could head up Lake Couchiching, then into the Severn River and Matchedash Bay on Lake Huron, or overland to Lake Huron along the Coldwater Trail. Governor Simcoe and his force took the Taronto route on their 1793 expedition to Penetanguishene Bay to select a site for a fort.

The area was rich in furs, and in 1800 it attracted the attention of a French nobleman. Laurent Quetton de St. George, a lieutenant in the service of Louis XIV, had fled the French Revolution to England in 1789, then emigrated to Upper Canada with other French aristocrats and soldiers two years later. These French gentlemen tried farming on land north of York, now Toronto. Most of them failed and returned to England. Quetton de St. George stayed and became a trader, with his headquarters and one house in York; and north of that community, a château, with a private lake, called Glen Lonely. Quetton de St. George grew rich, with branches from Kingston to Niagara, trading tea, whiskey, furs, potash, flour, butter, and cheese.

In 1800, Quetton de St. George set up a little post at The Narrows. He learned the Chippewa language. They affectionately called him "White Hat," as he usually wore a white hat in summer.

The trading post seemed to earn its keep.

A clerk's record from March 8, 1800, kept in the Simcoe County Archives, shows the following purchases of pelts: sixty-nine martens, twelve bears, two foxes, and one beaver. Other trading firms, such as Borland and Roe, may have used the post. After the Battle of Waterloo in 1815, which saw the defeat of Napoleon and the return of the monarchy to France, Quetton de St. George returned to his native land a rich man.

By then, the territory near The Narrows had attracted the attention of the British government. Worried about continued trouble with the United States, Britain bought about 1.6 million acres, in what are now Simcoe, Grey, Wellington, and Dufferin counties, from the Chippewa in order to ensure a safe route to the west that avoided the Great Lakes. The 1818 purchase cost the government a yearly payment of $1,200 in goods. For years, the Chippewa continued to roam the lands at will. Early settlers in Simcoe County huddled along the sound end of the Penetanguishene Road, which was opened in 1813, and ran from Kempenfelt Bay on Lake Simcoe to Penetanguishene on Georgian Bay. Few settlers wanted to go much farther north.

"They have six or seven months dead winter, and then four months of cold winter," Reverend Thomas Williams recalled one settler telling his family when his father was considering moving north of Lake

Simcoe in the 1820s. A few of the hardiest souls did brave the north, and a few of the sharpest saw in the junction of The Narrows a natural place for future settlement. Honore Bailey patented 500 acres of land beside the lakes in 1826, although he never settled on a lot himself. A year later, voyageur, fur trader, and ex-soldier Antoine Gaudaur paid Bailey $25 for a lot close to where today's Highway 12 bypass reaches the Atherley Road. It's not clear why the adventurous Gaudaur settled at The Narrows, but it might have been for love. On his travels, Gaudaur had met Mary Shilling, the daughter of a Chippewa chief, Big Shilling. (Gaudaur and Shilling, representing two of the founding nations of the country, started a family that became prominent in Canada. Grandson Jake was a world champion oarsman and a great-grandson, also named Jake Gaudaur, became commissioner of the Canadian Football League.) Antoine Gaudaur and Captain John Thomson, whose diary began this chapter, became neighbours, with a typical neighbourly relationship. They argued over fence lines, but when two of Thomson's cows fell into Smith's Bay on Lake Simcoe, Gaudaur and his two sons helped rescue them.

The two families gained more neighbours in the 1830s, as a wave of immigration from Britain reached Canada's shores. Britain was experiencing a period of unrest, and travellers returning from Canada sparked new interest in the colony. In 1830, as settlers began moving north, Sir John Colborne, the lieutenant-governor, gathered about 500 Chippewa in three bands on to a reserve of 9,800 acres stretching from The Narrows to Coldwater. The Coldwater

Trail was cleared into a road. One Chippewa band was moved to Coldwater, where a mill was built for them, and one to Snake's Island. A third band, the Reindeer clan, lived around The Narrows and was led by Chief Muskquakie from his home on what is now called Chiefs Island in Lake Couchiching. Chief Muskquakie, or William Yellowhead as he was known to the British, had to move his band to the site of present-day downtown Orillia on Lake Couchiching. The government hired teachers and builders to teach the Chippewa white ways, such as growing crops and milling grain. Just getting to the area proved difficult for these early white immigrants. Jacob Gill, hired by the British government to build a frame house for Chief Yellowhead and a mill on the reserve, moved his family to the new Indian Village on Lake Couchiching in 1832. His daughter described the journey many years later for a newspaper. The family had a head start on most pioneers, beginning their journey from Newmarket, rather than York. The first day, they took a stage to Holland Landing, staying overnight in an old log house. The next day, they took a schooner down the Holland River and up Lake Simcoe as far as Bell Ewart. The family built a fire on shore, ate supper and "made [their] beds with the sky for a roof, and slept until morning." It took another day to sail up to Eight Mile Point just south of the Indian Village. There was no wind, so the men had to row the boat from Eight Mile Point to the village. The family arrived at 10 p.m., taking three full days to travel from Newmarket to Orillia, about a forty-five-minute car ride today.

From Hotel to Asylum

One man's mistake gave Orillia its signature park on Lake Couchiching.

Henry Fraser, an innkeeper at Prices Corners near Orillia, figured that tourism would be the village's mainstay someday. In the 1850s, he threw his money into building a luxury hotel on the shores of Lake Couchiching, about where the Champlain monument stands today. Fraser could picture his three-storey brick hotel, with its two wings and lake frontage of 118 feet, full of tourists seeking the clean air. If he pictured them getting there, he did so with blinders on. The railway was twenty years away. The only way to get there was by stage and steamer. Fraser ran out of money and gave up the project before the hotel was completed.

About the same time, the province was looking for a building to handle the overflow at the Toronto Lunatic Asylum and, in 1859, bought the hotel and property for $16,800. The Orillia Lunatic Asylum opened in 1861 and soon had 140 patients. From a visitor's description in 1869, it sounded like a well-managed institution with compassionate caretakers and a surprisingly relaxed attitude toward security. Mrs. Ephriam Post came to the asylum to visit a friend she had not seen in eleven years. The groundskeeper who let her in explained she was too late to visit patients, but agreed to take her on a tour of the grounds. They came across the gardener, who took delight in giving Mrs. Post lengthy descriptions of the flower beds. As they returned to the asylum building, Mrs. Post was shocked to learn from the groundskeeper wthat the gardener was actually a patient who believed he was

Henry Fraser's luxury hotel on Lake Couchiching in the 1850s became an asylum and, when the asylum moved, Couchiching Beach Park. The Champlain monument now stands on the site of the former asylum.

the gardener. When the groundskeeper introduced her to the matron of the asylum, Mrs. Post was further shocked to learn he too was a patient, who happened to believe he was the groundskeeper.

The Orillia asylum fell into disrepair and closed in 1870, but the growing demand for places to house the infirm prompted the province to recondition and reopen the building in 1876, renaming it the Hospital for Idiots and Imbeciles. Within two years, the province had to put the overflow from the Orillia institution in the Queen's Hotel downtown. The province began building a new asylum in 1885 on the shores of Lake Simcoe, opening it in 1891 as the Hospital for the Feebleminded with about 550 patients. The village of Orillia bought Asylum Point on Lake Couchiching and turned it into Couchiching Park.

The teachers and government workers heading to the Indian Village had to land at The Narrows or at Shingle Bay at the foot of present-day West Street and walk through bush and swamp. The first white child to arrive in the village came in the arms of the Chippewa. The child's father, Robert Bailey, moved his family to the village so he could work with Gerald Alley, the government employee who was teaching the Chippewa how to farm. The boat the family was on got stuck in The Narrows, and the passengers and freight were put on a batteau and brought closer to shore. The Chippewa carried the young Bailey girl the rest of the way to shore through water and waist-deep mud.

The Indian Village was a relief to these first settlers. At least here there was some form of civilization. The Indian Village stood about 200 yards from the Lake Couchiching shore. The layout of the sixteen log houses formed a triangle, with the base parallel to the lake and the peak a frame meeting/schoolhouse. Each log house, built to accommodate two Chippewa families, was twenty-eight feet long and fifteen feet wide, with a fireplace in the middle. Gerald Alley and a succession of Methodist ministers each had a slightly larger log house. Shanties and wigwams were scattered here and there, with most of the residences south of Coldwater Road. Gill built Chief Yellowhead's frame house near the corner of Coldwater Road and present-day Peter Street. By 1833, about 250 Chippewa, 130 of them Christian converts, lived in the village. Alley helped them cultivate about fifty acres of potatoes, corn, beans, and oats in a field adjacent to present-day Neywash Street near Yellowhead's house. The village stood north of present-day Mississaga Street and east of present-day West Street to Lake Couchiching. About 100 whites lived along the edge of the village and nearby.

It did not take long for conflict to arise between the whites and Chippewa, or for the Chippewa to get caught up in white politics. No sooner had Yellowhead's band been moved from Chiefs Island to the village than British government officials and the Methodist ministers, sent up by their church to convert the Natives, began fighting over who was to do what. The ministers and British bureaucrats argued over who should teach the Native children, where the schoolhouse should be built, and when it could be occupied. Caught in the middle of an argument over who should teach the children, "… poor Yellowhead was so confounded … that the perspiration rolled from his face and finally could not say anything on one side or the other," reported Captain Thomas Anderson, the federal government's Indian agent in 1830.

The whites' opinion of the Chippewa was typical of the time. Methodist missionaries, a kindly lot from most accounts, viewed the Chippewa as children. Settlers saw them as savages. The Chippewa women were "very plain when young and hideous when old," wrote Millicent and Ellen Steele, the daughters of a prominent settler, in their 1833 diary. The British government saw the Chippewa as a reclamation project, and not an easy one at that.

"… it is hoped they will become industrious and useful subjects. But as long as they are permitted to ask and have whatever their

fickle minds may desire, they will be just as long before they will be either useful to themselves or to society," concluded one government surveyor in an 1833 report.

Many white settlers rejected the idea that the Chippewa should be taught anything, or even go to Christian church on Sunday, recalled Reverend Thomas Williams. His family had moved to Simcoe County in 1822, when he was twelve. Before he answered the call to religion, Williams worked as a settlers' guide for the Canada Company, a British agency charged with settling Huronia. Many years after he retired, he wrote his recollections for the *Packet & Times*, an Orillia newspaper. Williams recalled walking from the land agency office at Bass Lake each Sunday to the Methodists' Church Service for the Chippewa. Mission teachers gave Sunday school lessons to the children from 9:30 a.m. to 11 a.m. Then the mission teacher "or some strong lunged Indian would take a long tin horn and produce from it trumpet-like sounds, which would seem to echo in all directions. Then look! There would be a stir at the door of every Indian house as the people began to move towards the central schoolhouse to take part in holy worship."

Many of the white settlers, traders, and teamsters refused to attend church. It's true much of the service was conducted in Chippewa, but scriptures and preaching were done in English, recalled Williams. And, he observed, many of the whites could have used the instruction. "The prevailing disposition was not religious, and many wanted the Chippewa out of that," Williams recalled.

The Chippewa did not accept the animosity with indifference. They allowed some white settlers to live in the two-family log houses for a while, but they made it clear who owned the house and who was visiting. As more whites moved into the area, the Chippewa stood their ground. Indian agent Wellesley Ritchie decided in 1834 to build on a lot north of present-day Mississaga Street, west of West Street. The Chippewa felt that was too close to their houses and refused to let him build. Ritchie waited until the Chippewa men were away hunting, brought in his workers and built a large house of hewed cedar logs. The Chippewa were so angry when they returned, they burned the house down.

Yet the same British system that ensured a certain amount of snobbery also guaranteed the Chippewa protection under the law. Captain Thomson brought some Chippewa and white men together in spring 1834 to raise a barn. The work was plagued by rain and delays. During one supper break, a playful wrestling match broke out between Ronald McDonald and a Chippewa, Joseph St. German. McDonald threw St. German on the floor in the kitchen. St. German was mortally injured and died in eight minutes.

"He was a young, strong, active Indian, but from habit and education more like a Canadian," Thomson wrote in his diaries. The next day, a jury, assembled mainly of the barn raisers, found McDonald guilty of manslaughter. Constable John O'Connor refused to take McDonald to jail because he would not get paid for doing so. Thomson then sent McDonald to Toronto, where it appears he

served some time before having a proper trial. The only good thing about the accident, concluded Thomson, was that it kept a group of wet, cold, and unhappy barn raisers on his property another day to stand for jury duty, and they finished raising the barn.

In spite of a few disputes, life in the Indian Village and surrounding communities moved along as normally as it could. The farmers cleared their land by burning the trees, visited each other when they could, and tried to thrive in a land riddled with pests ranging from mosquitoes to bears.

"Could not sleep from the mosquitoes," reads a July 14, 1833, entry in the diary of Millicent and Ellen Steele. "Life is not worth having in their company. They are the only drawback we have found in this country." They were daughters of Elmer Steele, who built Purbrook, a house about nine miles from the Indian Village. Their neighbour, John Drinkwater, had equally bad luck with bears. He lived in a house and grounds called Northbrook, a few miles outside of the village just north of present-day Highway 12. Determined to catch a bear that had killed some livestock, John and his wife Sarah hid in their barn, with a shotgun aimed through a crack in the wall at the carcass of one of their cows. They sat until midnight when they heard a commotion outside. John shot off the gun, but he and Sarah would not go out until daylight in case the bear was merely wounded. The next morning, they walked out of the barn to discover they had killed their one and only bull. John had to walk to Bond Head to get a new bull, taking three days to go and bring it back through the bush.

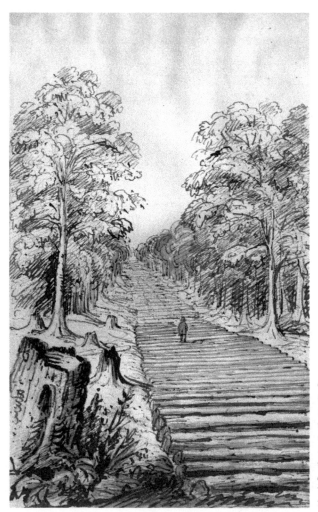

Getting to Orillia in 1844 involved either a sail up Lake Simcoe or a stage ride along rough corduroy road. Titus Hibbert (T.H.) Ware sketched this road, which passed over a swamp in Orillia Township, now Severn Township.

Life was becoming slightly more civilized in the Indian Village. Methodist teacher Andrew Moffatt took on the job of postmaster, keeping letters addressed to The Narrows, Lake Simcoe, in a little birchbark basket. Moffatt took whatever mail there was and sat on a log in front of his house, chatting with people as he thumbed through the contents of the basket, looking for their letters. The Connecticut Missionary Society posted Moffatt to the Indian Village in 1833 to teach the Chippewa men and boys. He was well suited to pioneer life. On his way to his new posting, Moffatt grew so delighted with the beauty of the countryside, he had his baggage sent on by stage and walked all the way from Toronto to Lake Couchiching. His partner at the school, Mercy Manwaring, taught the Chippewa women and girls, and was equally suited to life in the village. Manwaring was posted to the Indian Village in 1832 and became proficient in the Chippewa language. She and Moffatt married in 1834 and gave birth a year later to Thomas, the first white child born in the village.

Several villages vied to become the centre of settlement around the Indian Village. In the 1830s, Newtown arose at the foot of West Street on Shingle Bay, where some settlers landed. The Narrows also laid claim to becoming the true centre of activity. Leading settlers and Natives met in a council meeting January 6, 1834, in a tavern at Newtown to consider certain bylaws. Two chiefs, Yellowhead and Big Shilling, attended the meeting, presided over by Constable O'Connor. At that first meeting, council passed two bylaws, one allowing swine, cattle, and horses to roam freely, and the other describing to the inch how local fences must be built. The community's clerk was told not to worry about tax receipts, because no taxes were to be collected that year. There wasn't really much for a council to do in a community of a few hundred white settlers and Chippewa, so it met only once a year for the next few years. Yellowhead became a warden of the community, showing how much the white settlers respected the diplomatic chief. As the Indian Village's importance grew, Newtown's faded, and by 1835, the council was calling the community around the village and The Narrows "Orillia." By then, councillors had also had enough of bulls, rams, and goats running freely, and passed a new bylaw restricting their movements. Aside from the livestock, council had few other concerns. In 1836, fines for breaking the livestock rules and others gave council $9 in revenue, with $5 still in the bank at the end of the year.

Even the Rebellion of 1837 caused only a small stir in community life. In December, word reached Orillia that radicals were marching on York to overtake the government. Most Orillia-area settlers were appalled to hear the news. Captain Thomson, Captain Drinkwater, and Alley swore several men in as constables and ordered the local blacksmith to make pikes. Some men went to Barrie to join the loyalist forces, but they were too late to help — the rebellion had fizzled. But there was some sympathy for it. Reverend Williams wrote years later that the system of land grants

was unfair to those without connections to the government or military. And it's recorded that someone less peaceful than Williams burned down the house of a local loyalist leader, Captain William Kersop, while he was off leading the local militia against the rebels.

Armed rebellion isn't the British or Canadian way. The increasing friction between whites and Chippewa resulted in the removal of the band by paperwork, not force. The settlers were tired of travelling through swamp and bush from The Narrows to the settlement beside the Indian Village. Their community of log cabins was on the west side of West Street and on both sides of Colborne Street from West to Andrew Street, unable to spread any closer to the lake. The Chippewa had built their own store and wharf and refused to let them build a landing on the lake. In 1836, white settlers petitioned the government to move the Chippewa off the village site. The government agreed and the Chippewa surrendered their land in November 1836. Some whites wanted to have the Chippewa settled on Manitoulin Island, but Yellowhead's band refused, deciding to settle as close as possible to The Narrows. By the end of 1839, Yellowhead and his band of 184 Chippewa had completed their move to 1,621 acres of land on the other side of Lake Couchiching, land that white settlers had earlier abandoned. The Chippewa bought the land for twelve shillings and six pence per acre (about $4,000 in total).

The settlers who forced the Chippewa out soon petitioned the government to survey and sell the land in the former Indian Village.

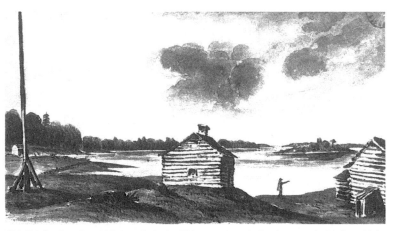

Chief Yellowhead and his band of 184 Chippewa bought land across Lake Couchiching from their original village and completed their move by 1839. T.H. Ware sketched the new village in Rama in 1844.

Andrew and Mercy Moffatt were among the first to move into the village, opening up a store at the corner of present-day Front and Mississaga streets, where the Champlain Hotel stands, and building a house on Mississaga Street between Matchedash and Front streets. (The house was torn down in 1959 to make a parking lot.) The population of the village grew slowly over the next thirty years. Drawing people to Orillia were good land and a market of farmers and shantymen working the bush to the north. In 1844, Orillia was made up of about 100 people, mainly mechanics and labourers, living in about thirty frame houses. For about $35, you could buy

a half-acre lot in a town that boasted two doctors, two mills, one clergyman, and, as yet, suffered no lawyers, reported Titus Herbert Ware, a lawyer himself, who toured and sketched the area in 1844. Besides his invaluable sketches, Ware gave an interesting written account of the village. There were plenty of jobs and wages were good. Farm servants could make $10 a month, besides free room and board, and female servants could make $5 a month. Immigrants to Canada preferred jobs in more southerly communities, creating a shortage of labourers in places like Orillia, said Ware. The high wages allowed labourers to soon own farms or businesses of their own. Ware seemed pleased with Orillia. The frame and log houses were pleasant, the farms self-sufficient, though not large enough for market farming, and many families respectable. Hard work in spring, summer, and fall was replaced by visiting and other amusement in winter. The only problem in paradise, said Ware, was the attitude of common labourers that they were the equal of the upper class, "the equality notions which the lower orders in a manner imbibe with the American air they breathe, the notions which the servants and the labouring classes generally entertain is that 'Jack is as good as his master.'"

In some ways, the labourers had it just as good, or rather, as bad, as their masters. Differences in wealth did not necessarily translate into differences in lifestyle. Just about everybody in 1844 owned a horse or a pair of oxen, and a cow, according to the assessment roll of that year. And everyone, rich and poor, struggled through

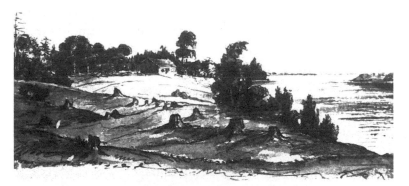

Bay Street in Orillia was once the fields and cabin of Captain St. John, captured in this 1844 drawing by T.H. Ware. Chief's Island can be seen on the right.

streets that were mud in spring and dust in summer, not to mention a pasture for the cows. Much of present-day Orillia lay in bush or swamps. Hard times demanded innovation. For example, there were no rivers nearby with the power to run mills, but that proved to be no problem for Frederick Dallas. He simply dammed a small creek, flooding much of the land around present-day Memorial Avenue. The dammed waters gave him enough power to run a saw and grist mill.

And life was good enough to draw more people. The population had grown to about 300 by 1854. Already the rugged beauty of the village was attracting attention. An 1851 article in the *Barrie Magnet* described Lake Couchiching as romantic and the situation of Orillia as beyond equal. The community had by now built two churches,

two schools, four general stores, two taverns, and one lockup house, and provided work for two blacksmiths, a tailor, a tinsmith, a wagon maker, a tanner, a cabinet maker, a butcher, a shoemaker, several carpenters, a physician, and a surgeon. Mail arrived three times a week in summer by steamer, and three times a week in winter by stage.

But the *Magnet* posed a question that has echoed in Orillia ever since: why was the place growing so slowly? "It may appear so strange that a village and township so well situated and so desirable for settlers should be at a standstill these few years back." The *Magnet*'s writer blamed the province for directing immigration to Owen Sound. For many years Orillia remained a small pioneer community, serving nearby farms and northern lumber camps, surrounded by homesteads and the woods. One visitor recalled that the most exciting moment in daily village life arose with the arrival of one of the steamers that plied the lakes.

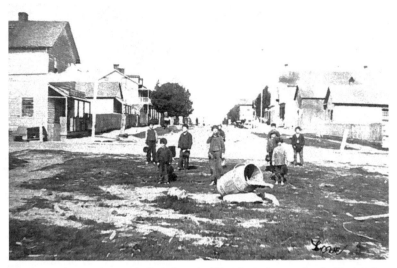

Mississaga Street, circa 1870, likely from the West Street intersection looking east.

Albeit slowly, the village did grow, and so did the aspirations of its residents. By 1866, they believed Orillia should stand on its own, separate from South Orillia Township. A petition signed by 122 ratepayers persuaded Simcoe County council to pass a bylaw on November 22, 1866, separating Orillia from the township and incorporating it into a village. The election in the Temperance Hall early the next year named James Quinn as the first reeve, head of a council of four. The creation of the village sparked some conflict with the township. Both sides claimed ownership of some tools and the library, housed at the Temperance Hall. A county judge settled the matter, giving the tools to the township and the library to the village. The township also refused to contribute to the building of a drill hall, so the village was forced to ask its residents for more money. Confident of their village's growing importance, Orillians handed over the money. Council was careful with taxpayers' money. About $1,500 in taxes was collected that first year. Expenditures totalled $400, with $161 for road work, and $180 for salaries. When the census taker refused to provide each member of council with a copy of the census, council refused to pay his $8 fee.

"The trees, I never saw the likes of them."

Few of the settlers who moved near the Indian Village had any experience homesteading, many of them military officers retired on half-pay and a grant of land. One Irish ex-sergeant said when he came across his choice lot of 200 acres: "The trees, the trees; I never saw the likes of them. Oh, the trees, the trees, if they had been stones I would know what to do with them."

Reverend Thomas Williams recalled that story and many more for the *Packet & Times* in the late 1800s. As a young man in the 1830s, he had worked as a settlers' agent for the Canada Company, which was charged with settling the area. The work of building a simple house in present-day Orillia was often dangerous, as the reverend's tale of the shanty building for an experienced Captain William Wood reveals. Wood was living with a Chippewa in one of the Indian Village houses, but feared he was going to be evicted before winter. He demanded the Canada Company help him move, so Williams was ordered to find a shanty boss and gather up a building party. Williams and his crew of ten men hiked down frozen Lake Couchiching to a building site.

I directed the men not to gather into groups, but to keep some distance apart, which they did orderly enough until we nearly reached our destination. When I judged we were near the place, I took out my map and spread it on the ice to compare the shores with the map. While I was intent on this work the men forgot my caution, and gathered round me. All at once I felt the ice bend ing; I picked up the map and ran out between the men, crying "Scatter for your lives the ice

Lawyer T.H. Ware sketched these log cabins in Orillia during a September 1844 visit. These cabins were likely near Chief Yellowhead's house, roughly where St. James Anglican Church stands today.

is bending." They were not slow to do this, and it certainly saved us a cold bath at least, for after we left the place the water came up over more than an acre of space.

The shanties were built of logs from eight to twelve inches in diameter with roofs of overlaid scooped-out basswood logs, similar to today's tile roofs. Typically, a foreman and his crew of nine axemen would cut out the space for a door for the new homeowner and leave it up to him to put in a door, windows, and floor.

"... and though they could never be made into a handsome dwelling, with skill, care and some taste, they were often made very cosey (sic), very comfortable in the inside," recalled Reverend Williams. "I have put in a good many evenings and nights with great comfort and pleasure in such dwellings."

Captain Wood and his wife found little pleasure their first winter without a fireplace, forced to build a fire at the end of the main room, and without proper chinking in the spaces between the logs to keep out winter winds. Fortunately, a hunter from the north came to winter with the family and, knowing more about life on the frontier, built a fireplace and chinked the logs.

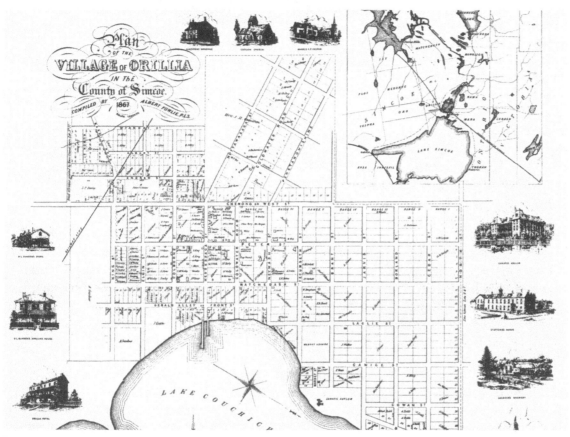

By 1867, Orillia was large enough to break away from the township and become a village. The railway did not reach Orillia until 1871, so the line marked on the inset map may have been the proposed route.

The slow but steady growth of Orillia gave the community the good fortune of coming to life the same year as Canada, and ensuring every significant "ennial" celebration of Canada's birthday could be proudly matched locally. By the time of Confederation on July 1, 1867, Orillia had laid down the foundation for the steady growth that typified Ontario's villages in the 1800s. The lumber boom rocked that foundation. The fuel for that explosion was the great Canadian pine belt that stretched for thousands of miles north. The fuse was the coming of the railway. And the spark was the enterprise of Orillia's next visionaries, the lumber barons.

CHAPTER THREE

The Lumber Boom

In the summer of 1874, the same social season that the Oddfellows Society took its annual excursion on Lake Simcoe, a party of shanty roughs took theirs on the streets of Orillia. The Oddfellows excursion aboard the *Lady of the Lake* epitomized, according to the weekly *Orillia Times*, fellowship, grace, and good humour:

> The Orillia Brass Band accompanied the excursionists and discoursed music sweet and soothing. Dancing was kept up nearly all the way out with commendable vigour, and arriving at their destination the party at once scampered in all directions in search of some shady nook wherein to partake of the contents of hampers supplied with everything to tempt the most sluggish appetite. Games of numerous kinds, idling, flirting and

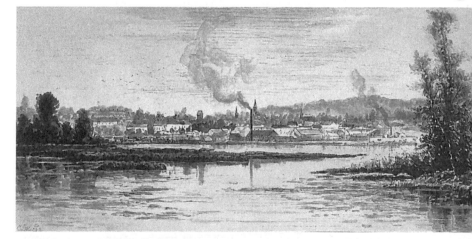

Lumber turned Orillia from a sleepy village to a bustling town, as this 1880s watercolour, *Orillia from the Narrows*, suggests.

other recreations equally interesting and pleasant beguiled the hours until the whistle warned the merry crowd that it was time to start for home.

According to the newspaper, the shantymen's excursion also epitomized fellowship and good times:

> A crowd of shanty roughs took possession of the village last Monday. It is perfectly amusing, were it not for their innate and unbearable brutality, to witness the abandon which they will buckle down to the task of reversing the conventionalities of society and making the time hideous to the orderly portion of the community generally.

The two social events of the season drew their people and their money from the same source — lumber. Trees built Orillia, its industry, its future, and a split personality that continues to be a source of amusement, frustration, and tension among city residents today. The 100-foot tall white pines of the Shield country were chopped, cut, planed, and sliced into millions of dollars shared unequally: among a few thousand mill workers, farmers, shantymen, cooks, tanners, and butchers; a few hundred clerks, artisans, tavern owners, merchants, and newspaper men; a dozen or so wealthy businessmen and their society wives, and a few rich lumber

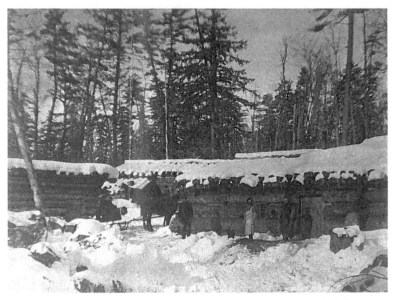

Lumber camps like Pearson's camp, shown in this 1890 image, released riotous shantymen upon the town each spring.

kings. Lumber gave Orillia a timber-rough core and a veneer of gentility, with every kind of texture of society in between. The railways, the newspapers, industry, and a sense that Orillia was destined for economic greatness — lumber brought it all.

Simcoe County had been lumbered as early as the 1780s, when masts for British ships were taken out of the Coldwater area. But little organized lumbering took place until the 1840s and 1850s,

Canada's First Medical Plan

To his contemporaries, the P in J.P. Secord stood for parsimonious. The cash-conscious realtor and developer was always coming up with new ways to make and save money. None were more imaginative than the Red Cross Hospital and Convalescent Home and what may have been the first medical insurance plan in Canada.

Sometime in 1888, Secord and seven other leading men of Orillia got together to plan a hospital that would help the town, give it status, and perhaps make a little money. Early the next year they put up $10,000, incorporated the hospital, and found a building on Orchard Point on Lake Simcoe near The Narrows. The plan was this: they would sell $5 certificates to anyone in good health. In return and if necessary, they would give that person free lodging, food, and medical and surgical care in the hospital for up to a year. Orillia doctors agreed to staff the hospital on a rotating basis.

The building and site were perfect for a hospital, the *Orillia Times* reported on October 11, 1889: "In summer, the lake breezes laden with ozone disperse the heat, afford sleep to the weary, vitality to the exhausted and health to all. In short, a better place for a hospital or sanatorium could not be found anywhere in Canada...."

With little fanfare but much optimism, the Red Cross Hospital was officially opened on November 6, 1889. J.P. and his partners had a plan to make sure the hospital thrived. They sent salesmen throughout lumber camps as far away as Whitney, Ontario, selling the certificates. Many of these men lived so far away, they would likely never collect on the $5 insurance. And those who did were the better for it: "There are several Lumbermen, as well

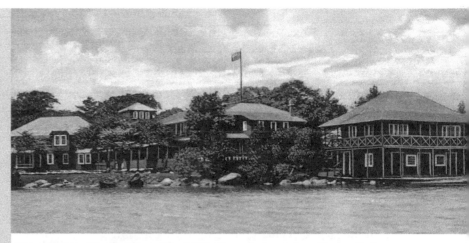

The operators of the Red Cross Hospital tried to make money by selling medical insurance plans to shantymen across Ontario. The venture failed and the hospital was turned into the Orchard Point Inn, shown here. The inn burned down in 1956.

as some Ladies, now in the Hospital," read a hospital advertisement. "One of the former would have been fertilizing the daisies now if it had not been for the Red Cross Hospital."

At least one operation was performed at the hospital, the removal of a tumour from a North Orillia Township woman. But the hospital venture lasted only about three years. People who could afford the insurance did not go to hospitals, which they considered houses for the poor. And the poor could not afford the $5 for the Red Cross Hospital insurance. Lacking patients and their money, the hospital failed. The hospital was later turned into the Orchard Point Inn, which burned down in 1956.

as settlement pushed north. Settlers saw trees as both a nuisance and potential income, selling the ash for soaps. A few sawmills in and around Orillia produced the lumber that was necessary for the community's buildings and houses. In the mid-1800s, the lumber trade in Ontario began to grow. Settlement in the United States was pushing farther west. Booming cities like Chicago needed more and more wood, as settlement consumed the forests of Ohio and Michigan. Ontario lumbermen were working their way through the forests of eastern Ontario, approaching Orillia. And in 1853, the Northern Railway reached Allandale near Barrie, linking lakes Simcoe and Couchiching, and the rivers and smaller lakes reaching into the great Canadian pine belt, with Toronto.

Dozens of mills sprang up. In 1846, there were twenty-nine sawmills in Simcoe County. By 1871 that had jumped to 114. A small self-sufficient community on the border between farm country and the towering pine forests of the north, Orillia naturally became a centre for supplying camps with food and equipment. Huge lumber companies, such as Dodge and Co. of New York, opened offices and yards here. Ambitious men began building mills in Orillia to make money milling the logs before they were shipped south. One such man was Andrew Tait, who started by making cedar shingles with his wife in a small building on Albert Street, south of Colborne Street. He made the shingles with a hand-powered machine and his wife bundled them up. From that simple start, Tait built a tidy lumber empire. The Tait and Carss Lumber Company mill, driven

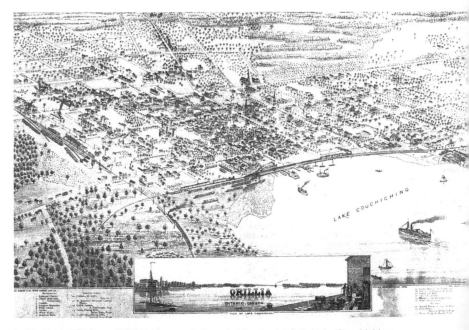

In this illustration from 1875, the logs and steam boats are visible in Lake Couchiching, as well as the Midland Railway wharf at the foot of Mississaga Street.

by steam engine, was built at the foot of the old Coldwater Road on Lake Couchiching, with a lumber yard stretching to Mississaga Street. Employees worked from 6 a.m. to 6 p.m. for a dollar a day and Tait made sure they worked hard for that dollar. He built a mansion on Colborne Street that looked over all the others, and people said he could sit in his tower and watch workmen at his

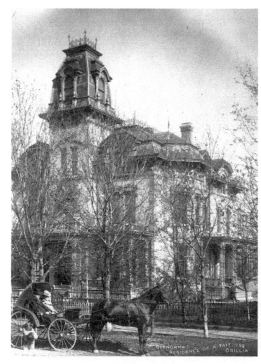

Andrew Tait and his wife, posing in front of their mansion, Glenorma, on Colborne Street between Matchedash and Peter streets, began their lumber empire with one hand-powered shingle-making machine. It later became the Orillia House and burned down in 1968.

It's said that Andrew Tait built a tower on his mansion so he could watch the workers at his nearby sawmill. The view from the tower to the west and north in this turn-of-the-century photograph shows the grounds and, in the distance, at the top right, the side of the Orillia Opera House.

lumber yard. Tait lived like a king. He thought dancing was sinful, so instead of a ballroom, he built a roller skating rink on the third floor of his mansion to keep his children amused and out of trouble. He played on Lake Couchiching on his own steam yacht, sharing the waters with one of Ontario's most successful lumber kings, John Thomson.

Born in Scotland, Thomson settled in Peterborough with his wife in 1855 and began dabbling in the lumber business there. The pine forests in Longford Township, north-east of Lake Couchiching, caught his interest, and he hired Rama Native John Young to guide him through the area. On the month-long survey, Thomson calculated how much the lumber was worth. In 1860,

The Dry Days Begin

Only fifteen years after claiming the former Indian Village for their own, a handful of Orillians decided the community needed cleaning up. With whiskey at only 25 cents a gallon, settlers looking for a break from toil and retired military officers failing at farming headed into the village of Orillia for recreation and comfort. Worried citizens believed they were turning Orillia into a shambles. A handful of Temperance supporters met on July 14, 1854, and formed the Orillia and Oro division of the Orders of the Sons of Temperance. The Sons bought a site on Matchedash Street and built the twenty-five- by forty-five-foot wooden Temperance Hall, which soon hosted meetings of all kinds, concerts, church services, and weddings, and gained support from community leaders.

But the Temperance movement's initial success was flattened by the lumber boom. By the 1870s whiskey was 50 cents a gallon, but shantymen were making $1 a day in lumber camps, with no place to spend their savings until spring, when they landed in Orillia. Law-abiding citizens were afraid to venture into the streets on spring evenings. To make matters worse, workers putting in the Northern and Midland Railways were making $1.25 a day, with Orillia hotels providing the best entertainment after a long day's work. By 1873, the village of 2,000 people had sixteen licensed hotels and eight shops that sold liquor.

In 1874, residents voted 144 to 3 to approve bylaw 54, which prohibited the sale of liquor in stores and limited the number of taverns to nine. A legal challenge questioning the power of Orillia

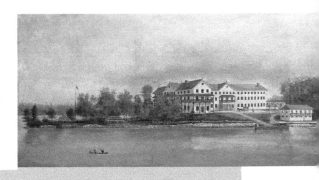

The Couchiching Hotel on Couchiching Point promised fresh air in comfortable surroundings. The hotel launched the tourism industry in Orillia, but its success was cut short by a fire in 1878.

to enact such a bylaw was made more confusing because no one remembered to sign the bylaw. With unclear legal backing, liquor inspectors had to endure wordy deputations from Temperance supporters and the briefer messages of rocks thrown through their windows from liquor supporters. The hotels were still allowed to operate, but there were rules about closing times that residents routinely ignored. Teefy Mulcahy, an insurance broker and council member, liked to tell the story about the time the town liquor inspector caught him and several other young men drinking after hours in the Daly House. The young men slid down a chute from the back room to the cellar, then scrambled outside. The last one down the chute was a rotund bank accountant whose rear end got him stuck at the chute's bottom. The liquor inspector discovered the accountant, or at least the front half of him, in the basement end of the chute and wrote him up in his black summons book. The next day, the inspector went to the bank to serve the summons. But the bank manager, himself

a patron of the Daly House, refused to let the inspector in. The inspector could not issue the summons as long as the accountant stayed in the bank. The accountant lived in the bank for ten days until the inspector finally lost interest.

When the liquor shop bylaw was finally declared invalid by the courts in 1906, Temperance forces pressed town council for a new shop bylaw. After a stormy debate, council put the bylaw to the people for a vote.

"Are the people of this town retrograding morally? Many of the present electors have seen the ravages made by the drink habit.... They have seen business concerns ruined, homes wrecked and worse than all, men destroyed through drink...." wrote the weekly *Times*.

The bylaw passed easily. The bylaw made it illegal to sell beer in Orillia, but not to buy beer outside the town and have it delivered into town. The Orillia Brewery Company at Mississaga and Andrew streets adapted. Each morning, the brewer loaded up his wagon and took the beer outside of town to a warehouse, a small shack with a door in the front and a door in the back. The driver unloaded the beer in the front door and reloaded the beer from the back door, and returned to town. That beer, having been delivered from outside of town, was perfectly legal.

The year after closing down the liquor shops, the voters of Orillia shut down all the bars and taverns as well. For the next four decades, officially at least, Orillia was dry.

the British-Canadian Land and Emigration Company paid the government about $181,000 for much of the land stretching from Longford Township east to Haliburton. But the emigration and settlement did not move quickly enough, so the company decided to sell its timber rights. Thomson headed to Toronto for the auction, armed with first-hand knowledge of the land. In the finery of the Queen's Hotel, Thomson bidded against other Ontario and American lumbermen for the timber rights. It's likely no one knew the land as well as he did, and bidding moved slowly up to $10,000. Thomson started raising it by $1,000 a bid. When it reached $20,000, Thomson, tired of waiting, stunned the room by offering an astounding $30,000. Other lumbermen thought he must be mad, for it was expensive to move the timber out of the area down to southern mills. But Thomson had a plan to mill the lumber himself and ship it south.

First, he bought access to an unusual service operated by a pair of other local lumbermen, James Durham and Thompson Smith. The pair had timber rights near the Black River and mills on Lake Simcoe, but no easy way to get the timber to the mills. The Black River connected to Lake St. John by a creek too shallow for log drives. So, Durham and Smith, with the financial backing of other lumbermen, dug a three-quarter-mile canal from the Black River to Lake St. John, and a steam-powered tramway from Lake St. John to Lake Couchiching. Spiked wheels drove a chain, which carried logs over the one-eighth-mile rise that separated the two lakes. The logs

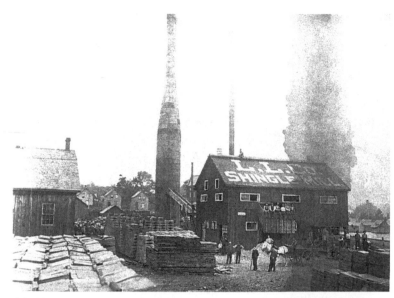

John Thomson stunned other lumbermen in 1860 by paying a princely sum of $30,000 for the timber rights on land east of Lake Couchiching. The Longford Lumber Company mill on Lake St. John cut about 20 million feet of lumber a year. Thomson also set up a shingle mill at the foot of Neywash Street in Orillia.

travelled about two miles an hour and, during peak times, workers put in twelve-hour days for 87 cents a day.

After gaining the timber rights to Longford Township at the Toronto auction, John Thomson built mills on Lake St. John. He brought the logs in by the new canal, milled them, then sent them to Lake Couchiching by his own train tracks. From there, the lumber was towed to Lake Simcoe. Before the railroads arrived, Orillia's harbour was often clogged with lumber booms. Thomson's Longford Lumber Co. alone cut 5 million feet of pine in 1869, its first year of operation, and averaged 15 to 20 million feet a year after that. By the time the trees ran out, about 200 million feet of lumber had been milled.

Thomson's success brought him wealth, power, and independence. The Dominion Bank of Canada opened a branch in Orillia to serve the Thomson account. Apparently, the owners of the Northern Railway originally intended to run the railway up the west side of Lake Couchiching, but decided instead to cross The Narrows and run up the east side of the lake in order to gain Thomson's business. That northern extension was completed in 1873, a few months after the Midland reached Orillia. For several years, Thomson used the rival Midland Railway to ship his lumber south. While the managers of the Northern stewed, he ignored their line just outside his doors. Finally, Colonel Fred Cumberland, the head of the railway, took a private train to Longford Mills. Cumberland was a powerful man who once threatened to turn the streets of Allandale to gold and Barrie to grass if Barrie did not support his railway. At Longford Mills, Cumberland told the conductor to tell Thomson he would like the lumber baron to visit him in his private car. Thomson refused, saying he did his business in his business office. Cumberland was not used to that kind of response, but the railway needed Thomson's business and eventually offered freight rates so attractive that Thomson started using the Northern line.

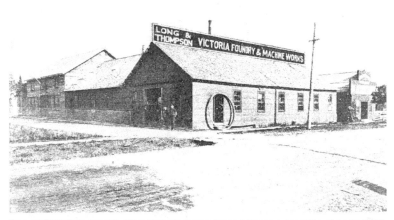

One of Orillia's longest-lasting manufacturers began life as a machine shop in 1865, on the northeast corner of Peter and King streets, supplying grist and saw mills. The Victoria Foundry became the E. Long Manufacturing Company and, in the early 1900s, moved to West and Queen streets. Changing names over the years, the plant came under control of Dorr-Oliver-Long mining company and employed 800 people in the 1970s. GL&V Canada and then FL Smidth operated the factory and foundry until they closed in the early 2000s.

The lumber from mills like Thomson's and Tait's provided raw material for a growing number of Orillia businesses. J.R. Eaton's planing mill, a large sash and door company, used a million feet of lumber a year and paid sixty people a total of $15,000 a year in wages. The Tudhope Carriage factory — two large, three-storey buildings on West and Colborne streets — made 4,000 vehicles a year, using half a million feet of lumber and providing $30,000 in yearly wages for seventy-five people. Other carriage factories, planing mills, and a hub and spoke factory sprang up. Dozens of companies supplied clothing, food, harnesses, and hundreds of other items for the camps.

Farm boys earned extra money working in the camps. About 80 percent of local boys "went shantying" in the winter, estimated one logger. They worked hard for their money and lived in rough conditions. "Everybody got good strong stomachs," recalled Harold Overend in a panel discussion on lumbering hosted by the Orillia Historical Society in 1970. There was rarely any fresh meat in the camps, but that was the least of their culinary worries, as Overend explained in his story about driving logs out of the bush one spring: "It was a pretty hot day and I walked down to see the cook and they had these old windows and he was baking and swearing, chewing tobacco and he wanted to spit it out the old open window. But the tobacco went in the dough. That spring I didn't eat anything else but canned tomatoes and boiled eggs."

The village's growth attracted newspapers, which added to the community's colour. The lone survivor from those days, The *Packet & Times*, had a birth fitting of the wild times. In 1867, Orillia's first year as a village, the publisher of the *Lindsay Post*, C. Blackett Robinson, sent a printing press and a young manager named Peter Murray to Orillia to begin a new paper. The *Expositor* first published on November 16, 1867, and prospered, although editing was done on a freelance basis, which made for varying degrees of quality from week to week. One mix-up caused Murray a huge headache, while at the

The Finest Position in the Dominion

Orillia's first high school got off to a rocky start. The headmaster hired for the new high school, a resident of Campbellford, shipped his wife off to Montreal to visit friends, then eloped with an eighteen-year-old. He telegraphed his resignation from Detroit, where presumably, he was enjoying his honeymoon.

Built for $4,606, the Orillia High School opened with fifty-seven students on January 8, 1877. Sitting atop the hill at Borland and Peter streets, it had four classrooms, an assembly hall, and a gymnasium.

From the school's tower, "… not only Couchiching, but the whole of Lake Simcoe with its bays and headlands is visible … and the country in all directions for miles and miles around can be seen," the *Orillia Times* exulted on November 9, 1876. "It occupies the finest position of all the High Schools in the Dominion." That school lasted until 1898. Weeks after the board decided against buying a higher insurance policy, the school burned to the ground. For two years after the October 14, 1898, fire, students attended classes in another building on the town's main street.

The new building opened in 1900 and the school was eventually called Orillia District Collegiate and Vocational Institute (ODCVI). Park Street Collegiate Institute opened nearby in 1961 and Twin Lakes Secondary School opened in 1973. A Catholic high school, Patrick Fogarty, opened in 1985. From 2013 to 2016, first Park Street and then ODCVI were shut down, and merged into the new Orillia Secondary School on the Park Street site.

The city's first elementary school opened in 1833, when pioneer James Dallas converted a stable on his property on Barrie Road

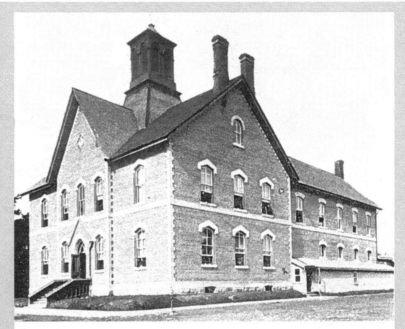

Orillia's first high school on the hill at West and Borland streets lasted from 1877 to 1898, when it burned to the ground.

into a schoolhouse. His wife and two daughters taught children free of charge. The first proper school, a one-storey log building, was built on the south side of Coldwater Street. In the early days, parents and school officials objected to hiring female teachers, believing women could not maintain discipline or teach boys how to be

proper men. By 1861, the first female teacher was hired. Elizabeth Rawson received about $120 a year for her troubles. The school's other teacher, William Jupp, made $320 a year. Until 1866, families paid a small charge, about 20 cents per month per child.

Orillia's Catholic students used their log church as their first school in the 1850s. Increased enrolment led to the building of the first elementary school, St. Mary's, in 1879 beside the new brick church, the Angels Guardian on West Street. It was torn down and replaced by a new school in 1970.

Orillia's population grew quickly during the lumber boom of the late 1800s, and soon 391 students were taking classes in three locations. The public school board decided to build one large elementary school. The two-storey Central School on Coldwater Street, located just west of the earlier school site, was completed in 1882 for about $12,000. It was followed by West Ward School in 1897 at the southwest corner of Mississaga and Dunlop streets and the South Ward School, built sometime before 1897, on the north side of King Street between Peter and Front streets. West Ward School burned down in 1968 and the site became the front parking lot of Soldiers' Memorial Hospital. The South Ward School on King Street was closed about 1970, and the building has changed hands several times since then. Central School was closed in 1985. The building remained in use and in 2016, city council put it up for sale, but under a process allowing the city to influence how the heritage structure is used.

same time allowing him to buy the paper. Some campaign material that the *Expositor* had printed for the Liberals went out by mistake with the newspaper's masthead on it. The Conservatives in town were enraged by the paper's apparent endorsement of their rivals.

Publisher Robinson rushed to Orillia, and Murray, perhaps figuring this was the best way to get out of trouble, offered to buy the paper. Robinson agreed. Murray had little time to enjoy his monopoly in the growing village. The handsome and ambitious Doctor Robert Ramsay had returned to his home town in 1868 after making a fortune in California. Ramsay wanted to get into Parliament and figured a newspaper provided the best platform for his views.

Ramsay let it leak out that he was going to launch a rival paper in Orillia. He waited a few days to make sure Murray was good and worried, then casually dropped by one day to see if it was true Murray was interested in selling the *Expositor*, rather than fighting it out with a new paper. William Hale and his brother George were working for Murray at the time and urged him not to sell. But Murray, a restless man, sold the *Expositor* to Ramsay and moved back to Lindsay to try yet another paper. The Hales left too.

After a while, Ramsay changed the name of the paper to the *Northern Light* and made it a supporter of the Liberal Party. In 1870, two years after selling Ramsay the paper, Murray returned to Orillia to work with him, bringing George Hale along. William Hale was enjoying life editing Murray's other paper in Beaverton: "I

was, therefore in no mood for a change when one day my employer, Peter Murray, again dropped in on me with a most amazing proposal. How any sane mind ever conceived a scheme so impossible one cannot imagine." The scheme was this: William Hale would move to Orillia to start a rival paper, supporting the Conservative Party, published out of the same office as the Liberal *Northern Light*. That way Ramsay could stop anyone else from starting up a Conservative paper. Such an idea, two rivals run by the same company, was unheard of, and Hale let Murray know what he thought of the plan with a "volley of ridicule." But Murray persisted, and Hale finally agreed, warning Murray the idea would float no better than a bar of iron in Lake Couchiching.

Ramsay was delighted, but he got more than he bargained for. When the Hales announced to the public they were starting a new paper in Orillia, Ramsay wrote an article in the *Light* ridiculing the upstart, called the *Packet*. The *Packet*'s first issue, on Thursday, November 16, 1870, launched a fierce counterattack, questioning Ramsay's credibility. Ramsay was astounded. He demanded Murray tell him who was writing the *Packet*'s editorials.

"The boys are doing it themselves," said Murray, the "boys" being William and George Hale. The Hales intensified their attacks on the *Light*, the Liberals, and Ramsay. A few weeks after the *Packet* started publishing, Ramsay announced he was running for reeve of the village. Much of the four-page December 7, 1870, issue of the *Packet* was taken up with accusations Ramsay was using his paper for political aims and that he made up quotes for his stories. Tea totalers and devout Christians, the Hales nonetheless knew how to throw around invective. Ramsay was no more than a drivelling, inconsistent, bad-tempered, public humiliation, they wrote.

It was getting to be too much for Ramsay, who was paying for the honour of being ridiculed. Six weeks after the start of his experiment, he told Murray to get rid of the *Packet*. William Hale turned to the local Conservative leader and the town's first reeve, James Quinn, and asked for a loan to keep the *Packet* going. With a small advance, Hale bought a press, rented an office and started publishing again.

The publisher of the *Northern Light* hired William and George Hale (with the beard) to start a rival newspaper, the *Packet*, so he could have a newspaper monopoly in Orillia. The Hales were so good at ridiculing their sister newspaper and their boss that they were fired.

For the next few years, the *Light*'s Ramsay and the *Packet*'s Hale boys waged an outrageous battle of words over each other's writing style, accuracy, and political stand. Ramsay called the small upstart "the Pamphlet," while the Hales called the established paper, which tried to please everyone on both sides of issues, "the Revolving Light." A fierce battle erupted over the railways. In 1871, two rival railroads raced to reach Orillia and its taxpayers' pocketbooks first. Extension of the Northern Railway from Toronto had stalled in 1853, after reaching Allandale, near Barrie. Legal battles and financial problems delayed the extension of the railway to Barrie until 1865. Four years later, a group of influential county and Orillia leaders incorporated to extend the line to Orillia and Muskoka. The new line was sometimes called the Toronto, Simcoe, and Muskoka Railway, but was more commonly known as the Northern. Meanwhile, the Midland Railway had been built from Port Hope to Beaverton. At about the same time, the Northern received permission from the province to extend north to Orillia, the Midland received permission to extend east to the same village. The race to reach the booming lumber town and a corner on its business had begun.

Railway companies demanded cash "bonuses" from municipalities before extending their lines. Rural residents especially were not always keen on handing over their money. Many county residents were still stinging from the high taxes paid out while the Northern was being built from Toronto to Allandale. Simcoe county historian Andrew Hunter calculated county residents paid about $1 million to build Northern rail lines in the 1800s. Trains also had a habit of killing livestock that wandered on to improperly fenced tracks and of rushing through hamlets that had expected to be important stops.

But Orillia leaders wanted the railways in order to ship lumber and other products out to bigger markets south and east. The *Light* and the *Packet* jumped aboard rival railways. Neither editor would oppose any railroad company outright — the importance of having any rail service in the village was too great — but in general the *Northern Light* favoured the Northern, while the *Packet* favoured the Midland. The reasons remain unclear. The Hales suggested in print that Ramsay and his newspaper, once the supporters of the Midland, had received favours from the directors of the Northern Railway in return for public support. Ramsay denied the charge. He wrote that the Northern would give Orillia access to the growing Torontoww market. The Hales countered that the real market was to the east in Montreal.

Just how much Ontario communities wanted rail service can be seen in an incident that occurred in Orillia. Early in 1871, the managers of the Northern told the village council they had until January 30 to give the railroad company a $12,500 bonus or face delays in construction. If there was no bonus ready, the contract would lapse and the railway delayed, warned Colonel Cumberland. Many councillors had won election on the promise the Northern would get the same bonus, $10,000, as promised earlier to the Midland, and weren't keen on the vagueness of the Northern's promises to build a

Churches

Church steeples have long defined downtown Orillia's skyline, with the four oldest churches still standing within a few blocks of each other.

The Methodists were the first Christian missionaries to the area, and in the late 1850s Reverend George McDougall had a frame church built on the west side of Peter Street opposite the Sir Samuel Steele building. As the congregation grew, the Methodists built a brick church on the northeast corner of Peter and Coldwater streets, opened in 1870. The church has been altered several times and union with many Presbyterian church members in 1925 prompted the name change to St. Paul's United Church.

The first Anglican services in the Indian Village in about 1833 were sponsored by The Society for Converting and Civilizing the Indians and Propagating the Gospel among the Destitute Settlers in Upper Canada. In 1841, Reverend John McIntyre formed the St. James Anglican parish, holding services in the old schoolhouse originally built for the Chippewa. A small stone church replaced the school house in 1857 and a larger brick church replaced the stone church in 1891, but it was destroyed by fire in 1905. The rebuilt church, opened only six months after the fire, stands on the southeast corner of Peter and Coldwater streets.

Some of the earliest settlers to Orillia were Presbyterians from Scotland, Ireland, and England, but it took the arrival of Reverend John Gray in 1851 to get regular services. A frame church was built on the northwest corner of Peter Street and Neywash Avenue

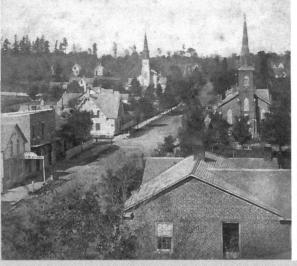

A view up Peter Street shows the Methodist Church (now St. Paul's United) in the foreground at Coldwater Street and, further back, to the left, St. Andrew's Presbyterian Church at Neywash Avenue.

in 1852. As the congregation grew, the frame church was twice enlarged, then finally replaced by the present building in 1889.

The first Catholic settlers to the area relied on travelling priests for services. Settler Peter Kenny bought twenty-five acres of land from Gerald Alley on the Coldwater Road in 1847, and offered his farm house for services. The first Catholic church, St. Michael's, was made of logs and built by members of the congregation. For a while, there were no pews or seats, and worshippers stood or knelt during Mass. In 1872, a new brick church on West Street was built and given the name Angels Guardian. A new church was built in 1910 and 1911, with limestone from the Longford quarries dragged by horse-drawn sleds across frozen Lake Couchiching. The church's spire and lighted cross, a landmark in Orillia, were added in 1927, and later the name was changed to Guardian Angels.

Serious endeavours that they were, the churches provide some levity to Orillia's history. In the early days of the Catholic services, according to church lore, one parishioner grew angry that his pew was not in the front, and after Mass one Sunday, lifted his up and over the others, putting it in the front row. Other pew owners turned up for the next service with hammers and nails and nailed their pews to the floor, so they would not lose their positions.

In 1865, Presbyterians were divided over the use of music to bring people closer to God. An organ in the church upset some church-goers so much that they carried it out. Church leaders had to refer to the Bible to convince the parishioners musical instruments could be used in worship.

In the early 1900s, St. James Anglican was led by Canon Richard Greene, the inspiration for a beloved character that lives forever, Stephen Leacock's Rev. Dean Drone in *Sunshine Sketches of a Little Town.*

station in the village. At a hastily called Saturday evening meeting, a stubborn council and Northern officials tried but failed to hammer out an agreement. Northern executives publicly expressed great sadness at the decision. After all, said Cumberland, the company never thought to make one single cent out of the people of Orillia, but only needed help to defray the cost of running the line north through the village. On Sunday, a group of alarmed village residents signed a petition asking council to give the Northern its $12,500. At an emergency meeting Monday morning, January 30, council agreed to the bonus. The *Light* celebrated. The *Packet* never forgave the Northern Railway for "bullying" villagers and stepped up the campaign to ensure the Midland received a smooth path to Orillia.

In the spring of 1871, the Midland railway began making plans to reach Georgian Bay. In order to do that, the railway needed bonuses from Orillia and the surrounding townships. The Northern, fearing its fledgling monopoly would be broken, called the reeves of all the townships together and discussed what the Northern could do for them. Northern executives hinted that those municipalities that rejected the Midland bonuses might get new rail lines and even stations from their company. One by one that June, the townships voted on the Midland bonus.

A few of the townships refused to give Midland a bonus. Those refusals and problems inside the company ensured that the Midland would lose the race to Orillia. The Northern tracks reached Orillia first, on November 14, 1871. Residents celebrated and tried to get used to the Iron Horse in their lives. The Northern line came so close to Atherley Road, farmers and travellers on horseback had a hard time keeping their horses calm when trains went by. So the Northern built sheds at three points along the tracks, for horses to be driven into when a train came. Town residents learned to drive quickly from shed to shed if the trains were scheduled to arrive soon.

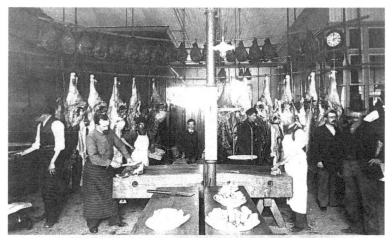

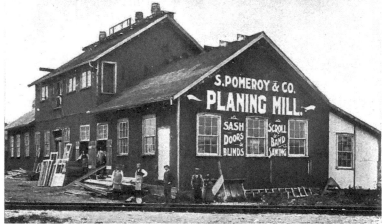

The lumber industry provided hundreds of customers to dozens of merchants, such as J.J. Hatley's butcher shop on Mississaga Street, top, and the Pomeroy Planing Mill on King Street. An 1880s directory listed eighty-four stores and professional services in Orillia.

In victory, the *Light* tried to be magnanimous.

> We do not wish here to allude to our Railway Policy; it has been severely criticized by friend and foe. We simply point now to those two locomotives shrieking at the Toronto, Simcoe and Muskoka Junction [Northern] Railway Station in our village. We are proud of the championship of that line who has been the first to enter our town.

A few days after the first Northern train reached Orillia, a three-car train consisting of two sleepers and the private car of the railway's managing director steamed into the village at 8 p.m. The crowd at the new station cheered, and after a short greeting, the railway executives, provincial and national politicians, newspapermen from Toronto, Barrie, and Orillia papers, and leading men of the village retired to a large freight shed for a banquet. The *Northern Light* described the celebration.

> The freight shed was handsomely decorated with flags and streamers. Around the room were the following mottoes in conspicuous characters: "Toronto and Orillia," "Our Government," "God Save the Queen, and protect her Dominions," "Long May the T.S. and M.J.R.R. flourish,"

"Hurrah for Cumberland and his Iron Horse." A streamer stretched across the middle of the building with a train of cars painted thereon, and the names of stations from Orillia to Fort Garry was a conspicuous feature of the decorations.

The *Packet* described the banquet at length as well, but refused to give up its allegiance to the Midland. In the same issue, a reporter noted how Midland surveyors were braving three-foot snowdrifts that week to extend the line to Orillia. The Northern's railway station was built at the bottom of Peter Street at King Street. When its tracks reached Orillia in 1873, the Midland built its station at the foot of Mississaga Street behind the Champlain Hotel. The Grand Trunk Railroad eventually took over two routes, itself evolving into CN. Where those two rival railways crossed, called the diamond, CN built the present station, which was for years the Chamber of Commerce building. The Canadian Pacific Railway built a track to Orillia in 1910, with a station, now the Royal Canadian Legion building, at the foot of Mississaga Street.

The *Packet* and the *Light* continued their fight for many years after the railways were settled. But the papers did more than feud. They gave a voice to the community, its dreams and fears. From debates about the shamelessness of young boys swimming off the public waterfront in front of strolling ladies to gossip about lovers spurned and grisly details of murders and drownings, the *Northern*

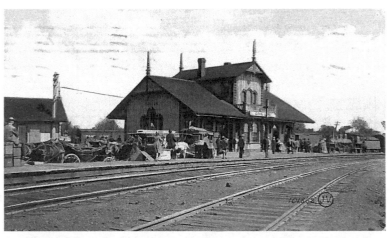

The Midland Railway Station was built near the lake on the north side of Mississaga Street. In 1897, a few years after the Midland and Northern railways were taken over by the Grand Trunk Railway, this station was moved to the junction, or the diamond where the two lines met, near Front Street between King and Queen streets. The station burned down in 1916. A new one built nearby was still in use in 2017, although not as a station. The last train through Orillia was in 1996.

Light and the *Packet* reflected the mundane and the exciting of everyday life in the 1870s. Occasionally, the publishers even agreed on something. For much of the 1870s, for example, the rival papers led the way in pushing successive councils to improve fire protection. Fire could wipe out a village built of wood, such as Orillia, in hours. And a fire or two seemed to take out a building or two each summer. A fire in May 1872 burned a hardware store and part of the post office. The village's firefighters ran out of well-water and

Steaming into Legend

The steamers that plied lakes Couchiching and Simcoe from 1845 to 1911 moved anything for the price of a ticket, from the first eager settlers to lumber, and, and after the railroads opened, young couples on church picnics. They were immortalized by humourist Stephen Leacock, whose story of the sinking of the *Mariposa Belle* was not as fictional as steamer captains would care to admit.

The *Sir John Colborne* made its maiden voyage on Lake Simcoe in 1832, and the happiness of the settlers on the lake turned a day-long affair into a week-long celebration. The steamer had to stop at each landing for a bit of cheer and it's a wonder there were no accidents on that maiden voyage. The *Colborne* could reach speeds of four knots, but drew so much water she kept getting stuck in shallow parts of Lake Simcoe and was eventually abandoned in the Holland River. Thus, she started three traditions on the lakes — steamboating, getting stuck, and meeting an unhappy end. After the *Colborne* came the *Simcoe*, known also in her career as the *Peter Robinson*, the first to make it through The Narrows to Lake Couchiching, where it too was eventually abandoned. Then came the *Beaver*, which ended up as landfill under a train station in Barrie, and the *Morning*, caught in a storm in 1862 and trapped by ice, left to rot near shore.

Lake Couchiching finally got its own steamers in 1864 and three years later the *Orillia Expositor* was reporting that three or four steamboats were calling on the community each day. By 1870, two of the most famous steamers, the *Ida Burton* and the

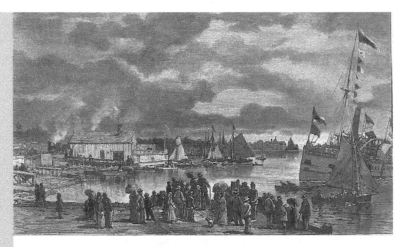

The arrival of the steamboat drew a crowd to Orillia's waterfront in this painting, thought to be from the 1880s. Note the asylum in the distance.

Carriella, competed for the business of transporting people and supplies to Washago at the north end of Lake Couchiching. The fare from Orillia to Rama was 20 cents, to Longford 25 cents, and Washago 40 cents. On its 1872 summer schedule, the *Ida Burton* left Orillia every morning at 9 a.m. except Sundays, stopping at Longford, then Washago, then Longford again, and returning to Orillia by 4 p.m.

The *Ida Burton* was a bigger boat, but the *Carriella* was considered faster. One day, *Ida Burton*'s Captain John Ferris Nelson promised his fireman a bottle of Scotch whisky if he could build up enough steam to get the *Ida Burton* to Washago first. The

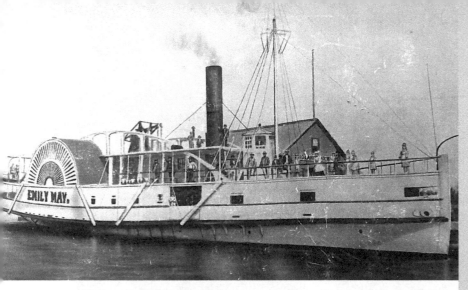
The graceful 144-foot *Emily May*, launched in 1861 and operated until about 1883.

Ida Burton won the race and the fireman got his whisky. But when Captain Nelson started unloading his freight, he noticed a few barrels of tallow destined for some northern tanneries were missing. The fireman had used the animal fat to give an extra boost to the fire. Like many steamers before, the rival boats ended up buried underground, the *Ida Burton* as landfill for the Orillia railyards, and now beneath the Royal Canadian Legion branch, and the *Carriella* under Couchiching Park.

A year later, the Northern Railway reached Orillia and the workhorse days of the steamers ended, to be replaced by excursion trade. Each Thanksgiving, the owner of the Longford Lumber Company, William Thomson, took the leading businessmen of the town on his steamer, the *Longford*. On the 1898 voyage, about halfway up Lake Couchiching, the *Longford* struck Sanson's Shoal near Ship's Island.

"With the first shock there was a general rush for life preservers," wrote a reporter for the *Orillia Times*, and by that he meant whisky flasks. "Commodore Haywood never goes to sea without one of his own. As he reached for his hip pocket, he had several officers to assist him 'Blow' it."

The embarrassed captain lowered a lifeboat and took the *Longford*'s anchor out a short distance, in a futile attempt to winch the boat off the shoal. A passing steam yacht took Thomson and some others back to Longford Mills, where they rigged up the schooner *Curlew*. The businessmen still aboard the *Longford* climbed aboard the *Curlew* for the trip back to Orillia. Then the *Curlew* went aground on the same shoal. Everyone clambered aboard the *Longford*'s lifeboat, and, lighter now, the *Curlew* floated free. The excursion climbed aboard the *Curlew* again, and finally made it home. After the captain hit the shoal a second time, he gave it a new name, the *Times* reporter joked. "As he did so in Gaelic, the reporter was unable to catch the title, but it sounded like 'Howingehannadididothat.'"

By the time Leacock immortalized steamboating — and steamboat sinking — on Lake Couchiching in 1912, the glory days were over. But traditions live on. Tourist boats, made up to look like steamboats, continue to take excursions around Lake Couchiching. And they still find the occasional shoal.

had to bring some from the lake. The only thing that saved the rest of the village was the lack of wind. Luck saved the village again in August, when a fire that started in a bakery swept along Mississaga Street. Village residents stopped the fire by wetting the walls of a stucco building, using an engine borrowed from the Oliver Co., and throwing wet blankets on the roof.

"In many parts of the town, people had their goods packed and ready for removal, fearing that the conflagration would be the destruction of almost the entire village," wrote the *Packet*. Thieves made off with hundreds of dollars of goods and one-third of Mississaga Street was destroyed. The constant fires finally prompted Orillia to set up a waterworks system, a series of wooden pipes running from the springs in Victoria Park to cisterns located at the four corners of the downtown. When the village reached 2,000 people and became a town in 1875, council decided even more protection was needed. The town bought a lot at 27 Peter Street North and built a firehall with a fifty-five-foot-high bell tower, for ringing the alarm and sounding the time of day at 7 a.m., noon, 1 p.m., and 6 p.m. The fire brigade had one wagon with a thirty-five-foot extension ladder and pump operated by eight men.

That small force, even with the help of a privately owned company fire engine, could do little to stop another major fire in 1879. It appeared an arsonist started a small fire behind a storehouse on Mississaga Street about 11:30 p.m. on August 5. The flames caught the wood buildings nearby and within minutes swept down the north side of the main street. Firefighters could do little more than

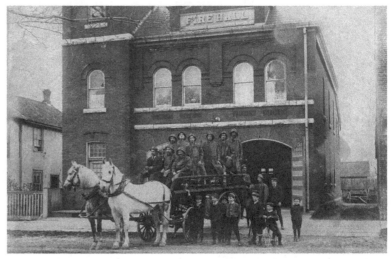

The 1896 firehall built at 27 Peter Street North featured a fifty-five-foot-high tower, heated so the hoses could be hung and dried, with a bell that sounded fire alarms and the time of day every six hours. Eight men operated the one wagon with a thirty-five-foot extension ladder and pump. Horses Pat and Barney lived in the building and a special pulley system dropped the harnesses on them so they could be quickly hitched to the wagon. Pat and Barney helped plow streets and deliver wood in the winter, and pulled a cistern to spray water on the streets in the summer.

try to stop the fire from spreading to the south side, which earned them criticism from businessmen on the north side of the street who watched their buildings burn without a fight. When the flames reached Peter Street, they raced down both sides to Colborne Street. Thirty buildings — a quarter of the town — were destroyed, and damage was estimated at $50,000. Fortunately, the wind died as

quickly as it had risen, and firefighters gained control of the blaze. Town businessmen rebuilt their stores and warehouses out of limestone from quarries at Longford Mills. Many of those buildings on Mississaga Street remain standing today.

Lumber continued to support the town's growth for the next two decades. But the frame buildings of downtown Orillia, the symbol of the lumber years, were replaced by stone and brick, as new industries and new ideas took over.

CHAPTER FOUR
The Orillia Spirit

Daylight Bill Frost woke up at the usual hour one Sunday morning in June 1912, thinking nothing was out of the ordinary. He dressed in his Sunday best, as befitted the mayor of the town of Orillia, and went to church. He arrived to find the congregation and minister already an hour into the service. Imagine his embarrassment. Not only was Frost late, but he had forced everyone else to arrive early. Daylight Bill had already forgotten his own revolutionary proclamation, that the clocks of Orillia be put ahead one hour at 10 p.m. the night before. His late arrival gave an extra edge to the question asked by the pious around town: "Do you go on God's time or Bill Frost's time?"

For two weeks that summer, half the town went by one time and half by the other. Town bells rang at different hours, factory workers arrived late or too early for work, and boarding-house operators had to cook two sets of lunch and two sets of dinner each day for

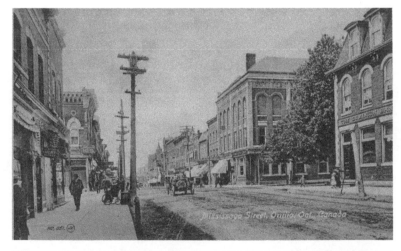

Mississaga Street, near the corner of Peter Street in 1912, the year Orillia tried to leap ahead in time and when an Orillia Tudhope car cost $1,600.

Daylight Bill Frost, mayor, merchant, and promoter of Orillia, forgot his own proclamation to move clocks ahead one hour and arrived late for church.

president of the Orillia Board of Trade in 1911, Hale suggested the town try daylight savings, adopting the slogan "The Town Ahead." The next year, Hale began a fifteen-year stint on council and with support from his colleagues, including William Frost, managed to get daylight savings a two-month trial in 1912.

The town greeted the idea with suspicion. Few people understood it. Some residents figured putting the clock ahead one hour meant they lost that hour permanently, every day, and would get less sleep. Others said it moved Saturday into Sunday, violating the Lord's Day Act. Daylight savings would force everyone to get up earlier and eat breakfast too early in the day, claimed some opponents. As the hour of daylight savings approached, 10 p.m. on June 22, fear grew. The Bricklayers Union voted against the proposal and petitions against it circulated through several factories. Some factory workers claimed daylight savings was a plot to make them work extra hours.

Hale tried to allay their fears in the *Packet*:

> The bone and sinew of the town, who work from 7 to 6, day in and day out, find it dark almost as soon as tea is over. Moving the clock one hour ahead would give these men an opportunity to enjoy another hour's daylight in the evening… Life will have a new zest… because they will sleep in the dark hours and have an hour more sunlight added to the waking period.

roomers. Daylight Bill had his good friend Charles Harold Hale to thank for mixing up him and the rest of the town. C.H. Hale had inherited the *Packet* from the "Hale boys" — father George and Uncle William. C.H. Hale was always looking for ways to make Orillia stand out from the crowd of Ontario's small towns. A few years earlier, Hale had become interested in the idea of daylight savings, first proposed in England. Turning the clocks ahead an hour in the summer would give working people, with a common shift from 7 a.m. to 6 p.m., an extra hour of sunlight in the evening. As

Hale tried to explain to people that the hours of a clock were set arbitrarily. Six o'clock came at the same time every morning because everyone agreed it was six o'clock. Putting the clock ahead did not mean you lost sleep, because you still went to bed at 10 p.m. and got up at 6 a.m. The controversy attracted the attention of newspapers across the country. Although Port Arthur, Ontario, had already switched to daylight savings, Orillia was credited with trying a grand experiment.

"All eyes are on Orillia," the *Packet* proclaimed. "Manifest the Orillia Spirit."

At 10 o'clock on the evening of Saturday, June 22, the town bells rang to remind everyone to turn their clocks ahead one hour. Time and Orillia jumped ahead, sort of.

"The confusion was beyond belief," recalled Hale. "Some of the church bells were off time. The Town bell rang at six o'clock, daylight time, instead of seven. On Monday morning merchants who were meticulous in their arrival in the stores found themselves an hour late."

Some workers tried to take advantage of the confusion, Hale recalled. On the Monday morning, employees of the Hewitt Brothers trucking yard arrived at 7 a.m. daylight savings time, but sat around for another hour, waiting for standard time to catch up before starting work. Meanwhile, they teased other workers on their way to work at the proper time. At 8 a.m. daylight savings time, 7 a.m. standard time, they started work. The tables were turned when the town bell rang at noon. The employees of the Hewitt Brothers quit for lunch, but were told they still had another hour

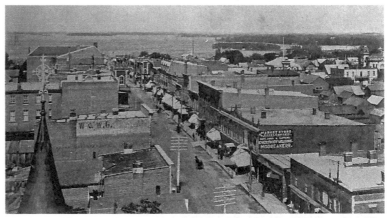

This view of Mississaga Street looking east toward the lake was taken from one of the towers of the Opera House around 1896. After the 1879 fire, Orillia's buildings were rebuilt using brick and stone.

Some companies adopted daylight savings, but others rejected the plan. That caused a nightmare in everything from shipping schedules to baseball games. Employees working under the daylight savings time got off an hour before everyone else. As they wandered to the ball diamonds, they teased the men still at work, causing some bad feelings in town. Still other workers thought the new hours meant they had to go to work at 6 a.m. and waited for an hour for everyone else to show up. There were some advantages, however. Baseball teams could get a full nine innings in before darkness fell. Parents and their children attending the circus could go home when it was still light. But boarding-house

A Motoring Adventure

Muddy roads and ruts that seemed deep enough to swallow cars whole awaited the first drivers of J.B. Tudhope's automobiles. In 1909, Bell Telephone employee A.W. Robinson was instructed to pick up the company's first truck and deliver it from Orillia to London, via Toronto. Bell Telephone had decided to try the automobile as an experimental replacement of horses. Tudhope workers gave Robinson and other company officials a quick tour of the factory and brief instructions on how to drive the car.

That first day, Robinson, two Bell officials, and a Tudhope worker on his way to Toronto to demonstrate the car to Toronto Hydro drove the thirty miles to Barrie in two and a half hours, scaring horses and startling spectators along the way. The next day, they picked up two more company officials and enough mud to build their own road. The car got stuck in the mud once, and Robinson had to get a farmer to pull it out, while frightened company officials in their patent leather shoes stayed in the car.

"The weather was really nasty when we reached the Yonge Street road leading to Aurora," Robinson recalled. "The mud was flying in all directions (there were no mud guards or canopy on the car). When we stopped in Aurora at noon for lunch the mud was spread on us pretty thickly and it took us about twenty minutes to wash up."

It had taken about ninety minutes to travel about fifteen miles from Newmarket to Aurora. One company official elected to take the train from Aurora to Toronto, but the other five stuck with the Tudhope. On the way, they noticed that the railroad tracks appeared the same width as the Tudhope's steel-rimmed, rubber tires. So, they tried the car on the railroad tracks.

"We opened the throttle wide and must have been making about twenty miles an hour," recalled Robinson, "when the section man flagged us down. He told us to get the hell off the track and stay off."

The group arrived in downtown Toronto covered in mud, but triumphant in making the last thirty miles in three-and-a-half hours.

keepers put pressure on town council to give up the experiment. With men going to work at different hours, boarding-house keepers had no idea when to serve meals. The confusion in boarding houses and the friction in town persuaded council to reluctantly repeal daylight savings time two weeks after it started.

Daylight Bill Frost suffered his nickname for years, and Hale felt badly about the ridiculing he had put his friend through. But when Canada adopted daylight savings several years later, Frost began wearing the nickname proudly. Orillia's daylight savings experiment turned out not to be a failure, but simply ahead of its time.

And it was only one in a long line of brave attempts to make Orillia the best town in the province — not the richest or biggest perhaps, but the most spirited and innovative.

From 1880 to 1929, what is considered Orillia's first Golden Age, the town reached for and often clasped greatness. Behind all the achievements stood a group of young men who shared what they coined the "Orillia Spirit." The dream to make something out of Orillia, and the energy and unity to realize that dream defined the Orillia Spirit. The dozen or so men who led the town in those forty-nine years called upon the Orillia Spirit to cajole Orillians into backing their schemes. The same names appear throughout those years as reeves, council members, board of trade presidents — Hale, Frost, the Tudhopes, Erastus Long — names that still carry the mark of honour in the city today. In the Golden Age, the town gave birth to one of the first Canadian automobile companies, the first successful medicare plan, the Champlain monument, the fairy-tale Orillia Opera House, the province-wide county battalion system, and the first long-distance hydro transmission system on the continent. The accomplishments came with drama, tragedy, and comedy attached, none more so than the greatest — the Orillia power scheme.

Nothing less than province-wide ridicule, the near drowning of the mayor and council, a steamboat sinking, dozens of accidents, a midnight raid on the power plant, and a civil insurrection lay ahead when Orillia's leaders first contemplated tapping a distant river to bring electric power to the town.

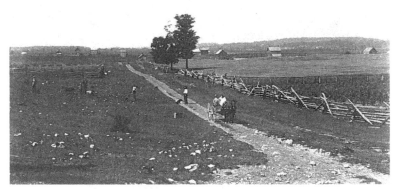

In 1888, Oxford Street was just a pathway to building lots and, beyond that, a few farms.

"Oh for the Electric Light," wrote the *Orillia Times* editor in May 1887. "When it is so dark that a man has to strike a match to see his way, it is getting pretty bad."

The town built an arc lighting plant that year. That first plant in Victoria Park used wood as fuel to drive the steam engines that provided electricity. The plant provided light for fifty lamps downtown. But the town was increasingly hungry for power. In the first recorded expropriation of private property in Orillia, the town bought seven acres of land and access to springs at Fittons Road and Stanton Drive from a reluctant H.W. Fitton for $2,000. An eight-inch cast iron pipe brought water from the springs to the steam pumping

plant at the bottom of Jarvis Street. That plant, built in 1894, gave the town power for forty-five more street lights and 2,300 incandescent lamps that factories and private citizens could use.

The world had seen nothing yet. As early as 1889, the town had considered schemes to purchase hydro-electric power from a mill in Marchmont or produce its own power at Wadsell Falls in Washago. Nine years later, Thomas H. Sheppard urged council to consider using Ragged Rapids on the Severn River. He ran for mayor in 1898 against J.P. Secord on the ticket of tapping the Severn River to provide cheap lighting and cheap power. Secord ran on a less glamorous ticket — opposing the move of the railway station a few blocks in town. Sheppard and a slate of power-scheme supporters won the election.

The new council wasted little time. After only a few days in office, on January 24, council, with a surveyor and reporters from the *Packet* and the *Times*, travelled to Ragged Rapids. They rode as far as they could by sleigh, then snowshoed the remaining ten miles. Measurements showed the rapids had a fall of about thirty-five feet in less than a mile, enough to provide power. Buoyed by council's optimistic reports, town ratepayers voted 399 to 61 in February to build the plant for $75,000. What opposition there was came from people worried that the demand for wood would drop and hurt suppliers to steam plants. The hydro-electric proposal was ridiculed in the provincial legislature, but in Orillia, support rarely dropped, even during the misadventures surrounding the scheme.

And there were plenty. Council dropped the first contractor, the Buffalo Construction Company, because it soon appeared to have financial difficulties. The contract was handed over to P.H. Patriache, a Toronto builder. The *Times* rejoiced, "There is no doubt about the work being pushed to a speedy conclusion now that it is in Mr. Patriache's hands," and predicted the plant would be running by the fall of that year, 1899. A journalist's visit to the site in the fall revealed 115 men were working eleven hours a day to erect the dam. Yet the men were hampered because there was no way to get steam-operated equipment to Ragged Rapids. Trips to the site invited disaster. Boats hit rocks and dumped workers into the icy waters of the Severn. A scow carrying council members on one inspection trip was cut by ice and started to sink. The passengers saved the boat by shifting bags of cement to the stern to lift the sliced bow out of the water.

Early in 1900, anxious to see how work was progressing, council members, their wives, and other dignitaries, including a Scottish minister, Reverend George Grant, took a trip to Ragged Rapids. Their return on Patriache's steamer, the *Syesta*, took them through the Sparrow Lake Chutes, where the waters of Sparrow Lake plunged seven feet down through a narrow, 100-yard-long chasm of churning water. A crew on shore had to pull the *Syesta* over the rapids with a rope and windlass. Most of the party got off the boat before the rapids and walked along shore. Eight men stayed with the *Syesta*. Mayor J.B. Tudhope and Councillor Robert Curran sat in two of the small

rowboats towed behind. Somehow the men on shore running the windlass allowed the rope to slacken and the steamer turned broadside to the rushing water. In seconds the current flipped the hull onto its side and water poured in. A reporter on the trip described the sinking: "You can hear the snarling of the fire as the water strikes the boiler and then she strikes a rock and straightens up on an even keel for an instant. A second later she is borne down again, careens over on her side and with one rush the water fills her and sucks her down."

The engineer and one man jumped out and swam to shore. Another man struggled through the twenty-foot-deep stream to Tudhope's rowboat and, taking hold of it, almost tipped it over. The man swam off to Councillor Curran's rowboat, and Tudhope managed to row himself to shore. Curran's rowboat was still attached to the steamer, but someone cut the rope just as the steamer sank. With a man clinging to each side of his boat, Curran rowed to shore. As the horrified party on shore watched, the last man in the water, Frank Evans, struggled to another boat. He couldn't cut the rope to the steamer in time and the sinking *Syesta* took the rowboat with it. A couple of paddlers in a nearby canoe quickly rescued him.

"It is little less than a miracle that all escaped alive," wrote the reporter. Councillor Crawford Miller led the group in singing "Praise God from Whom All Blessings Flow." (The blessings didn't flow far enough for Rev. Grant. He watched his valuable picnic silverware go down with the boat. Grant sent the town council a claim for the silverware, but council rejected it.)

Council's visit did nothing to speed up construction. Patriache had trouble paying his men and his suppliers. Acting on behalf of the town in the winter of 1900, Patriache bought some hydraulic equipment from the Jenokes Machine Company of Sherbrooke, Quebec, for $8,000. He was supposed to pay for the equipment, which was being stored in Severn Bridge. By June, the company had received little of its money, so it sent a private train and crew to Severn Bridge. At midnight one Sunday in June, the crew sneaked into the storage shed and loaded the equipment onto a rail car, then headed back to Quebec. The theft was so bizarre, Mayor Tudhope refused to believe rumours about it the next morning. But two councillors rushed to Atherley, just in time to see the train pull out. Police stopped the train in Lindsay, and Orillia council won possession of the equipment through a special provincial order.

Patriache himself soon ran afoul of the law. He had bought another steamboat, the *Queen*, and was taking it through Lake Couchiching to the Severn River. He had stopped in Orillia to do some repairs. In the meantime, there was a mix-up over his payments on the boat and the Orillia police had been notified. While Patriache was away from the steamboat trying to settle the payment problem, an Orillia constable tied the boat to the Orillia dock to prevent it from leaving. Patriache settled the financial problems, finished his repairs, untied the boat, and headed to Washago. Knowing nothing about the settlement, the angry constable raced to Washago. Meanwhile, Patriache's repairs had come undone and

Ragged Rapids Power Dam in course of Construction, Orillia, Ont.

The Ragged Rapids dam gave builders nothing but trouble, and it was eventually learned that the contractor used loose rock as a foundation for the first dam.

the boat began to sink. He had to beach the boat near the railway bridge in Washago. While wandering through the town, Patriache felt a hand on his shoulder and heard the words of an angry constable, "You are my prisoner."

"For unexpected developments, downright hard luck, continued bungling and amusing incidents, Orillia's power scheme takes the cake," concluded the *Packet* after the arrest.

That matter was settled, but breaks in the dam, trouble transporting equipment, and inexperience delayed work on the dam. By 1902, taxpayers and council were reaching the limits of their

patience over the delays and rising costs of the power plant. Tudhope won his third term as mayor by acclamation, and Frost was returned to council. But in a bitterly fought election, three council members, including Miller, a strong supporter of the power scheme, were defeated. Tudhope vowed to push Patriache to complete the dam and start sending power to Orillia, even if the town had to take the plant over itself. The dam was completed on January 16, 1902, and townspeople were told power would be transmitted the next day. It didn't come the next day or for several days after that. Patriache began lighting the town to test the plant, but the town waited and waited for full power. Early in March, Patriache got the plant running to full capacity, but threatened to shut it down if he wasn't paid for providing the town light for the past few months. He showed no intention of completing the plant to council's satisfaction or turning the plant over to the town. Late in March, council gave Patriache a forty-eight-hour deadline to get the plant up and running. He ignored this. On Saturday, March 22, council met and secretly planned the next step. A clause in the contract gave the town the right to take over the plant if contractors were moving too slowly, said the town lawyer, F. B. Johnson. Patriache was in Toronto trying to sell that city on another power scheme, so council launched its attack. First, a city worker cut the phone lines to the Ragged Rapids plant, then council notified Patriache that the town was taking over the plant. Patriache tried Monday afternoon to call the plant and warn the workers there to defend it, but of course he

A Monument to the Past

On vacation in Quebec City and Saint John, New Brunswick, in 1912, it struck Charles Harold Hale as odd that these two cities had wonderful monuments to Samuel de Champlain, but Orillia did not. Hale immediately set out to build a monument to Champlain in Orillia. A competition for design attracted twenty-two entries from France, England, and Canada, and a young sculptor named Vernon March, just twenty years old, won.

The Champlain monument was supposed to be built by August 1915, to mark the three hundredth anniversary of the explorer's visit to Huronia. But the First World War delayed work on the sculpture until July 1, 1925. The gathering in Couchiching Park for the $35,000 monument's unveiling drew about 18,000 people, more than twice the population of the town itself. The crowd watched a re-enactment of Champlain's visit, with more than 250 men, women, and children dressed up as Huron, first frightened when Champlain arrived, then full of joy, singing and dancing.

The twelve-foot-high bronze Champlain, dressed in full court attire and cloak blowing in the breeze, stands alone, plumed hat in hand, looking down as if in thought. Below him on one side, symbolizing Christianity, a robed priest holds the cross high above the wonder-struck Natives at his feet. On the other side of Champlain, symbolizing commerce, a fur trader examines a pelt brought to him by two Natives, also at his feet.

The subservient position of the Huron in the 100-tonne monument was reflected in the first words on the monument's plaque:

Sculptor Vernon March, on the right in both photographs, examines the figures that will make up the Champlain monument.

"Erected to commemorate the advent into Ontario of the White Race under the leadership of Samuel de Champlain...."

Several times over the past twenty years, the statue has come under criticism. In 1996, after Mnjikaning First Nation elder Sue Anderson expressed her concerns, a committee was struck to produce an alternative text on the plaque:

> With the arrival of the French in North America, both they and the Huron Confederacy

recognized and welcomed the benefits of equal trade and cultural alliance between the two nations based on mutual trust and respect.

Because of the historic partnership, the French gained strategic access and a warm welcome to the vast territories of Turtle Island beyond the lands of the Wendat, while the Huron became a significant partner in what was to become a world-wide trading network based upon the fur trade in beaver pelts.

Parks Canada didn't follow up on the committee's effort to change the wording. When the issue arose again in 2001 after a visitor to Orillia complained, a Parks Canada official promised to take action. Five years later, the faces of two of the aboriginal people depicted were spray-painted white, apparently in protest of the statue.

Talk of changing the wording on the plaque began again, but nothing was done. Parks Canada planned to begin restoration of the monument and repair of its base in 2017. It is unknown if a revised plaque will eventually become part of the restored monument.

could not get through. At noon that Monday, three police constables, town engineer Peter Ritchie, and two other town employees started the march to Ragged Rapids. They reached the plant by 10 p.m. and took the workers by surprise. An anxious council received word by wire that night that victory was theirs. But it appeared victory would be short-lived. William Wagner, the foreman ousted by the town's force, began gathering men in Severn Bridge for a counterattack.

"Is it Civil War?" the *Packet* asked. Rumours spread through Orillia that an army of men were launching a counterattack on the Ragged Rapids plant. Mayor Tudhope instructed the power plant force to provision themselves for a siege. By that Wednesday, Wagner had gathered a troop of eight men at nearby McLean's Bay. He promised them $10 each to help him take back the power plant. They were ready to march, until some residents told the men they'd be foolish to get in the middle of a fight between the town and Patriache, and most of the so-called soldiers deserted. The next day, two men, claiming they were sightseers, appeared at the plant and started to make fun of Patriache. The suspicious constables at the plant refused to allow them in for a tour. One of the men showed up the next day with the ex-foreman, Wagner, and admitted he had been paid $5 to get into the plant. Outside the plant, Wagner ridiculed the workers inside who had given up the plant without a fight. He demanded to get in to take an inventory. The constables refused, and Wagner tried unsuccessfully to push his way in. The persistent foreman — and one hopes he was well paid by Patriache — next tried to get a judge to issue a warrant of arrest against the town's men in the plant. When that didn't work, he apparently asked another magistrate to issue a warrant to arrest the entire town of Orillia. That didn't work

either, so Wagner went back to Severn Bridge and Gravenhurst to again hire men to retake the plant, but found few interested. He returned to Toronto on the Saturday, finally defeated.

Orillia at last had power, thanks to Patriache's delays a little more expensive than planned, but still less expensive than in most places. Industrial and commercial users bought most of the power produced by the plant, with the town using the rest for the water-pumping station and lights. But neither Patriache nor his dam were through with the town yet. He sued the town, seeking $1,075 for his costs in running the plant from January 25 to March 24, and $12,000 for equipment seized in the March raid. Patriache tried to make a deal with the town. If it sold the plant back to him, he would guarantee low rates. Town council told him to forget it. The court awarded Patriache $250 for expenses and $1,000 for equipment. It was likely more than he deserved, because on April 7, 1904, Patriache's dam burst, plunging the town into darkness and stopping factory engines. Town engineers discovered the Ragged Rapids dam was not built on solid granite, as promised, but on loose rocks. The steam plant on Jarvis Street was put back into use, and factories had to rely again on their own wood-powered steam plants. A temporary replacement dam was built at Ragged Rapids in 1905 and a new permanent dam in 1908. The permanent dam cost the town about $11,000 more than expected, and also caused it trouble. Lights and power went out again January 19, 1911, when a flume burst and flooded the power house. Two men narrowly escaped death by clambering up through an opening in the dam.

By now town council had had enough and decided to build a new dam a few miles down-river. About the same time, the federal government announced plans to complete the Trent–Severn canal system, and town council eventually worked out a deal with the federal government to build on a different location. The Swift Rapids plant was the result. It was completed in 1917 and is still operating today.

Despite the early problems, the electricity from the Severn River gave Orillia a jump start over other towns in the early 1900s. In 1909, the town's factories employed 1,048 people, paying $344,850 in wages and producing about $1.2 million in goods. By 1912, those figures had jumped to 1,488 employees earning $802,650 in wages, producing $4.6 million in goods. Orillia had twenty-nine factories in 1901, but forty by 1911. In the same period, Barrie gained two factories. In 1911, Orillia finally topped Barrie's population, 6,828 to 6,420.

Electric power inspired the creativity of many great industrialists in Orillia in the early 1900s, but none continue to tease the imagination like James Brockett "J.B." Tudhope. What's left of his former factory on Colborne and West streets still takes up a city block. The question "What if?" simmers beneath Tudhope's legacy. What if he had done it? What if Tudhope had succeeded in building an automobile empire in Orillia? He had a good car, made in Canada for

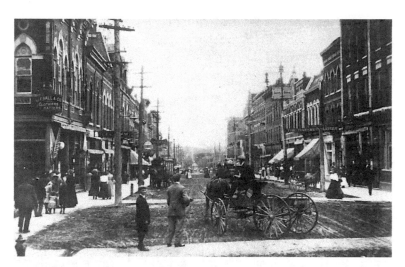
Mississaga Street, looking west from Peter Street in 1908. The offices of rival newspapers, the *Times* and the *Newsletter*, can be seen on the right.

the Canadian climate, an innovative staff, and the best production plant. If the Tudhope automobile had driven into everyone's garage like the Ford or Chrysler, Orillia could have become Detroit north, and Canada would have its own car industry dependent on no other country. But the Tudhope did not become the Ford, and one of Orillia's chances at industrial greatness slipped away. Tudhope remains a legend, though, for his vision and daring.

Tragedy struck the Tudhope family as soon as they arrived in Canada in the 1800s, and forced independence on the first generation born here. James Tudhope and his eldest son, George, sailed from Scotland in 1831 and settled on Concession 11 in Oro Township to clear the land and make a home for the rest of the family. After two years of hard work, James sent for his wife, Christian, and eight other children. He had never seen the youngest, William. As his wife and children were sailing over, eager to reunite the family, James suddenly died. Christian was met only by her son when she arrived. She died two years later, and George, twenty-three, was forced to raise the rest of the family. In 1835, George became clerk of Oro Township, starting a 134-year Tudhope dynasty in that position.

The youngest of the Tudhopes, William, grew up after losing his mother when he was four and without ever seeing his father. That may account for the fierce strength of mind he carried all his life. Mechanically inclined, William learned the blacksmith trade. He tried to open a shop in Orillia in 1864 and failed, then tried again a few years later. In a small wheelwright shop and smithy on the south-west corner of Colborne and West streets, William Tudhope began fixing carriage and wagon wheels. This attempt succeeded. As Tudhope began to build wheels, then entire carriages, the business expanded east on Colborne Street. His son J.B. joined the company in 1880. As William grew less active in the business, J.B. took on more responsibility.

The dashing J.B. Tudhope built an empire over the next three decades, putting his stamp on the Canadian Wood Specialty Co. Ltd., the Dominion Wheel Co. Ltd., the Orillia Furniture Co. Ltd.,

MR. JAMES B. TUDHOPE,
Manager.

THE TUDHOPE Carriage Co's.
Factory is the largest in Canada, and has a floor space of over two acres. Output, over 5,000 vehicles annually.

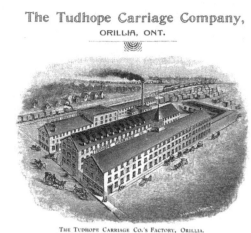

The Tudhope Carriage Company,
ORILLIA, ONT.

THE TUDHOPE CARRIAGE CO.'S FACTORY, ORILLIA.

James Brockett Tudhope, always dashing and always thinking, built one of Canada's first automobile plants. He served as mayor, member of the legislature and parliament, and almost made Orillia the "Detroit of the north."

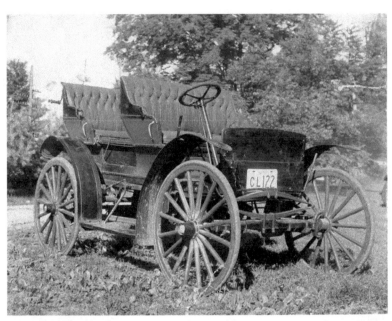

A 1908 Tudhope-McIntyre

and the Standard Chemical Co. Ltd. in Longford Mills. But the base for all his enterprises became the Tudhope Carriage Company Ltd., formed in 1897 when brothers William and Hugh joined. The firm leapt the boundaries of local prominence in the 1900s, forming a partnership with Harry Anderson of Winnipeg to sell wagons and other equipment to the farmers in the booming west.

Although the carriage company continued to grow, Tudhope noticed that the latest invention, the automobile, was taking a bite out of his market. With the typical straight ahead spirit of the

Tudhopes, he decided to build automobiles in Orillia. Tudhope sent his son Bill and another man to the United States to arrange a deal to buy engines. The two talked for a while with a young man in Michigan named David Buick, but Buick's car didn't have enough financial backing to satisfy Tudhope, so he went with another firm and engine, McIntyre. (Buick eventually got out of early financial difficulties by merging with Chevrolet and Oldsmobile into General

Motors.) The first Tudhope-McIntyre, a two-cylinder, air-cooled, horseless carriage with hard, rubber buggy tires, drove out of the plant in 1907. It sold for $550, more than a Ford Model T, partly because it was tougher. Included was a horn and three lamps. Its top speed was thirty miles per hour.

But the Tudhope-McIntyre met an early doom. About ten of the cars sat in the factory on a hot Saturday afternoon, August 22, 1909, awaiting shipment to the automotive show at the Canadian National Exhibition. A few men were working in the four-storey, brick factory, one part of the Tudhope compound that took up the entire blocked bounded by West, Colborne, and Andrew streets, and Barrie Road. Most workers got Saturday afternoon off, but some had to stay behind to put the finishing touches on the automobiles heading to Toronto. Many of the Tudhopes, including J.B., were working in the offices. Suddenly a shout rang through the building. "The factory is on fire!" Workers rushed out of the paint shop as flames leapt into the plant. Tudhope's brothers, William and Hugh, sounded the alarm and scrambled to close the fire doors between the various buildings. They managed to get a few shut but the fierce heat and flames drove them and the others outside.

By the time firefighters arrived, smoke was pouring from the upper windows of the car plant and carriage factory. Flames shot 150 feet into the sky with the roar of a giant furnace. The four-storey front wall collapsed in half an hour. Within an hour the building lay in ruins. Townspeople fought to save nearby foundries

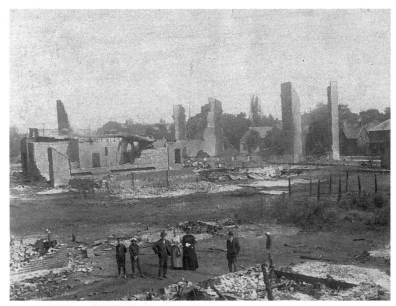

A fire in 1909 destroyed the Tudhope Carriage Company, threatening to put hundreds of people out of work.

and homes for another two hours. Housewives on nearby streets formed bucket brigades to try to save their homes. Workers at the J.R. Eaton Planing Mill across the road sprayed the flames from the roof, as they watched the large letters on the wall of their building melt off. The town wired Barrie, which sent up a steam fire engine. The flames burned through one hose, and firefighters could only

watch helplessly as the fire hydrant remained opened, sucking the pressure from the rest of their hoses.

By the time it was over, the fire had claimed the twelve buildings of the factory, ten houses, a bakery, and scores of outbuildings in backyards. Ten automobiles and 2,000 cutters were destroyed. About 150 carriage wheels, some auto frames, and a few files remained. The losses totalled $500,000. Worse, the town had lost its largest employer and 200 men were put out of work.

J.B. Tudhope refused to say publicly if he would rebuild. Town residents demanded council do something, while nineteen other municipalities across Ontario tried to tempt Tudhope away from Orillia. One offered him a grant of $50,000, a free factory site, a tax exemption, and a dock site. Orillia council, at a quickly called meeting, could offer Tudhope only an interest free loan of $50,000 to stay. In return, Tudhope had to buy $1,600 a year in power, light, and water and pay at least $50,000 a year in wages, which was no hardship since the payroll averaged $100,000 a year. To loud cheers, Tudhope told council and residents he wanted to stay in Orillia. "From the Atlantic to the Pacific there was not another town like it," he said. Based on the support shown at that meeting, he would begin building immediately, Tudhope concluded.

The agreement had to be ratified by plebiscite. Town leaders left nothing to chance and, through the newspapers, urged supporters to get out and vote for Tudhope. The vote carried 763 to 22, one of the largest majorities in any vote on any subject in Orillia's history.

Tudhope must have been pleased, but all along, he had no intention of leaving. Perhaps he was waiting to see what the town would offer, or how much Orillia Spirit he could count on. For Tudhope, never one to move slowly or cautiously, had decided the evening after the fire to rebuild a bigger and better plant on the site of the destroyed one. That evening, sitting with his family, Tudhope asked his daughter for a large piece of paper. On it he sketched the rough plans for a huge plant. Work on the factory's foundation started September 18, 1909. The factory was finished on December 6, seventy-nine days later. The contractor boasted his crew had set a record for the fastest construction in Canada.

Tudhope formed the Tudhope Motor Company the next year and built an addition to the new plant. He bought the rights to build the Everitt-30, or Tudhope-Everitt, a four-cylinder car that sold for $1,200 to $1,500. The Orillia plant purchased the tires, radiators, and lights, but built the rest of the car, including the engines. Tudhope wasn't happy just to produce another man's design or compete with just the ordinary Ford. The Tudhope cars were sold with a two-year warranty against mechanical defects, a rarity in those days. Tudhope modified the design for Canadian customers, adding a primitive shock absorber. The car eventually dropped the name Everitt and became known as the Tudhope. The price had risen to about $1,600 by 1912.

His car was good and his factory used the latest mass-production equipment and techniques, yet Tudhope did not have the network of

dealers, in Ontario especially, to sell his product. At the same time, Tudhope had sunk a lot of money into his modern production line. By 1913, the Tudhope Motor Company was in serious financial difficulty. Two industrialists, one named Fisher, helped reorganize the company as the Fisher Motor Company Ltd. Tudhope retained some control over the company and auto production continued.

The First World War, beginning in 1914, gave a boost to the troubled Tudhope factory and the rest of the city's growing industries. During the war, Orillia foundries worked around the clock to make ammunition. It was estimated three of the biggest manufacturers, E. Long Ltd., National Hardware, and Fisher Motors, made $1 million in gross revenues in 1915 just on shell production. The munitions factories employed 1,200 to 1,500 men. The *Orillia Times* boasted in 1917 that fifteen large factories and a dozen or so smaller ones employed about 2,500 people. The largest, Fisher Motor Company Ltd., had 650 people working mainly in munitions. The five companies, including Fisher, that Tudhope controlled, employed 1,360 people. That same year, Orillia turned on a new power plant at Swift Rapids, which replaced the troublesome Ragged Rapids plant.

Orillia entered the First World War with its municipal spirit inflamed with national fervour, much like many other towns and cities across the province. But the town continued to keep a step ahead. A local committee charged with recruiting men for the army decided to raise not a mere company of town boys, but a

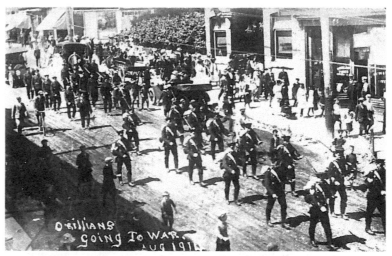

In an August 1914 parade, troops bound for the First World War marched confidently down Mississaga Street. A local tanner promised to tan the Kaiser's hide if anyone brought it home.

complete battalion of companies from Simcoe County. Midland, Collingwood, Barrie, and county council got behind Orillia's idea. The federal government, sceptical that a county could form an entire battalion, gave its approval. Within ten weeks the Simcoe County battalion, complete with officers and equipment, was raised out of headquarters in Barrie. The county battalion system spread like wildfire throughout the province, becoming one of the most effective recruiting methods in the First World War. Rallies were

held throughout the war to raise money and recruit men. Orillia gave her best. On August 15, 1915, at one of the first Orillia rallies, about sixty young men, including the entire championship hockey team, signed up and $15,000 was raised for seven machine guns, two ambulances, seven field kitchens, and a complete set of band equipment for the Simcoe battalion.

By the time the war was over, about 1,000 young men from Orillia and the surrounding regions had signed up. The sons of Orillia went across the ocean to fight the Kaiser with all the parades, bands, and optimism a small town can muster. Tanner John Miller told the first group to leave that he would tan the Kaiser's hide for free if anyone brought it home. The YMCA, the local Red Cross, church auxiliaries, and other charities sent reminders of home to the servicemen in the form of clothing, baked goods, and local newspapers. Patriotic drives raised about $265,000 during the war to help soldiers overseas, to provide for their families, and to help pay for ammunition and hospital ships.

The newspapers brought the war to Orillia, in reports of battles, and in the revealing letters from soldiers to home. In the early letters, the men are stoic, and casual in their descriptions of injuries and battles.

"The wound bled rather too freely during the operation," wrote Private Walter Dunham to his mother in Orillia in May 1916, after he was shot in the cheek. "… I have to undergo another operation tomorrow to get a piece of fractured bone out, which has made my face swell again. I don't relish the thought of more chloroform."

But the despair faced by soldiers in muddy trenches, fighting for months over inches of land, began to show in later letters. After four and a half months in hospital, Dunham returned to battle. His last letter to his mother, September 10, 1916, shows little of his earlier confidence.

> Listen to me. I cannot see the sense in attempting the impossible under the present circumstances — trying to make one believe that things are not what they really and obviously are. Facts are facts and you know, and I know thoroughly (God knows I ought to know, it is not the first time I've been here) exactly what I'm up against, that I may go down very shortly.

Dunham, twenty-five, was killed a month later.

Orillia lost about 150 of its young men in the war, and each week the papers published lists of the dead and wounded. At home, the war took its toll on everyday life. In 1917, the town launched a thrift and production campaign to encourage everyone to grow more food for the war effort and waste less. At rallies, speakers urged homeowners to use every square inch of yard to grow food. "While our boys are conquering the enemy, let us conquer the soil," urged one speaker.

These three young men, all about eighteen years old, shared a few laughs in 1914, photographed on the shore of Lake Couchiching in Orillia. From left to right, Harold Deans, Crawford Miller, and Fred Bailey were all killed in the First World War. Orillia and neighbouring communities lost about 150 of their young men in the war.

Everyone had a role. High school students were to work the fields in the summer. Stable owners were urged to sell manure at reasonable prices to town gardeners. "Smite the weeds! A potato in every plot!" were the rallying cries in newspapers. One editorial writer for the *Orillia Times* even suggested all dogs not used for work be killed, because they ate too much meat. The Board of Trade and churches encouraged manufacturers to spare workers who could help in seeding and harvest. The board set up teams of workers to help on the farms.

As the war continued, measures became more extreme. In February 1918, the town's factories and businesses shut down for three "Heatless Days" under the order of the federal fuel controller, to save on coal and wood. By then, the first wave of soldiers had returned home. The fanfare that greeted some could not hide the scars others carried.

Bright and cheery George Bradbury had heard someone shouting about the war on August 5, 1914, while driving his delivery wagon up Mississaga Street. He stopped his team, jumped down, and rushed to the telephone. Get someone here to take the team, he told his employer, the Canadian Express Co. Then he ran to the enlistment office to sign up. Nine days later, Bradbury was one of the first men to leave Orillia for training. Twenty-six months in the trenches, with only two seven-day leaves, destroyed more than his early enthusiasm. He returned to Canada a corporal, but broken emotionally and mentally.

"Let George Bradbury slip in very quietly," a YMCA worker wrote to C.H. Hale in June 1917, while travelling from Halifax on a hospital train.

"George is nervous, and subject to attacks. Something the same as hysteria and I am told by the other men that he was a fearless fellow and a fine soldier," the letter to Hale reads. "George is sensitive, so do not say anything about his condition."

A second letter, written from Quebec City, warns against any large homecoming for Bradbury. "He had a bad attack on the train last night and I sounded him this morning by saying, 'Well George, they'll be glad to see you back at the old town and I'd like to be there for the reception.' His reply was a wish that there would be nothing of the kind for fear he could not stand it and collapse again."

Bradbury eventually recovered enough to take part in an August ceremony welcoming the boys back home. But he was never the same. Family and friends looked after him when he was not in hospital. He returned to England under the care of a friend, but was soon admitted to hospital, where he died in October 1922.

Hale dealt with all the suffering in a typical way: he tried to think of some way the town could lessen it. One night in the middle of the war, he lay awake, wondering how the town should best honour the fallen. His thoughts settled on the town's hospital, an over-crowded building of thirty-five beds. "Why not build a new or additional hospital and make it a memorial to the Orillians who have fallen?" he asked himself. Hale didn't just want to tag the hospital with the word "Memorial" and leave it at that. "How can we make it a real memorial?" he asked. His answer, drafted before he fell asleep that night, created a unique hospital. In those days, people paid for their hospital stays. There was no medicare plan. Hale wanted to change that, for the soldiers at least. He proposed building an entire hospital to honour soldiers, with plaques remembering the dead and free medical care for the living, for as long as

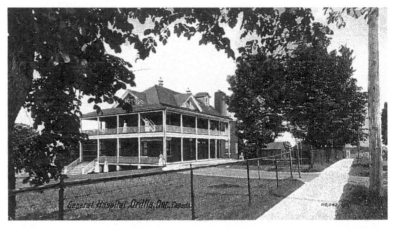

By 1908, the thirty-five-bed Queen Mary Hospital on Dunedin Street had become overcrowded.

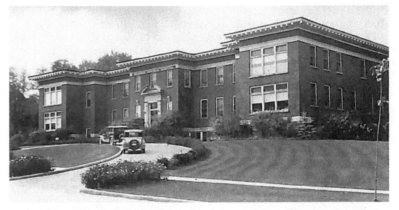

C.H. Hale led the creation of Soldiers' Memorial Hospital, completed in 1922, on Colborne Street.

they lived. The leading doctors in town, Arthur Ardagh and A.R. Harvie, liked the idea and had no trouble convincing other doctors with hospital privileges to give free treatment to war veterans. A committee was struck, with J.B. Tudhope as a member, naturally, and money was raised from canvassing. The town gave $25,000, but only one township, Orillia, accepted the offer to join the deal, paying $10,000. It was just as well, recalled Hale later, because the doctors probably could not have handled too many more patients.

The hospital was completed in 1922 at a cost of $100,000. At first, many soldiers did not like the idea. Some said they would have preferred a cenotaph instead. Hale and other hospital builders figured 1,000 men deserved the certificates for free medical help, yet they could get details on only 150 for the opening ceremonies. Only half of those 150 soldiers accepted the initial offer. But as word spread and the plan began to work, more veterans joined the free medical plan. Hale remembered one Orillia veteran coming from his new home of Halifax for an operation. The money he saved by having the operation done at Soldiers' Memorial Hospital paid his way to come home and see his family. (Eventually, a cenotaph was built. Benefits were extended to the Second World War veterans.)

The town greeted the official end of the war on November 11, 1918, with a seventeen-hour celebration of noise, prayer, tears, and laughter. Mayor Robert Curran learned about the armistice at 3 a.m. and called up the town's leaders. All the church bells rang and all the factory whistles blew at 7 a.m. to announce the news and

Captain Merton Plunkett of Orillia and his brothers, Albert and Morley, founded the comedy troupe the Dumbells during the First World War. In this photograph, they are arriving at Tincques, France, on July 1, 1918, to entertain the troops. Their fame grew during the war, and after, the Dumbells toured England and the United States.

kept ringing and whistling for half an hour. Thousands gathered in the market square at 9 a.m. for a thanksgiving service. So many bands, soldiers, impromptu floats, and decorated motor cars took part in the afternoon parade that the first units reached the lake before the last had left the market square. Clowns, a kazoo band, tin horn brigades, and politicians dressed in wild costumes that "would have created a furore even in Paris itself" marched before thousands on Mississaga Street, reported the *Packet*.

One effigy of the Kaiser was dragged behind a car, and another was suspended from a gallows while a veteran stabbed it with a fifteen-inch butcher knife. Downtown that evening, residents built a huge bonfire and burned yet another effigy of the Kaiser, cheering as it dropped into the flames. Fireworks lit up the sky and a second bonfire in the market square burned until midnight.

The First World War claimed more than people as its victims. It also ended the Victorian Era ideals of gentility and restraint. The 1920s across North America and Europe were marked by an initial depression, followed by rapid growth, good times, and cynicism. Orillia reacted in a typical way, with a mixture of retreat and advancement.

The retreat came in the automobile industry. When the First World War broke out, Tudhope's carriage and auto plants were converted to munitions production. After the war, Tudhope chose not to carry on with automobile production, but concentrated on the carriage business. It was a strange decision, given that automobiles were well on their way to replacing horse-drawn carriages. But the car business had not been making him much money before the war. Tudhope merged three other carriage manufacturers and continued to produce carriages and car bodies until 1924. The Fisher Motor Company faded into a minor supplier of car accessories until it too closed in 1928. The Tudhopes remained involved in metal and appliance factories until 1966, but never returned to making automobiles.

Horse racing on Lake Couchiching in winter became popular in the 1900s. The circuit of races included Montreal, Hamilton, Toronto, and Ottawa.

After the war, the Board of Trade found it difficult to attract new industries to Orillia for several reasons. A lack of suitable buildings to rent kept four manufacturers away in 1923. Other companies looking to expand refused to move too far from growing Toronto. Even the will of the town to bring in new industries seemed to be fading. The board refused in 1927 to even consider giving a rubber factory and textile mill $50,000 bonuses to move to Orillia. Before the war, the board's annual reports and most of its efforts focused on industry, with a little footnote about the importance of tourism thrown in almost as an afterthought.

It's not as if the town's leaders had ignored tourism. In 1898, the town's young business leaders took over the defunct Board of Trade and at the same time as it began encouraging industry, it began promoting tourism. To make up for the shortage of accommodation, the board persuaded sixty homeowners in Orillia to take in summer visitors. The board began promoting Orillia in the American south, from Baltimore to New Orleans, convinced people in the south would want to head to the cooler north in the summer. The good response from that campaign inspired some board members to buy the defunct Red Cross Hospital on Orchard Point and turn it into the Orchard Point Inn. In 1901, tourism advertising accelerated. The board made a deal with the Grand Trunk Railroad, which had merged the Northern and Midland lines, to distribute 20,000 brochures advertising the town. Each year the board promoted Orillia, and each year more people arrived for fishing, canoeing, sailing, steamboat excursions, and picnics in Couchiching Park. More and more, the economy of the town became tied to tourism. When the Grand Trunk Railroad went on strike during tourist season in 1910, the Board of Trade and town newspapers urged a speedy end. Leaders embarked on a new campaign to clean up residential yards and fix up houses to impress tourists. Yet, through all the tourism campaigns, industry remained the board's priority.

The first Board of Trade report after the war shows that trend was reversed for good. The efforts to increase tourism led the reports, with the industrial promotion now relegated to secondary status.

The Eaton Vanishing Motor Camp was another great idea ahead of its time. The rear of the car, which looked like a small pickup-truck box, could be converted into a tent camper. Inventor J. Russel Eaton, who operated the family lumber mill near Orillia, built his prototype in 1922.

Where once the construction of the motor car carried the hopes of Orillia, now simply getting them here with ease occupied town leaders. Throughout the 1920s, business leaders urged the provincial government to improve roads so tourists could drive to Orillia quickly and comfortably. The completion of the Trent-Severn Waterway in 1920 added boat traffic to automobile visits. So busy was the town in

A Fairy-Tale Ending

In the very heart of Orillia sits a fairy-tale building where legends have performed and legendary political battles wage. If it weren't for politicians, the place might be nothing more than a shed today.

Not long after Orillia became a village, residents began to think about moving the market from its location near the waterfront. After a few years of debate, a landowner named Goldwin Smith agreed to donate a half-acre lot on the northwest corner of Mississaga and West streets, in exchange for the village clearing Mississaga and West streets of tree stumps so Smith could subdivide a parcel of his landholdings.

Some people in the village wanted nothing more than a good, large shed and a few stalls put up in the market for farmers. But the village councillors wanted a new town hall to replace the Temperance Hall and a proper lock-up for the rowdies that plagued the lumber town. Arguments over the building of the hall delayed its opening, but council finally had its first meeting in the new hall on August 7, 1874. That town hall and lock-up served well from 1874 to 1877. But council again decided something grander was needed for both the shed and town hall and, after a few false starts, the Orillia Opera House was completed in 1895. It cost taxpayers $25,000 and held the council chambers, auditorium, city hall offices, market stalls, and eventually the lock-up.

The Opera House, described as "the finest building for corporation purposes of any town in Ontario," became an immediate

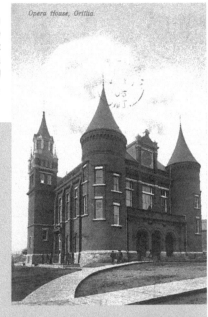

The original Opera House, built in 1895, looked even more castle-like when plank sidewalks were set over the mud like bridges over a moat. The Opera House included a tower at the rear of the building, along Mississaga Street.

source of pride for Orillia. Of course, pride has a price tag, and Orillians would only pay so much for it. A fire broke out in the Opera House in July 1915, sparking rumours that Kaiser Wilhem's Germans had attacked Orillia and destroyed much of the building. The last of the debentures for the building had just been paid, and Orillians did not want to pay a lot for a new theatre. Council and the Board of Trade pushed for a bylaw authorizing a $50,000 debenture to rebuild the Opera House, but residents voted it down. It was too much to spend on a theatre in times of war. The next year's council tried for a smaller plan, costing taxpayers $35,000, and it was approved. A rear tower destroyed in the fire was not replaced. The official opening of the repaired building on March 1, 1917, featured the English pantomime *Aladdin and His Wonderful Lamp* and cost from sixty cents to a dollar for admission.

(Left) The market square grew especially crowded on days when Massey-Harris sold farm implements. This 1897 photograph looks toward West Street and the back of the old town hall and lockup, which were both destroyed in the 1960s.

(Below left) Beside the new Opera House stood the new market, with sheds for farmers' displays. Farmers drove their livestock to and from the market along Mississaga Street, seen here at the intersection of West Street looking west.

Orillians at first blamed the Kaiser for the fire of 1915, which destroyed much of the Opera House. The view in this photograph is from the back of the building, looking toward the intersection of Mississaga and West streets.

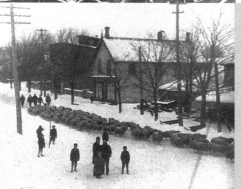

For many years, the Opera House hosted politicians upstairs and criminals down, with the politicians generally causing more ruckus than the criminals. The jail was eventually moved, but the council chambers remained until the 1990s. The acoustics of the auditorium have drawn the greats, such as Oscar Peterson and Gordon Lightfoot. One of the most legendary performances was witnessed by an audience of one. Opera House technician Terry Rideout drove by one night in the 1970s and noticed someone was in the auditorium. He slipped inside and heard someone playing the piano on stage, beautiful notes rising clear in the cold, darkened auditorium. Rideout turned up the lights and for half an hour enjoyed a private concert by one of the world's greatest pianists, Glenn Gould.

That is the kind of legend the Opera House inspires. Stories about secret tunnels under the building have burrowed into the city's mythology. It is said one tunnel was dug from the Opera House to a store basement on the other side of Mississaga Street, where politicians and their cronies could head unseen and enjoy the company of women and liquor. The grand old lady has shown her age over the years and has continued to need city support for upkeep and restoration. Despite the occasional grumbling, Orillia taxpayers and politicians have continued to put millions of dollars into the legendary Opera House, a far more expensive investment, but with a far greater return, than offered by a simple shed.

the 1920s that more homeowners were urged to open up rooms for tourists. And so important was tourism by 1928 that the board asked the Canadian National Exhibition in Toronto to change its start date to September. When the CNE opened in August, it killed the tourist trade before summer ended, the board complained. That same year, the board contacted thirty-four industries looking to relocate, but managed to persuade only one to move to Orillia.

The 1920s set the stage for a long-lasting debate in Orillia over what was more important to the economy, tourism or industry. The debate over which was better for Orillia was never really about money — both tourism and industry are important and can co-exist quite nicely — but about image. Should Orillia maintain its small-town image, an image that, as a fringe benefit, attracts tourists? Or should it seek large new industries, more jobs and growth, at the risk of losing its small-town appeal? The argument over the community's image, rooted as far back as the debate over liquor in the 1850s, became a permanent fixture in Orillia with the publication of a gentile satire on small-town life in 1912.

Of all the projects, schemes, and dreams that marked Orillia's Golden Age, none has had a bigger impact on the community than the small collection of stories written by Stephen Leacock titled *Sunshine Sketches of a Little Town*. The book immortalized Orillia as Mariposa, and its characters were based on the residents Leacock knew. The writer lived on Brewery Bay on Lake Couchiching from 1908 until his death at age seventy-four in 1944. He loved the town and made good, long-lasting friends here. Many of the characters

Stephen Leacock.

and incidents in *Sunshine Sketches* were easily recognized by Orillia residents. Some Orillians never forgave Leacock, first for having the nerve to be a writer and a drinker, and second, for lampooning their town. Ironically, those conservative Orillians benefited the most from Leacock. His sunshine image of Orillia stuck and Mariposa became, for some, the ideal Orillia. In yet another irony, which he would surely enjoy, many who liked Leacock the man grew sick of Leacock the image. Attempts to spur growth in Orillia have often been blocked by the invocation of the Mariposa image. In the 1970s especially, certain development lagged because many Orillians decided it did not fit the Mariposa image. Today, Leacock and the image he created for Orillia comforts, encourages, annoys, and frustrates its citizens.

The complex relationship between Leacock and Orillia would take an entire book to explain. Yet no one doubts the veracity of Leacock's view of Orillians. Eccentric characters continued to spring up long after *Sunshine Sketches* was published, none more colourful than the man who would lead the town through the Great Depression, J. Benjamin Johnston.

CHAPTER FIVE
King Ben

Orillia's mayor Ben Johnston was looking for government handouts to help build a sidewalk. He asked the township, county, provincial, and federal governments for grants. When he was done, one of his rivals pointed out that Johnston had been so stupid as to collect 125 percent of the grants, more than was necessary. To that, Johnston replied, "Usually when I am behind something, I am behind it 100 percent." This time, he was just adding an extra 25 percent to his usual effort. John Benjamin Johnston, auctioneer, farmer, pedlar, and politician — and just plain Ben to friends and enemies — often gave a little extra, and for his efforts, sometimes took a little extra.

For five one-year terms during the Depression — 1929 through 1931, 1935, and 1936 — Ben Johnston held court as the mayor of Orillia. He created his own rules and his own money. He offered hope to the unemployed, despair to the democratic, and a welcome mat to the bootleggers. The truth never impaired Johnston's vision, nor reality his mission. Mixing a sharp temper with a sharp wit, he out-shouted, out-insulted and outraged his real and imagined enemies. Scandals plagued his administrations, and council meetings routinely drew a full house of spectators primed for fireworks. Johnston was the focus of people's dreams, frustrations, and anger. His rise and fall, and rise and fall again, helped define Orillia in the Depression.

His long reign began quietly, with few signs of the storm ahead. In fall 1928, six incumbent council members, including the mayor, dropped out of the election race. The door was wide open and Johnston stepped in. Born in 1878 in Leaksdale, Ontario, he moved with his family to Orillia in 1893. He worked off and on as an auctioneer and peddler. For three years he farmed near Brechin, then moved to town because he couldn't stand the loneliness of rural life.

"I wanted somebody to talk to," he told reporters. What he always dreamed, said Johnston, was to someday become mayor. He had served on council in the early 1900s, twice lost the race for mayor, and sat as East Simcoe MPP in 1920. In the fall of 1928, Johnston promised voters he would do more to bring factories to town and wanted to take Orillia out of the county to save money — nothing too controversial. The bigger issue that year was a bylaw authorizing council to spend $58,000 on a new sewer system. The spring thaw and yearly rains had been forcing sewage up through the manholes and into the streets. Sewage overflowed the ditches at the pumping station and ran into Lake Couchiching three-quarters of a mile from the pipes that drew in the town's drinking water. A bad snowstorm on January 7, 1929, kept voters at home and Johnston squeaked to victory, 670 to 573. In the same election, voters defeated the bylaw to repair the old sewage system. Perhaps it was an appropriate omen. There was about to be a lot more muck and a lot more raking of it.

The year the Depression started, 1929, began calmly for Orillia. Johnston and C.H. Hale, editor of the *Packet & Times*, engaged in a respectful debate about the town's sewer bylaw, which was defeated in yet another vote that year. Hale maintained that taxpayers voted down the sewer bylaw because they wanted the system to be run by the Water, Light, and Power Commission, not by the town. Johnston disagreed, saying taxpayers simply didn't want any more taxes. When the *Packet & Times* and the Board of Trade offered to hold a third vote on the bylaw, free of charge to the town, Johnston called them "fanatics," perhaps the first sign that year of what was to come.

Hale sparked the war that would rage between him and Johnston for the next seven years. Over the summer, the town had worked out a scheme with Simcoe County to pave several major town roads: Coldwater Road, Coldwater Street, and Barrie Road. It was a complicated deal, but Hale discovered the bottom line meant town taxpayers would be paying to pave a county road — the portion of Coldwater Road from the town's limit at Emily Street to the Fourth Concession. The sewer system would have cost taxpayers about $3,700 a year to build, while the paving was to cost $5,600 a year. Not only that, said Hale, but the deal was probably illegal. After the story ran, several taxpayers had the Supreme Court of Ontario issue an injunction against any work until the issue was sorted out. The Department of Public Highways investigated and told the town and county to forget any such deal. The deal "was the most improvident and ill-digested scheme that has ever been entered into, or even considered, by the council of the town of Orillia…," Hale concluded. Johnston had more in store for Hale. A few months later, Johnston suggested the town sell the Orillia Water, Light, and Power utility to Ontario Hydro. "Having failed to get his way cutting a paving melon, Mayor Johnston, like a petulant child, is now intent on smashing the china," wrote Hale.

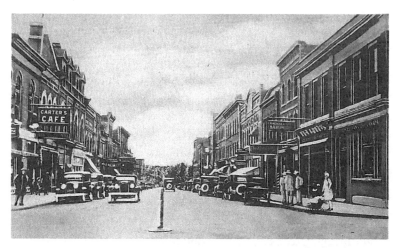

In the 1930s, heading west on Mississaga Street from Peter Street, you could drop into Carter's Cafe, on the left, and the Royal Bank of Canada and MacNab and Sons Hardware, on the right. This is a postcard from a souvenir folder made by the Valentine Black Company.

Hale stepped up his attacks throughout fall 1929, as the impact of the October stock market crash reached Orillia. He accused Johnston of running up a $3,500 deficit, after starting his first term as mayor with a $747 surplus. Johnston seized on his battle with the erudite Hale as reason enough for people to vote him in as mayor for a second time.

"This journal is like canned eggs. It hits you and runs. If the editor can't have a council he can can, he proposes to can the council he can't can," quipped Johnston in his fiery election speeches. Like any good populist, Johnston appealed to the working man's sense that he wasn't getting a fair shake from the intellectuals in power, such as Hale. Johnston promised to clean up city hall (although he had been in charge of it for a year already) and get good jobs for all. That was enough to win him a second term as mayor for 1930.

Meanwhile, the Depression had taken root. That winter, tramps and hoboes began riding the rails to town. Lying between the cities to the south and north, Orillia gathered in displaced young men, cold, dirty, and begging police chief Lew Church to let them sleep a night in the cells.

"The cities, and even the villages, are full of men out of work, starving, desperate," said one town policeman. "It's not the spineless old guard, the old hobo who took things lying down that make up their numbers. It's young, able-bodied men, eager for work, self-respecting, courageous and desperate because of the raw deal life is handing them."

The federal, provincial, and municipal governments began a system of relief payments. Indirect relief went to help municipalities hire men for public works projects. Direct relief went for food, fuel, and clothes for the worst-off families. In Orillia, the combination of relief and growing unpaid taxes made money — the pursuit and spending of it — the key issue for the ten years of the Depression. Johnston was a free-wheeling spender, but even better at hiding his spending behind lengthy speeches and confusing bookkeeping.

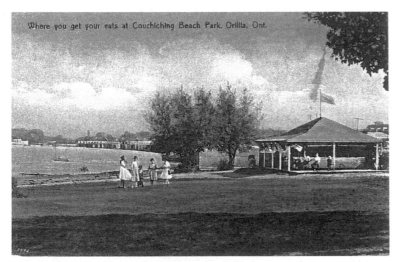
Where you get your eats at Couchiching Beach Park. Orillia, Ont.

George French, disabled and looking for a way to support his family, obtained a lease in 1920 to open a hotdog stand on the waterfront. Business at French's stand boomed when up to twenty excursion trains a day ran from Toronto to Couchiching Park. Stephen Leacock himself stopped by the stand now and then.

Hale's claims that Johnston had rung up a deficit in 1929 sparked the first of many battles between Johnston and his 1930 council. The wrangling over the auditor's report for 1929 took weeks for the 1930 council to resolve. So angry was Johnston over claims of a deficit, he stomped out of a March meeting when aldermen tried to pass the auditor's report and threatened to pass an injunction declaring council's business invalid if it did anything after he left. He did leave, but came back and displayed the oratorical style that came to typify his debates.

"You're out of order, anything you say is out of order," he shouted to Alderman Teefy Mulcahy, an insurance broker and one of Johnston's chief opponents. (The auditor's report, showing a $2,960.10 operating deficit, was accepted at a later meeting.) Johnston continued to make up new rules for running council meetings. He accused the deputy reeve of taking a kickback, a charge later proven wrong. When Alderman Mulcahy asked for a written report on the charge, Johnston made up a new power of the mayor's office.

"When I say it out loud, it's a written report," he said

So rambunctious were the council meetings in 1930, newspapers made special mention of the first calm meeting of the year, held on July 7. The calm lasted one week. At the July 14 meeting, a reporter found that spectators had taken all the chairs and asked a man in the crowd to get him one so he wouldn't miss any of the debate. As the man got up, Mayor Johnston shouted at him to sit down. The reporter asked again for the chair. The man went to get the chair. "Them guys should be made to stand up!" Johnston shouted. "Them guys think they can run this place."

With relief money in one hand and the other raised against the forces of evil, Johnston won the race for mayor for the third straight time in the fall of 1930. His popularity was at a peak, and he thumped his opponent in not only the working-class south and middle-class west wards, but the conservative and old-money north ward. Almost twice as many voters turned out for the election as the year before, about 2,300, with the heaviest voting in the south ward.

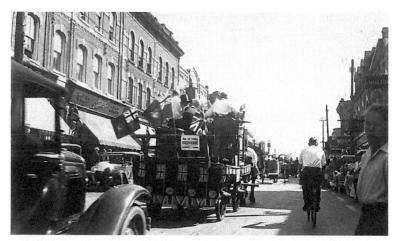

A parade on Mississaga Street in the early 1930s featured a float from the *Packet & Times*. The rival newspapers the *Packet* and *Times* merged in 1926.

Johnston truly dug himself a place in Orillia history that winter. A third vote on the sewage system had taken place a year ago, and, just as Hale had predicted, ratepayers approved the plan as long as the trusted Orillia Water, Light, and Power Commission operated the system. As part of the sewage plan, council approved the construction of a storm-water pumping station at West and James streets. The station would drain the swampy land in the southwest area of the town and pump it into Lake Simcoe. Over the summer of 1930, Johnston had suggested the town build a long canal from south of Barrie Road just east of West Street to Lake Simcoe, to do much the same thing as the pumping station. Nothing came of his idea, or so everyone thought. That December, after his big election win, Johnston hired teams of men to begin digging the canal. Shocked council members first read about the digging in Hale's *Packet & Times*. Ever one to notice the bottom line, Hale pointed out that Johnston's canal bypassed the new $6,000 pumping station, making it useless.

Seven angry council members forced Johnston to call a council meeting late in December. They tried to get three motions passed: one, that the drainage work follow the original plan; two, that the canal work be stopped; and three, that a county judge investigate the mushrooming relief payments Johnston had been authorizing. They wondered why Johnston was paying men to dig the canal, when digging machinery owned by the town was sitting idle.

Johnston packed the Opera House council chambers with supporters from the south ward and stonewalled the council members. He refused to allow any aldermen to speak, threatened to have one alderman thrown out, then ordered a constable to throw out another, Teefy Mulcahy. The constable refused. Johnston ruled every motion made by council out of order, and after several hours, a frustrated Mulcahy asked him, "What makes a motion out of order?"

"Being out of order," the mayor replied.

Playing to the crowd, so noisy it was heard outside the Opera House, Johnston accused his rivals of sitting on the relief money to starve the unemployed into taking less money per hour next

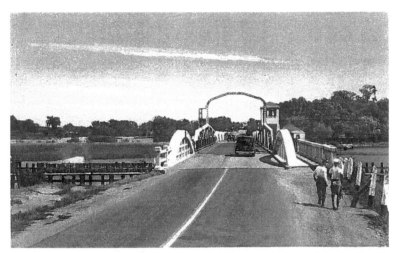

Motorists driving to Orillia in the 1930s and 1940s often had to wait for boat traffic through The Narrows. A worker in the tower made sure cars in both directions had stopped before he swung open the bridge.

Johnston predicted his four-foot-deep, twenty-foot-wide canal would become a resort-like area of fine houses. The canal never did reach the size or grandeur Johnston planned. However, it did provide work for several men on relief and became a useful drainage ditch. It's also one of the few things named after Johnston, still known as Ben's Ditch.

After the canal debate, about 300 people met in the South Ward Community Hall to start a boycott of the *Packet & Times* and its advertisers, "should any further intimidation of his Worship, the Mayor occur." Johnston showed up to lend his support. "I don't know the purpose of this meeting, but I am always willing to address a meeting of the ratepayers of Orillia," he said, before launching a fierce attack on Hale and the *Packet*. Of the man who spearheaded Soldiers' Memorial Hospital and the Champlain monument, Johnston said, "In thirty-five years as a resident here, I have yet to see anything in the *Packet & Times* that brought anything in the way of industries or work to the town."

"Ben is Ben to us all," said one man at the meeting. "There is no high-hatting at the Mayor's office nowadays."

Johnston kept up his attacks on the powerful in town. Attending court as a spectator at one spring session, he ran afoul of a police court magistrate in the spring for opening and discussing a document while court was in session. The magistrate told him to put the document away.

"I didn't know you wanted to make a Methodist Sunday school out of the proceedings," Johnston told the magistrate.

spring. As for the success of the canal, "I don't need engineers to tell me water will run downhill," said Johnston. Nothing could be accomplished at that meeting, so council met in a private session in January 1931 to consider the canal. After several hours behind closed doors, council agreed to a compromise between the original plan and Johnston's. The town would spend about $8,000 of its own and other governments' relief money to have a canal dug from Mount Slaven Creek to Lake Simcoe. The pump house would be used to drain swampy land into a series of ditches that connected to the canal.

The magistrate ordered police chief Church to remove Johnston. A couple of years earlier, Johnston had accused Church of getting confessions by promising criminals leniency and of misusing a free railroad pass. None of the charges were proven. In court that day, Church smiled when the magistrate ordered him to remove the mayor. As Church guided Johnston out of court, he assured him, "It is only in compliance with my orders."

"I'll go out quietly but this won't be my last word," Johnston shouted. Later that spring, council gave the magistrate a pay raise, as required by the province. Johnston refused to sign the paycheque. His tirades fell on deaf ears, and council simply passed a motion giving an alderman the right to sign the cheques.

Johnston's appeal to the frustrations of south-warders might have kept him in power for several more terms. But his increasingly embarrassing personal battles and questions about the way he handed out relief began to turn public sentiment in the summer and fall of 1931. It became apparent he was not always the friend of the worker. When the town clerk asked to cut the hours the office was open, so she would not have to balance the books after 6 p.m. every day, Johnston replied he would rather fire her and hire a man.

Aldermen began pushing for more control over the town's money, especially relief payments, which were handled mainly by the mayor. In the fall of 1931, they put several plans in motion that should have guaranteed a good fall and winter. The town's bank account was thinning out, and it would be a month before the province promised more money for relief. At the same time, relief work was about to stop for the winter, leaving men without a paycheque for several months. So council decided to hold back half the wages for men working on relief. The men would work a full day now and get half of the 20- to 30-cents-an-hour pay immediately. The rest would come December 15. This way the town could save money until December 15 and the men would have money over the winter. Men with special circumstances could ask to get the full pay immediately. At first, the unemployed men in town agreed to the plan. And in October, town council came away from a meeting with provincial officials confident of getting a request for $171,000 in relief projects approved.

The optimism crashed a few weeks later. The province told Orillia council it would have to make do with $50,000 in relief projects, with half coming from the town. There was worse news. Expecting more money from the province, the town had already spent all but $13,000 of the $50,000 promised. Meanwhile, the unemployed in town, about 575 men and women, began getting restless and started organizing. The full-day for half-pay plan had some men working from dawn until dusk with little to show for it. At an October 6, 1931, meeting at the United Workers Hall, 300 men agreed to ask council for an eight-hour day, and for 35-cents-an-hour pay instead of 20 cents, and no more contract work, and no holding back of the money. Contract work was especially galling to the men. The town paid relief to certain contractors, who then hired the men. The

contractors were getting rich on relief, many of the men charged. It was no longer enough to stand on street corners and shout, said organizers. Workers had to unite and demand that council listen.

At later meetings that November, workers wondered aloud why Mayor Johnston took so many trips to Toronto on taxpayers' money. They approved a slate of candidates for the next election that did not include Johnston but had several of his rivals, like Teefy Mulcahy. Meeting chairman A.E. "Paddy" Ball told workers they should vote in a new administration, and ran for office himself. At an uproarious nomination meeting in the Opera House that fall, Johnston attacked Ball, calling into question his war record and accusing him of never paying taxes.

"Where were you during the war, Mr. Johnston?" someone shouted.

"Here at home in Orillia, doing my work and supporting my family," a flustered Johnston replied, to more boos than cheers.

Johnston attacked another labour candidate for having a police court record.

"You were in court yourself, Ben!" someone else shouted.

When Johnston called the workers who opposed him "canned heat agitators," he was roundly booed. His opponent for mayor, Robert Curran, pointed out that Orillia paid its contractors twice as much for relief projects as other towns, suggesting someone was getting rich from the taxpayers. Other candidates wondered aloud how much money was getting into the pockets of working men.

Johnston tried his best to win back the favour of the town's unemployed. On the Saturday before the Monday, December 7 election, Johnston opened up the till. He got together all the men who had been working on relief. A week before the town was supposed to, Johnston paid the men the rest of their wages, about $4,000 in total. It didn't help him. Curran won the mayor's race 1,488 to 1,380, and four other men backed by the United Workers Club also won.

But Johnston wasn't through yet. The new council discovered, to its horror later in January 1932, that Johnston had gone on a spending spree after the election. "Not one dollar of relief money, direct or indirect … is in the treasury," announced new mayor Curran. In the six weeks between the December 7, 1931, election and the sitting of the new council in January, the "spiteful, selfish, and small-minded" Johnston had spent the rest of the town's relief money, which was supposed to last all winter, said Curran. In the last week of December alone, $4,500 was spent for relief, with 320 men on the public payroll even though the public works construction had stopped.

"It is a cruel thing to the people who had looked to these huge sums to ensure them employment and livelihood during the severe winter months," said Curran.

The town started 1931 with $11,000 credit in the bank, but now had a $31,000 overdraft. When Johnston first came to power, the town had an operating surplus of $1,411. After his three terms, it had an operating deficit of $46,500. On the assets and liabilities

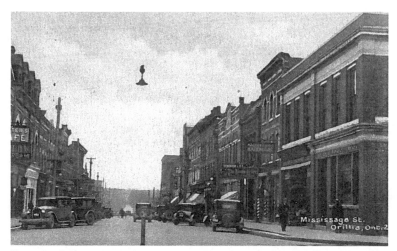

Oncoming Orillia drivers had a hard time navigating when Mississaga Street tried angle parking in the early 1930s, according to postcard collector and historian Marcel Rosseau.

balance sheet, the town went from a $49,000 surplus three years earlier to a $38,000 deficit. The Dominion government sent a representative to town to examine the relief payments. The government worker criticized Orillia's handling of relief payments, which were not supposed to be paid to contractors. The town had to borrow $100,000 instead of the usual $50,000 to tide it over the winter. A volunteer Citizens Relief Association sprang up to help the town raise money for relief. Teachers and other town employees were the first to contribute 5 percent of their wages to the fund.

Over the next three years, Johnston-free councils tried to whittle down the operating deficit and the debt that had piled up. The cost of relief and unpaid taxes forced the town to cut all but essential services. The unemployed continued to meet. Some spoke of violence, but nothing came of it. Town council created a public welfare board to handle relief more properly, and the Depression settled in. Several large companies, such as J.R. Eaton and Sons and Tudhope-Anderson, fell into ruin. But there was some good news. The Royal Bank of Canada sent a man named Ross W. Phelps to Orillia to see what, if anything, of Tudope-Anderson could be sold or salvaged. After talking things over with town officials, Phelps decided to keep the company going. He asked council for a fixed tax assessment of $15,000 for ten years. Council agreed and put the bylaw giving the fixed assessment to a vote of ratepayers. The bylaw lost by a few votes. Phelps was upset, but agreed not to do anything until council checked into matters. A recount gave the bylaw a victory, and what was to become one of Orillia's largest industries — the Orillia Tudhope Anderson Company, Otaco — was born.

Another of the town's largest employers came to town during the Depression. A group of businessmen in Toronto, under the name Ventures Alloys, were ready in 1935 to take advantage of the booming metal industry. They had several patents but little money. When National Locks Ltd. on Barrie Road in Orillia went under in 1935, Ventures Alloys jumped at the chance to get a large, if ramshackle, building for only $50 a month. Inexpensive power offered

by the town's utility and a fixed assessment of $3,500 a year from the town sealed the deal. Fahralloy Canada Ltd. started off small. When the sirens screamed to signal the molten metal was about to flow, office workers scrambled into the foundry to help out, recalled Alex Wilson, an original employee and president in the 1970s, for the *Packet & Times* in 1985. That first year, Fahralloy employed eleven men producing stainless steel parts. At its peak in 1970, the company employed 500 people. During the Depression, with companies such as Fahralloy and Otaco demanding more power, Orillia built a new power plant in Minden. With inexpensive labour and government help, the bold move turned into a wise one.

It also allowed Ben Johnston to get back into the mayor's office. A local firm had lost the tender for the construction of the plant. That was all Johnston needed to make himself the friend of the working man again. He won the election for the 1935 term, and soon town residents had a source of inexpensive entertainment. Early in the year, Johnston tried to have the town's only high school, Orillia Collegiate, shut down because it was costing too much money. The world didn't need intellectuals; it needed workers, said Johnston.

The *Packet*'s Hale served up Johnston's plan with relish to its readers. "Our only criticism is that it is so intensely practical. The plan lacks the true imaginative touch that is the mark of true genius," wrote Hale in a March 21, 1935, editorial. Hale suggested, "Orillia should be transferred, holus bolus, to the Moon." There would be no taxes, no worries about the Depression or another war,

and no school to trouble children. On the moon, the mayor would have no Huey Long, the controversial governor of Louisiana, to compete for space on page one of the newspapers. "There will be the question of who shall make the first trip," concluded Hale. "We are willing to toss with the Mayor for that honour."

The Toronto newspapers loved reporting on the rumours that buzzed around Johnston's administration that year. Reports that gangs of workers were being forced at gunpoint to work on the Minden power plant, and that young girls of thirteen and fourteen were getting drunk after hours in the town's restaurants found their way into the *Star* and *Telegram* in 1935.

But Johnston kept taxes down, partly by borrowing money from the bank, ensuring his popularity. Given his popularity, Johnston wondered aloud why he wasn't more respected. A mayor of his standing should be acclaimed for the 1936 term, Johnston told reporters. When he had to run a campaign, Johnston blamed the elite in town for spreading lies and rumours about him. He would get them, vowed Johnston. He would keep on running for mayor until someday he was acclaimed.

"I am going to contest the Mayoralty until I am seventy-five, until I am treated as well as anyone else would be," he said.

He won the mayor's race that fall by only thirty-nine votes, but entered 1936 as confident and controversial as ever. It was one of the wildest terms of office in Orillia's history. Johnston was accused of drinking with bootleggers and running up his expense account

Otaco borrowed an idea from U.S. mechanics and developed the Autotrac, a kit that converted the back end of a car into a tractor. The kit cost $149, whereas a new tractor cost about $600. During the Depression and over the next twenty-five years, about 6,000 farmers bought the Autotrac.

relief vouchers to city hall, he was paid 97 cents on the dollar. That gave Kitchener three cents on each relief dollar it had originally received to pay off the interest on the money borrowed from the bank, or build up a surplus. The merchants might have complained, but without relief, there was little money coming into their stores.

Johnston thought the vouchers, or scrip, was a great idea for Orillia. So did Reeve Wilbur Cramp, later a mayor modelled on Ben's style. The scrip "would be as good as a U.S. dollar," he predicted. Some of their colleagues on the 1936 council were less enthusiastic, and in a stormy meeting in September, a council committee voted the idea down. Johnston brought the issue up a week later. When an alderman pointed out the vote had already been taken, Johnson ruled that the matter still had to come to council. Protests about order got aldermen nowhere. "Well, this is my ruling," said Johnston, and ordered the clerk to read the proposed bylaw.

A name-calling session erupted, with Johnston calling one alderman a "yapper," and the alderman comparing the mayor to something found under a rock. Council passed the scrip bylaw by one vote. The town prepared $30,000 in denominations of 1 cent, 5 cents, 10 cents, 25 cents, 50 cents, and $1. The system was different than Kitchener's. Merchants had to use the scrip and buy 1 cent stamps from the town to put on the vouchers. Each time the dollar scrip was used, the merchant or bill collector was to stick one stamp on it. Only when four stamps had been placed on the voucher could the merchant take it to city hall or a bank and get

on personal business. But what was money to Johnston? As mayor, he could make his own, he figured. So he did. His inspiration came from Kitchener, Ontario, where scrip had been used for three years. That city received money for relief from other government levels and borrowed from the bank, just like Orillia. Instead of handing that money over to people on relief, however, Kitchener paid the relief in special vouchers. The people on relief could use the vouchers at Kitchener stores. When a Kitchener merchant brought the

Mayor Ben Johnston's scrip looked good enough to replace real money for a few weeks in fall 1936. It was redeemable, although merchants disliked the idea of subsidizing relief.

it redeemed for 99 cents on the dollar. The town made that penny, plus the four other cents in stamps the merchant had to buy to get the scrip redeemed. Bylaw 1356 approving the scrip plan allowed the mayor and treasurer "to make such other arrangements as may be found necessary to have the said Voucher or Scrip as perfectly made as possible."

And perfectly made it was. The scrip looked so authentic, Johnston slapped a $1 voucher on the counter of a Cleveland hotel, just as a joke, to buy five cigars. The clerk put the voucher in the till and gave Johnston 50 cents in good American silver. Johnston let the clerk in on the joke later, but he had proved Cramp right in predicting the money's worth. On one side of each "Co-operative Purchasing Relief Scrip," under the fancy scroll work, stood the imposing figure of the Champlain monument and the signatures of Johnston and town treasurer Carrie Johnston (no relation). On the other side was a picture of the Swift Rapids power plant on the Severn River. Above the picture were the words, "Orillia-Pioneers in municipally owned electric development."

Ironically, and despite the free advertising, the Orillia Water, Light, and Power Commission refused to accept the scrip for payment. The Commission believed it would become a clearing house for scrip from merchants looking to pay their heat and hydro. Merchants reluctantly accepted the scrip, because they had to. But they complained about the nuisance of the stamps, and council repealed that part of the bylaw. The scrip did not catch on. The first week, city hall released $1,150 in scrip, and only about $700 was redeemed. After the city paid off interest to the bank, it was left with $35. The scrip never did make much money, costing almost as much to print and administer as it brought in. During that fall's election campaign, Johnston offered to repeal the scrip if that's what council wanted. Voters refused the offer, electing rival John Good instead. At the first meeting of the new council, January 11, 1937, council took only fifteen minutes to abolish the scrip. Many Orillians held on to the scrip as souvenirs. In 1956, $159.45 was still held in city hall

reserves to redeem any leftover scrip. At this time, council gave up holding on to the money and put it in the surplus account.

Rumours had plagued Johnston's administration throughout 1936, but the extent of the scandals did not become fully public until 1937. The new town council, tired of problems and rumours in its police force, demoted Chief Church to constable. An angry Church issued a report suggesting the problems lay not with the force, but with council. Some council members tried to interfere with police business, he charged. In the fall of 1936, Mayor Johnston told a constable to drop two Liquor Act charges against some of his friends, Church said. Johnston denied Church's claims, and Church eventually apologized. But council investigated the incident and discovered the interference charge was true. Not only that, but Johnston had written the letter of apology and, with the help of an alderman, forced Church to sign it to cool things down.

The past continued to catch up to Johnston in 1937. A muckraking weekly newspaper *Saturday Night* had run a series of articles in 1936 and early 1937, accusing Johnston of several crimes and unseemly acts: engaging in wild drinking parties at an Orillia hotel; selling a car seized by town officials and pocketing the money himself; lowering the tax assessment on property he owned; falsifying information about a shirt factory coming to town in order to get elected; and generally fattening himself at the taxpayer's expense.

"… relief has been made a racket by cheap chiselling politicians who have been waxing fat while others are on the verge of starvation," wrote *Saturday Night* editor George Bryan Curran, trying to live up to the motto on his little paper, which read "Print the Truth" and "Condensed but Dynamic."

When Johnston sued for libel in 1937, detailed allegations against his administration came out in the preliminary hearings that April, and they were covered by the newspapers. Johnston admitted he charged the town for taking taxis, often four a day, but said he was always doing town business.

"You have cost the Town $300 to $400 a year for cars," said lawyer Hugh Grant, defending Curran against the libel charges.

"I was a cheap man even at that. You are not worth $5," Johnston retorted. "All you have done this year is criticize."

Johnston maintained throughout the preliminary hearings that his business was always the town's business.

"I can't separate myself," he said. "The Mayor and J.B. Johnston were the same person."

The stories about the seized car were harder for Johnston to defend. Three people from Windsor drove through town in a car in rough shape. The police stopped the car and fined the three because the car did not have proper lights or brakes. The three did not have enough money to pay the fine, so Mayor Johnston intervened and ordered police to buy the three people train tickets back to Windsor and seize the car. While the car was being held by the town, about $14 In repairs were done. The town paid for the repairs. Meanwhile, Johnston found out a Windsor company was owed money on the

Chasing Rum-Runners and Nazis

Al Hunter was only on board to make sure the new owners of the Orillia-built Ditchburn patrol boat were satisfied with its performance. The new owners, the Royal Canadian Mounted Police, seemed satisfied. The captain seemed satisfied, except that suddenly he began shouting at a boat speeding across the St. Lawrence. The patrol boat had a machine gun on board, but not a full crew. Hunter, who knew something about guns, volunteered to fire a few warning shots across the bow of the rum-runner. The rum-runner then raced to shore, but the Ditchburn patrol boat caught it, forced it to beach, and arrested the men on board. Al Hunter returned safely to Orillia, the city's reputation for boat building enhanced yet again.

Based in Gravenhurst, the Ditchburns could trace their boat building ancestry back to the builders of iron-clad battle ships for the nineteenth-century British Navy. Herbert Ditchburn represented the fifth generation, and he built an Orillia branch factory at the foot of Elgin Street about 1924, so the company's 100-foot cruisers could be shipped down the Trent system to the sea. Newspaper accounts of the day state that Ditchburn was an unsung nautical genius. In crude experiments with single planks of wood, he saw first-hand how water resistance and vacuums created by moving boats slowed those boats down. His racing boats, *Rainbow III* and *IV*, won international competitions in 1923 and 1924 and forced design changes in other racing boats. Ditchburn boats set a world record of travelling 1,218 miles in

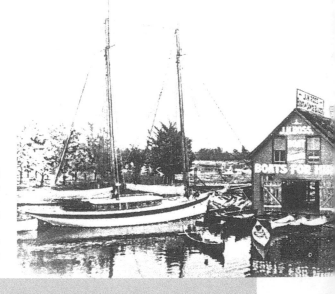

The J.H. Ross Canoe and Boat company and Deans Boats were the first to sell their crafts on Orillia's waterfront in the 1870s, with Ross just north of the town dock and Deans on the south side.

twenty-four hours on Lake Rosseau in Muskoka in 1924, and the *Rainbow VII*, built in 1927, had 1,100 horsepower and could supposedly reach 62 knots (72 mph).

That speed caught the attention of Canadian authorities and Ditchburn built thirty-eight-foot, 290-horsepower boats with top speeds of 29 knots (33 mph), cabin space for three men, and a mount for a machine gun to chase rum-runners on the Atlantic. Politicians, financiers, and industrialists of North America, from the Eaton family of department store fame to the president of

In 1899, Frank Rolland's Palace Boat Livery began renting canoes, some with shade covers.

Imperial Oil, ordered custom-built Ditchburn boats. At the company's peak in 1928, about forty men worked in the Orillia plant, with 100 in the Gravenhurst factory, doing about $300,000 in business that year with one cruiser selling for $60,000. But Ditchburn's millionaire customers ran out of money after the stock market crash of 1929, and the company closed its doors two years later.

In 1932, Al Hunter bought the Ditchburn boatyard from the city. He began a much smaller operation, building canoes in a small shop heated by an oil drum converted into a stove. The Second World War changed Hunter's operation overnight. The Allies commissioned several boat builders in Ontario to build the Fairmile, a small and fast coastal patrol boat to sink German submarines. Hunter's small canoe shop turned into a boatyard with 120 men scurrying through the original Ditchburn buildings and a new one that Hunter built. In 1941, Hunter Boats produced the first Canadian Fairmile, the Q060, the only one produced to get a name, the *Mariposa Belle*. The 112-foot-long and heavily armed Fairmile could reach 32 knots (37 miles per hour) and hunt submarines in shallow waters.

Hunter Boats built seven Fairmiles, and after the war returned to building pleasure craft. Al's son Don Hunter closed down the manufacturing in 1965, although the service department continued until 1976. His was the last boat works on the waterfront. The Ross boat works caught fire in 1964, burning part of a neighbouring boat livery, Rollands. Deans boat works, by then a livery, sat out on the water and collapsed from the shifting ice in 1964. By then ice had damaged the two dozen private boathouses that lined the waterfront almost without interruption from the town dock to French's fast-food stand at the foot of Tecumseth Street. The city ended the leases and had the boathouses torn down to create Centennial Drive and Centennial Park. Hunter Boats caught fire in 1990 and again in 1993. The city tore down the remaining buildings to create a waterfront park.

car. He paid that company $20 for the car, paid the outstanding fines of $29, then sold it for $80, making a nice $31 profit. He never did pay the town back for the repairs made.

Each day the hearing drew a crowded house, especially when the court heard allegations Johnston had been drinking in the mayor's office and at a bootlegger's house. Three lacrosse players testified that while hosting a convention of postmasters, a drunken Mayor Johnston and Reeve Wib Cramp ended up at a female bootlegger's house on Front Street. Johnston drank so much there he fell into a storage room, fell onto the floor, and finally passed out on the bootlegger's bed, where he was the object of passing interest until he woke up about 8 a.m. the next day. Johnston admitted he had a few beers that day before going to the bootlegger's house, where he lay down to rest and woke up the next morning. There were no postmasters with him, he added.

After three days of hearings, the judge decided the libel suit should go to trial. Before the matter came to trial, Curran issued an apology, accepted by Johnston, that read: "I apologize to you for and retract any such statements which may have unfavourably reflected on you personally."

It wasn't much of a victory for Johnston. George Bryan Curran and Johnston both ran for mayor in the fall of 1937. Curran insisted his apology was only for the slights against Johnston's character.

"The charges concerning town affairs have not been disproved," insisted the publisher.

Neither man won, and for the rest of the Depression, life in Orillia calmed down. There was even a movement to have the 1937 council acclaimed to run the town in 1938, to acknowledge its steady work and to save the $400 cost of running an election. Johnston decided to run, ruining the chance of acclamation. He suffered his worse defeat at the polls. He ran for mayor four more times and threatened to keep running until he won by acclamation. Johnston died in 1942, before his threat could be carried out. He was hauling a load of hay down Laclie Street near his home at the corner of Borland Avenue, when a spring pole holding the unbaled hay down sprang loose. The pole struck him on the head and knocked him between the horse hoofs and wagon wheels. His death was mourned by many, friend and adversary alike.

By then, the Depression that had both handed him and taken away his career had been overtaken by war. Orillia was already getting its affairs in order as trouble broke out in Europe. At end of 1938, the town had an operating surplus of about $4,600 and the debt down under a $1 million, signs things were finally looking up. The Second World War turned everything around. There were more jobs than Orillia had ever seen.

That first year, Otaco had eleven employees. Three years later, it was running three shifts of 1,600 people turning out undercarriages for Mosquito bombers. As it did in many other towns and cities, the Second World War turned Orillia's industry around. E. Long Ltd. supplied cartridge case machinery for manufacturers throughout North America. Hunter Boats Ltd. produced the Fairmile submarine chaser.

Orillia's factories boomed during the Second World War and women got many of the jobs. The Tudhope Specialties plant, at the southwest corner of Colborne and West streets, produced thousands of PIAT (Projectile, Infantry, Anti-Tank) shells that could be launched by the infantry. This National Film Board photograph was taken in June 1944.

And just as they did twenty-five years ago, Orillia sent its youth overseas to fight. Many of them trained at Camp 29, where Orillia Secondary School stands today. At the outset of the war, a soldier would join a specific regiment, but later he would attend Camp 29 to determine the outfit he was best suited for. Soldiers trained from 6 a.m. to 5 p.m., then walked into town for a bit of relaxation, most often at the Maple Leaf Club. From June 1942 to February 1946, the club, nicknamed the Hostess Club, gave soldiers a taste of romance and home in the vestry of St. James Anglican Church. Soldiers could visit the Writing Room, Games Room, Reading Room, Lounge, Canteen, Table Tennis Room, or Mend-it Corner, where volunteers fixed their clothing. The Writing Room proved the most popular. Soldiers and members of the Canadian Women Army Corps (CWAC) posted letters from the Writing Room, as many as 300 a night, 33,000 a year. Town organizations, such as council, the Orillia Water, Light, and Power Commission, the Lions Club, Board of Trade, Y's Men's Club, and factories, donated money to keep the busy club going.

The Maple Leaf Club was one of the busiest of its kind, making about 3,000 meals a month. The canteen began with 54 workers and had to expand only a year later to 100 workers. About 200 patriotic local girls volunteered to spin around the floor of the main hall on dance nights, allowing the young soldiers to let off a little steam while obeying the strict rules of the dance. "It is a patriotic duty to help keep the soldiers happy, thereby you help to win the war," read one rule. Keeping them happy did not involve, however,

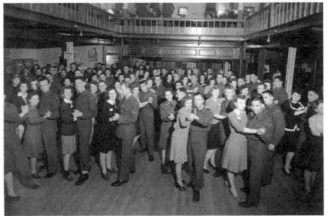

Orillia's Maple Leaf Club provided soldiers with a home away from home. They could get their clothes mended, relax in the reading room, or blow off some steam while dancing with local women in the vestry of St. James Anglican Church.

dancing too long with one soldier, or leaving with a soldier, unless you were his guest.

"Develop excellent topics for conversation," stated the Dance Night rules. "The Supervisors should be pleased to supply excellent subjects for conversation…." Occasionally, a girl broke the rules. Recalled one volunteer for a newspaper article in 1995, "Quoting from the Good Old Church of England prayer book, 'I hope I will be forgiven the things I did which I should not have done, and for things which I left undone which I should have.'"

The soldiers appreciated whatever was done. In 1944, members of the Champlain Barracks of Camp 29 wrote, "Many is the man, now overseas who will carry with him memories of Orillia as their home away from home, and many is the man on his way over who will carry him over rough spots."

Marriage ceremonies for soldiers were eventually performed at the club. The first was the marriage of Corporal Katherine Lillian Smith, member of the CWAC at Camp 29 in Orillia, and Lance Corporal Nyk Katarynych, of the same camp, on August 17, 1944. The Maple Leaf Club was the cheapest place they could find for the service. An unexpected wedding gift was the announcement of a change of orders the following day. At the wedding ceremony, they were each presented with a new stripe.

Like other towns and cities, Orillia got behind the war in countless other ways, raising money for armour, sending care packages home through the Red Cross, suffering shortages of wood and coal,

and rationing of other everyday supplies. In 1941, the Orillia War Committee was asked to raise $13,500 a month for the rest of the war to build two armoured carriers and two universal carriers. The campaign began with the tolling of church bells and blowing of factory whistles, a school children's march down Mississaga Street, and a fundraising dinner at the YMCA. The war did not make ordinary people rich, and by the end of the first month, Orillia's 9,400 residents had raised only three-quarters of the amount needed for one carrier.

Life at home wasn't easy either. Suppliers ran out of coal in the winter of 1943. The few men around to cut wood had trouble getting in the bush because of heavy snow. Housewives were used to seeing up to seventy-five loads of wood a week for sale at the Farmers' Market, but, one week in March 1943, only one farmer arrived with just one load — just under a cord of wood. It was quickly snapped up.

The news that the war had ended came at 11 a.m. on May 7, 1945, with the sound of factory whistles and church bells ringing in the cool, Monday morning air. VE-Day was not officially announced until the following day, but Orillians were impatient to celebrate. Orillia's VE-Day committee, assembled several months earlier, could not decide whether to begin the festivities on the Monday or wait for the official announcement, scheduled for the following day. The committee members quickly decided to celebrate immediately. Factories shut down and merchants closed their stores. Factory workers rushed out of town to get liquor as Orillia,

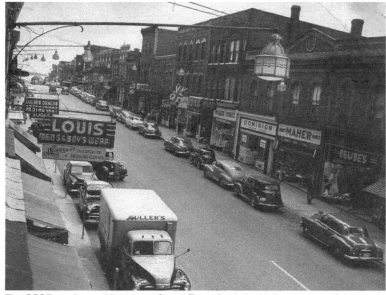

The CFOR studios on Mississaga Street East afforded a bird's-eye view of downtown in the 1940s.

being dry, had neither liquor stores nor taverns. An official parade was to be held the next day, but the *Orillia Newsletter* reported an impromptu march "led by a soldier playing a bagpipe, accompanied by make shift drums of garbage lids and old scrub brushes for drumsticks." That night, Mississaga Street was roped off and a crowd danced to Andrews' Orchestra until the early morning hours.

The next day at the Lions Oval, thousands listened to an amplified radio broadcast of King George VI's VE address, then paraded down

Mississaga Street to Couchiching Beach Park. An effigy of Adolf Hitler received the same treatment the Kaiser had two decades previously. Reported the *Newsletter*, "While the scarlet-uniformed mounties stood rigid at attention, the torch was applied to the gasoline-soaked effigy [of Hitler] as a roar of cheers broke from thousands who lined the park."

Later in the day, "the blazing effigy of Hitler was drawn through the streets on a trailer behind Howard Thiffault's car to the din of motor horns and shouting children. They finally came to a stop in front of veteran Dorm Raymond's residence. More fuel was added to the blazing torso and flames rose high in the air in their eagerness to wipe out every sign of the once deadly enemy."

According to Royal Canadian Legion records, Orillia lost seventy-eight soldiers in the war. Many more were injured. Wives lost husbands, children their fathers, sisters their brothers. However, through ten years of the Depression and five years of the war, Orillia had survived, its spirit intact.

CHAPTER SIX
Anything Was Possible

"Can a man make a cloud dissipate and vanish simply by willing it to do so? Does the human mind possess some strange force which, if recognized and harnessed, can alter the entire destiny of the human race?"

These two questions, slightly more cosmic than the usual posed by reporters, led off the front-page story in the *Packet & Times* on September 10, 1954. The answer brought readers down to earth, in Orillia no less. "To both of these questions Dr. Rolf Alexander of 15 Whitney Avenue answers 'Yes'."

For twenty years after the Second World War, anything, even cloud busting, seemed possible in Orillia. The 1950s and 1960s are sometimes called the second Golden Age of Orillia, when industry boomed, politics sparked, and ordinary people built a community centre, started a national folk festival, and came within an inch of red tape of building a university. Yet the second Golden Age

shone with a different light than the first. The debate over moving ahead and keeping things the same intensified as some of the players changed sides. The company owners and industrialists lost the mantle of heroes they wore in the early 1900s as they moved the town ahead. Ordinary people began to see these leaders as a clique determined to keep things the same for their own benefit. The owners of the large industries were accused of keeping out new companies and the accompanying unions and higher wages. New blood infused the Orillia Spirit. Anyone could give anything a try — from factory workers and housewives to a newcomer who predicted he could destroy clouds at will.

Dr. Rolf Alexander was born in 1891 to a Scottish physician and his wife, on a ship bound for New Zealand. He spent much of his life travelling, and studying other cultures. After graduating in medicine from the University of Prague in 1912, Alexander lived

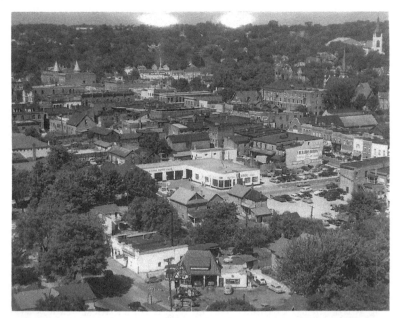

In the 1950s, car dealerships, service centres, and dairies dotted the downtown, as seen in this 1954 aerial photograph. In the middle of the frame is J.W. Clarke General Motors Dealership, started in 1948 at 21 and 22 Matchedash Street South. In the foreground are Cooke's Wonder Grill and Supertest service station on Front Street at Colborne Street. To their left is Beers Dairy.

and studied with Tibetan lamas, Buddhist monks, Hopi Indians, North African medicine men, and West Indian sorcerers. After decades of study and experimentation, Alexander was ready to write the book that would change the world. Something drew him to Orillia.

The tall, white-thatched man with pale blue eyes settled in the small town with his wife and young son. He began recording weekly broadcasts at CFOR radio station for another station in Port Arthur, where a devotee paid for the air time. Young Orillia broadcaster Pete McGarvey taped the material and grew fascinated with Alexander.

The two became friends. The idea that man's mind was a powerful force was not new, but Alexander's arguments were more lucid and reasonable than most. Alexander was not content to spread the message by radio. He had something bigger in mind, and he invited McGarvey over to his house one day in August 1954. Alexander told McGarvey he would have a book called *Creative Realism* published in October, explaining how psychic energy could influence both animate and inanimate objects. To prove his point, he would wipe clouds out of the sky right then and there. A surprised McGarvey followed Alexander outside.

"Pick a cloud, any cloud," Alexander told him. McGarvey did and, to his surprise, the cloud disappeared. Several experiments with equal success fuelled McGarvey's amazement, and when Alexander asked if he would help publicize the book and a public demonstration of cloud busting, the radio broadcaster agreed.

In the days before the experiment, Alexander explained to newspaper readers and CFOR listeners that a strange power lay in the subconscious mind, rising to the surface in the form of daydreams and fantasies. He had learned how to release that power at will, said Alexander. "This cloud busting is not a unique power I alone

hold. Anyone can learn to do it," he said. Cloud busting was only a device to prove the existence of the power. The power itself would free men and women to tap their own creativity. It strengthened the mind. Jesus Christ understood this power and described it in His own words, said Alexander. The Russians were already using some of the power, he added.

"I have spent a lifetime studying this subject. And I believe this force must be brought to the attention of science in so concrete a form that the necessary expensive research into it will be undertaken," Alexander said. "This can be one of the biggest ideas in twenty centuries if we can get it accepted." Alexander told reporters he chose cloud busting to prove the existence of the power because no one could accuse him of falsifying results.

Conditions for the experiment were ideal the afternoon of Sunday, September 12, 1954. A bank of cumulus clouds had settled over Lake Couchiching. About 300 people gathered at Couchiching Beach Park. Just after 2 p.m., Alexander arrived at the mound behind the ball diamond, where McGarvey introduced him to Mayor John MacIsaac and reporters. Alexander spoke briefly, then invited the mayor to pick a cloud, any cloud. The mayor, perhaps being polite, picked a small one. After a few minutes, the cloud disappeared. Twice Alexander did this, while nearby clouds remained unmoved. The crowd murmured. Then a newspaperman stepped forward, and politeness be damned, chose a large cloud. This was the real test, and the reporter recorded the events by the

Dr. Rolf Alexander told Orillians he could make clouds disappear at will and invited them out to watch in September 1954. The *Packet & Times* recorded Alexander's efforts before an astonished audience at Couchiching Beach Park.

minute. At exactly 2:09 p.m., the experiment began. Alexander took a deep breath and concentrated on the cloud. It enlarged slightly, then began to twitch. At 2:11 p.m., it showed unmistakable signs of thinning. At 2:14 p.m., it had been reduced to wisps. By 2:17 p.m., the cloud was gone. Observers applauded. Alexander repeated the experiment several times, and each time, the cloud disappeared while adjacent ones remained intact. A few observers claimed Alexander knew which clouds were going to disappear, but that did not explain how he wiped away clouds others had chosen. One enterprising reporter contacted the Weather Bureau later. A dry front moving in likely broke up the clouds, said a weather forecaster, but he doubted anyone could predict which clouds would break up and when.

An exhausted Alexander quit after about an hour, but the news spread through Orillia the next day. Reporters from Toronto, then across North America, picked up on the story as interest in his experiment and book grew. Unfortunately for the Alexanders, the radio interviews and magazine articles drew the attention of the federal immigration department. Government officials checked out Alexander and found his visitor's visa had expired. He and his family were forced to move to England, and he eventually died in Florida.

Alexander's experiments were the strangest but not the only sign things were a little different in Orillia after the war. The industries that boomed during the war continued to thrive. The leading companies were still owned by the founding families: the Longs at E. Long Ltd., and the Tudhopes at Tudhope Metal

Specialties, for example. Other owners had run their plants since the 1930s. But the men who returned from overseas soon learned the boom gave them jobs but not necessarily a fair wage. They were ripe for unions, and the Canadian Congress of Labour responded, sending the tough George Brough to town in early April 1949 to organize six to eight of the leading factories. Brough found willing workers at the Heywood-Wakefield plant on the northeast corner of Forest Avenue at Atherley Road, where founder Jim Lloyd oversaw about 110 employees making the Lloyd Baby Carriage. Workers like Kenneth Howes were making 65 cents an hour to chrome-plate carriage handles. That seemed like good pay at first, recalled Howes in an interview for this book. But, after a while, workers realized others in Barrie or on provincial highway contracts were making $1.25 an hour for similar work. Within a month, Brough signed up about seventy employees of Heywood-Wakefield to the Orillia General Workers Union. Lloyd gathered his workers together and told them he didn't mind if they joined a union. Then he laid off eighteen employees, most of them with long service, and all but one a union member.

"We put two and two together," remembered Howes. Without Brough's knowledge, a group of workers met Sunday, May 1, 1949, and voted that night to strike. About seventy employees walked off the job Monday, circling the plant and blocking the main entrance off Forest Avenue. With handmade signs, they began marching twenty-four hours a day in Orillia's first large-scale industrial strike.

CFOR reporter Pete McGarvey, left, interviewed union leader George Brough in 1949 after pickets at Heywood-Wakefield overturned a car carrying non-striking employees.

The strikers gained immediate sympathy. In the first week, construction workers at a nearby housing site raised $40 for the strike fund. Merchants sent over free ice cream and pop to keep up the strikers' spirits. Tempers flared occasionally that first week. One striker opened the car door of a worker driving into the plant and punched his colleague in the head. A truck refused to stop for the picket line and carried a couple of strikers for a short but slow ride on its fender. One cab company that drove non-striking employees across the picket line the first day was plagued the next day by dozens of phoney requests for cabs. After sending cabs all over the city for phantom passengers, that company, like others, refused to go near the lines again. Orillia's frustrated factory workers, seeing a sign of hope for better pay, joined in. The Canadian Congress of Labour organized a parade and speeches on the Saturday after the strike began. Several hundred workers gathered in the Oddfellows Hall, where fiery labour leader Henry Rhodes of the congress urged them to fight the family-run factories in Orillia that kept wages low.

The speeches worked. Monday's picket lines drew 200 angry workers, many from other factories, waiting for the cars of non-strikers to come in before rushing off to begin their own work days. One car of non-striking workers came up Forest Avenue too fast for the pickets' liking. The pickets forced the car to stop, then rolled it, with its five occupants still inside, into a ditch. No one was hurt. But the five town constables were powerless to stop the roll-over or the fights that broke out all morning. The strikers even

stopped Lloyd's car and let the air of his tires. Town council met that night and gave Mayor W.M. Seymour and the police committee the power to call in the Ontario Provincial Police for help if necessary. Tuesday was relatively quiet. Strikers and their sympathizers bounced a few cars up and down, bending the licence plates. And a factory foreman returned from a lodge meeting that night to discover strikers had splattered red paint on his car and put paint into his gas tank. By now only foremen, a nurse, maintenance staff, and office workers were getting into the building. Lloyd maintained throughout the strike that employee relations had always been good, and that the strike was illegal, as the union had not been certified. Some of his points were valid, but he lost support in the community when he sent notices to all the striking workers telling them they had "fired themselves" and were out of jobs.

The strike grew violent again that second week. Wednesday morning some pickets tried to overturn a car. The mayor called in twenty OPP officers to handle the strike. He and council members stressed they would not take sides but would not tolerate violence. Council tried several times, with the help of the Department of Labour, to get the two sides to compromise. But Brough wanted his workers to get their jobs back before ending the strike, and Lloyd refused to hire anyone back. Meanwhile, the strike was inspiring other factory workers to sign union cards, and more businesses were offering the strikers money, groceries, and other goods. The support of the town's merchants was understandable. It was the town's workers, not the factory owners, who bought the groceries and the paper supplies and the ice cream every week. Support for the strikers was hardly unanimous and the picket lines divided the town. Yet as the strike finished its second week, the anger seemed to lessen. On the Monday night, fifteen days after the start of the strike, the Department of Labour announced the strike was over. Management and labour congress officials reached a compromise — all strikers would be hired back, except for the eighteen laid off. A county court judge would determine if dismissal of the eighteen was justified. His decision would be considered final.

The judge's hearing, like the strike itself, made front-page news for several weeks. Union and company lawyers clashed over the reasons Lloyd had laid off the eighteen workers. The judge eventually ruled that all but two workers should be taken back. Kenneth Howes didn't bother to return, as he was offered an unskilled job, not the job he had held before the strike. In his parting speech, labour congress leader Rhodes took a shot at all Orillia manufacturers. Orillia could no longer be an anti-union town run by a few factory owners, Rhodes warned. When the fifteen-day strike was over, Orillia had become, if not a union town, at least a town with unions in it.

Unions never gained the power in Orillia they did in other towns. But the working class in Orillia had gained new self-respect and showed signs it was a potent force. Any doubts about that were destroyed the year after the strike. A working man's hero, in

In 1960, the wives of 215 striking workers at Otaco defied police orders and set up tents and telephones so their husbands could seek shelter and contact their families. The wives used their hand mirrors to reflect the sun into the eyes of a company official attempting to film a clash between police and pickets. The strike began June 1 and lasted seven weeks, raising the average salary to $1.26 an hour.

friend of the labourer, and enemy of the "minority interests" running the town. In style and even looks, he was another Huey Long, the populist governor of Louisiana in the 1930s. Cramp himself first tasted power in those days, running a campaign for council in 1932 with the slogan "Fair play for the taxpayer and square deal for the unemployed," finishing fourth in a field of thirteen. In his first term as alderman, Cramp co-sponsored a motion calling on all municipal bureaucrats earning $1,000 a year to take a 10 percent cut in pay, with the money going into relief funds. Council amended the motion to a 15 percent cut for four months. Only a few years later, as reeve, Cramp tried to get council members a pay raise of $50. After that and a second motion of his were defeated, a petulant Cramp donned his coat and hat and left the council meeting. Councillors tried to get him back, so they would have enough members present to vote on two bylaws. Mayor Ben Johnston asked a reporter to telephone Cramp at his seed store across the road from the Opera House. Cramp told the reporter to tell council to find a proper messenger. Two aldermen then called, but Cramp's reply was that things had gone "from bad to worse." Finally, a third alderman convinced Cramp to return, in exchange for reintroducing one of his motions. His association with Mayor Johnston and that administration's scandals only improved his popularity. Cramp presented himself as an outsider fighting "the hush-hush tactics of council," although he was on that council as often as anyone. He served four times in the 1930s, two as reeve, and three times in the 1940s.

his own mind at least, rose to power and began another colourful reign at city hall. Wilbur Cramp was his name, Wib to just about everyone. A local seed merchant and comrade of the late Mayor Ben Johnston, Wib Cramp styled himself the protector of the poor,

Wilbur Cramp — seed merchant, friend of the liquor trade, and fiery defender of the working class — led the councils of the 1950s, just as Ben Johnston had in the 1930s. Cramp rode dissatisfaction with Orillia's elite to the mayor's chair four times.

wipe out the bootleg trade, they said. Temperance supporters, naturally enough, argued liquor was evil and its sale should be discouraged. On radio and in the press, the two sides battled in the fall of 1950. The Temperance supporters called on voters to respect the opinions of their church leaders. Mayor Austin Cook, speaking as a private citizen, argued on the radio against the rowdyism that liquor brought to a town. Cramp led the other side, countering that special interest groups such as the church ministers were trying to interfere in the town's life and business. The liquor fight turned nasty when someone threw a brick carrying a death threat through the window of Cramp's apartment at Mississaga and Andrew streets. Crudely written in ink and lipstick, made to look like blood but less hard on the writer, the note told Cramp to "get out of town in 24 hours or you die."

Each side collected the names of supporters, either new in town or not enumerated before, to add to the voting list. The Temperance supporters added 450 names, the liquor store backers more than 1,000. Still, many expected the Temperance forces to win, as they had done several times since 1907, when prohibition had settled on Orillia. Besides a long tradition and the town's sunshine image, the Temperance forces had thrift on their side. The liquor supporters needed a 60 percent majority to win. But many of the twenty-one-year-old men in town, new to voting, refused to put their names on any list because they would be subject to a $5 poll tax. Wisdom had it the liquor forces needed those young men to carry the vote, but it seemed a lot of people in Orillia were tired of driving out of town just to get a beer.

But it was during the 1950s that Wib Cramp earned his legendary status. Like Johnston in the Depression, Cramp galvanized the discontented in Orillia. His dreams were their dreams. His anger was their anger. He wanted what they wanted — for one thing, a good drink. In 1950, a group of businessmen in town formed the Orillia Volunteer Workers to bring a liquor store and brewery warehouse to the town. Too many Orillia people were driving to Barrie or Bracebridge to shop because they could pick up beer and liquor there, argued the businessmen. Making the sale of liquor legal would

Times had changed and it was time to be progressive. The voting on November 28 drew one of the largest turnouts in the town's history. Sixty-one percent of the voters agreed the town should allow a government liquor store and brewery warehouse. There would still be no beverage rooms in Orillia for another seventeen years, but the vote was the first crack in the Temperance foundation.

Cramp rode the success of the liquor vote into the 1950 election campaign for mayor. He stepped up his attacks on the "Minority Pressure Group" that ran the town — the industrial leaders and old-money Orillians who wanted to keep wages low and life the same. "Who is it that keeps new industries out of Town?" asked Cramp in his election ads. His speeches were confrontational, though much less concise than his ads. The town was run by "a fascist-like group who don't believe in democracy to such an extent they won't even let you talk or think as you like if you don't agree with their views," Cramp charged, to cheering audiences. He accused incumbent Cook, a manufacturing executive, of being the front man for the so-called pressure group. In the best Eugene McCarthy-style of the era, Cramp held up a piece of paper during a debate at the South Ward Community Hall and said it contained proof that two workers had been fired because they were talking to a union organizer. "Is that the kind of democracy you want?" Cramp asked the crowd. Challenged to name the company, Cramp refused to answer publicly, saying he would not embarrass the firm, but would give the name to anyone who asked privately.

Cook was heavily favoured to win the 1950 election. A good sportsman, member of St. Paul's United Church's male quartet, and an active member of an influential service club, Cook represented the best of old Orillia. He could be as tough as Cramp in an argument, though he was not as showy. But Cramp surprised the political wise men with a big win at the polls in December 1950.

Thus began one of the strangest reigns at city hall. Only five months into his first term as mayor, Cramp took on one of his favourite targets, the police, and all hell broke loose. The police arrested an acquaintance of Cramp's, a chain store manager, for a minor infraction of the Liquor Control Act after finding him with a Coca-Cola bottle full of liquor. Cramp had long complained about police "harassment" over minor liquor infractions and somehow found out his friend had been arrested early in the morning of April 20, 1951. Cramp called the station to find out what was going on and got Corporal Everett Lynn on the phone. When Lynn told Cramp he was going to charge the man, Cramp said, "We'll see about that," and rushed to the station. There are two versions of what happened when Cramp reached the station, at about 4 a.m. Cramp claimed he had heard many complaints about the police and wanted to see if they were true. Learning the accused had gone home, he started to leave, too, when Constable Murray Robinson charged him at the counter and said he would tramp him into the floor. His own hand might have brushed the constable's tunic as he raised it in self-defence, Cramp admitted, but nothing else happened.

A Leacockian Tale

Were it not for the back-room politics of an Orillia broadcaster, Stephen Leacock's graceful home on Lake Couchiching would likely have been demolished a long time ago.

In his summer home on Brewery Bay, Leacock wrote, entertained friends and family, and horrified the pious of Orillia with his eccentricity and indulgence in alcohol. He loved Brewery Bay and, after his wife died in 1925, built a beautiful home there. On his death in 1944, the home passed into the hands of Leacock's son, Stephen Leacock, Jr., and the home began to deteriorate.

Fans and friends of Leacock tried to gain possession of the home but ran afoul of Stephen Jr. None other than C.H. Hale — the champion of Soldiers' Memorial Hospital and the Champlain monument — continued to press for public ownership of the home in the early 1950s. He gathered a group of like-minded Leacock boosters, including young alderman and radio broadcaster Pete McGarvey. For several years, the committee fought council indifference, even hostility, and the whims of Stephen Jr. in its efforts to buy the home. The committee's best chance came in 1956. Toronto developer and publisher Louis Ruby bought the property, and, after a little persuading, agreed to give the Leacock Home Committee a year to find $25,000 to buy the home and the surrounding 1.4 acres. Town council again refused to spend any money on an old, falling down summer home. Premier Leslie Frost, though born and bred in Orillia, offered little help. There is

Stephen Leacock's first cottage on Old Brewery Bay ran along the shore in front of the current Swanmore Hall. Note the baby carriage in front for his son, Steve. In 1928, the cottage was replaced by the stately home that is a national historic site today.

speculation that the Frost family, devout Temperance supporters, did not appreciate Leacock's healthy thirst.

Determined to devote his time to the purchase of the Leacock home, McGarvey told fellow aldermen he would not be running for the 1957 council. To their horror, they realized McGarvey's withdrawal would result in acclamation of council. One of the only six people left in the race was a town eccentric who promised to make council's life miserable. The incumbent councillors pressured McGarvey to stay in the race and keep the eccentric out. McGarvey made them a deal. If he ran on a single platform, the saving of the Leacock home, and won a lot of votes, they would have to back him in buying the property. McGarvey collected the second-highest vote count, and the rest of council kept its part of the bargain. The town purchased the Stephen Leacock home in 1957.

Constable Robinson told a different story. In Robinson's version, Cramp argued with police, pounding the counter and shouting, "I will not stand back and see my friends persecuted." The mayor swore at Robinson and grabbed his tunic. Robinson said he knocked Cramp's hand aside, then took off his hat, belt, and holster. "If you lay a hand on me again I'll tramp you into the floor," he told Cramp. The mayor left the office.

The police charged Cramp with assault, and Cramp retaliated by calling a special meeting of council on April 25, 1951, to demand the resignation of Chief William Carson. No other council members showed up, saying through a statement to the press that the matter was before the court. But 130 people crowded into the council chambers in the Orillia Opera House and 1,000 more listened to the mayor's attack on the police through loudspeakers on the market square. Cramp said the police went after him only because he opposed a $100 raise for them and had stopped paying for the phones in officers' homes. He raised the spectre of police department corruption and offered a convenient excuse to avoid proving his claims. Because he had been summoned to court on the assault charge, he could not reveal what he had learned, Cramp told the crowd. Cramp had Stephen Leacock, Jr., the author's son, to help him craft his speeches. The mayor and the eccentric Leacock, Jr. had formed a friendship based equally on the appreciation of a good time and a dislike of authority other than their own.

Highway 11 used to run through Orillia along Colborne Street, then along Laclie Street north. After a frustrating drive through town in summer 1953, Premier Leslie Frost had a bypass built the next year. After several major accidents, stoplights and overpasses were eventually added to the bypass.

"On numerous occasions I have tried to impress upon councils that a reign of terror exists and has existed within many years due to the oppressive, high-handed and vindictive actions of our police," Cramp told the crowd that April night in the council chambers. The chief was in his office near the council chambers that very minute, "skulking in the dim light of his office listening with one ear to the door while a stenographer took down my speech in shorthand," Cramp charged.

After an hour-long tirade, Cramp announced he would ask the attorney general to investigate. "Do you believe that I should continue my crusade on behalf of your personal liberties and democratic rights?" Cramp asked the crowd. The crowd cheered and those parked in the market square honked their car horns.

Cramp's dislike of the police likely started about the same time he began enjoying the services of bootleggers. But there were always some questions about the force. For example, the Orillia police routinely refused to allow an arrested person to make a telephone call to family until they were through dealing with him. In the middle of Cramp's war on the police, council's police committee changed that rule. But council refused to do anything else with Cramp's complaints about the police chief.

Cramp countered that council was in the pockets of the mysterious minority pressure group that had opposed his election in the first place. In court on May 16, 1951, Cramp was found guilty of assault and fined $10. It came down to Robinson's word against Cramp's. The constable had made no notes that night, but scribbled some down the next night. His colleague on duty, Corporal Everett Lynn, did the same thing and confirmed the incident took place just as Robinson had said. Cramp's lawyers pointed out a few minor inconsistencies in the officers' testimony, but it was hardly enough to change the judge's mind.

His pockets lightened of $10, Cramp continued his attack on the police force all summer long, suspending Chief Carson in July until an investigation into the police force was launched and completed. The town lawyer told an upset council that the mayor had the right to suspend the chief. But a week later, the lawyer learned the province had just rescinded the part of the police act giving mayors that right. A rebellious council voted unanimously to declare the suspension illegal and the investigation dead before it even started.

Support for Cramp's crusade had started off strong, but his constant attacks aroused the fears of many Orillians that the town's valuable image was suffering. So vitriolic were Cramp's charges against the police, they attracted the attention of the Toronto media. Orillia's sunshine image suddenly fell into shadow. And that upset a lot of the merchants who depended on the tourist trade. Led by business people and Orillia Water, Light, and Power commissioner Frank Tissington, Jr., Cramp's enemies formed the Citizens Committee for Civic Betterment to counter-attack the lies that had made Orillia a "laughing stock throughout the province."

To Cramp, the betterment committee was nothing more than the official front for the "mysterious pressure group." But more than a minority were tired of Cramp's tirades. Tissington, running again for the power commission, and former mayor Cook, trying to win his seat back, focused on Cramp's feud with the police and the tarnished image of Orillia in the 1951 fall election campaign.

"It is hard to convince outsiders that something has not gone wrong with Orillia and Orillians," Tissington told election crowds.

"During the past eleven months, Orillia has taken it on the chin," said Cook, who usually campaigned in a quieter style.

Cramp deflected some of that criticism by charging that Tissington, Cook, and the rest of the minority that ran the town tried to keep power rates low for industrial users. Tissington owned the Tools and Hardware plant, and Cramp charged him with a conflict of interest. But Orillians had been stung by Cramp's feuds and voted him out.

Cramp's political career was hardly over. He won the mayor's race for the 1953, 1956, and 1957 councils and served as reeve in 1959. He made headlines again in 1965 when he was found not guilty of three charges of municipal corruption. Nine years earlier, Cramp had accepted free shares from the Northern Ontario Natural Gas Company and had coincidentally promoted that company's quest to gain the franchise to serve Orillia. The court ruled Cramp did get the shares for free but did not promote the company any more than he normally would have. Cramp returned to politics the next decade, serving as a councillor from 1973 to 1979, when a stroke ended his career. Cramp died in 1985, and his shenanigans have taken on legendary status. To those who served with him, Cramp remains a darker figure, a dangerous would-be demagogue who lied to get his way and had no real interest in the average man.

Whether Cramp really was always the friend of the working man remains open to debate. And there were other mayors more or equally effective in the 1950s. But Cramp remains a telling figure

In 1957, American comedian Bob Hope was persuaded to visit Orillia to officially turn on the switch to boost CFOR's power to 10,000 watts. Thousands of people crowded into the station's parking lot across from Orillia and District Collegiate and Vocational Institute to watch the ceremony, hosted by broadcaster Pete McGarvey, whose back is to the photographer.

of that decade because he focused the dissatisfaction many Orillians had with the powerful men guiding the town. In most of the yearly elections for council in the 1950s, Cramp won overwhelming support in the working class south ward, while losing heavily in the more well-off, established north ward. When he struck a chord

among merchants, clerks, and foremen alike, he won election by gaining the votes of the relatively middle-class west ward. When his bombast grew too much to handle, the west ward removed him from council for a year or two. Each of his election races was marked by Crampian complaints against the secrecy of the Orillia Water, Light, and Power Commission and the powerful elite of industrialists running the town.

No one has been able to prove that a collusion of industrialists kept wages low in Orillia, although years later it had become an accepted fact among many Orillians. There were plenty of other reasons why new industries did not come to Orillia in the 1950s — a lack of available land, especially on Highway 11, and high assessments are two of them. Don Hunter, a former member of the Orillia Industrial Associates, a group of industrial leaders that met frequently in the 1950s, said there is no truth to rumours industrialists colluded to keep industry out or wages low.

But it is clear some business leaders preferred the status quo over large-scale growth in the 1950s. At a dinner in April 1950, some business leaders suggested Orillia did not necessarily need more factories or more jobs. Things were fine just the way they were. The Orillia Junior Chamber of Commerce fired off a counter-attack in a letter to the newspapers a few weeks later. The town needed to grow to provide jobs, the junior members said. No unemployment? the letter writers asked. Tell that to the 508 people looking for work in the city. More industry might bring Orillia's wages back up. The Junior Chamber pointed out that a provincial study divided Ontario into eighteen areas, and only one of those had lower wages than Orillia. More factories would provide competition for skilled labourers, thereby increasing wages. Higher wages would inspire more spending and create even more jobs. The letter concluded — and this was no populist mayor or union leader writing, but the Junior Chamber of Commerce: "Until these new industries come to Orillia then we might as well accept the fact that this is an industrially controlled town. As long as the industries control the wage scale they control the buying power and through it they control Orillia."

Trust in their leaders, Temperance — many of the standards of the early 1900s fell in the 1950s. None symbolized the change in Orillia as clearly as the 1953 vote on the OWLP's bid for a new power plant. The town's public utility, and one of the most innovative examples of the original Orillia Spirit, had grown considerably since the early 1900s. Industry, business, and residences all consumed more power, with demand doubling in the period from 1925 to 1945. The OWLP Commission had built another power plant in 1935, this one on the Gull River near Minden, and one more in 1950 at the Matthias Falls on the Muskoka River. It seemed obvious Orillia would need even more power as it grew.

About that time, Ontario Hydro renewed its efforts to get Orillia's power utility into its system. *Packet* publisher and former OWLP commissioner C.H. Hale had tangled for years with

Orillia said goodbye to the 1950s by saying hello to Queen Elizabeth in 1959. The royal couple made a stop in Orillia during their 1959 tour of Canada.

Ontario Hydro officials suggested Orillia join their grid, rather than build a new and expensive power plant.

The question became two-fold. Should Orillia build a new plant or join Ontario Hydro? It divided the OWLP, council, and the town. The OWLP's new engineer and a Montreal consulting firm recommended Orillia join Ontario Hydro. The town's engineer for the past twenty years recommended against joining the provincial utility. Each side threw a barrage of facts and figures at the public. Some of the industrialists favoured joining Ontario Hydro so they would be guaranteed power at rates that were equal to all plants. Others, like Clarence Long of E. Long Ltd., asked publicly how anyone could decide, with the conflicting numbers and many questions still in the air. OWLP commissioners in favour of affiliation said the new plant would cost more than estimated and not produce as much power as calculated. The idea that industries came to Orillia because of low power rates was ridiculous, said the manager of Fahralloy, which had started up in the 1930s. Some rates paid by the company were just as high as those charged by Ontario Hydro, he said.

Supporters of the new plant and the OWLP's independence argued that controlling its own power would continue to guarantee Orillia low rates. The Horseshoe plant would provide plenty of power, and the OWLP had three more sites on the Severn River for future expansion. Besides, said supporters, the $1.2 million debt and the extra $900,000 debenture would not be repaid by taxpayers, but out of OWLP revenues. The complex battle threw people onto

Ontario Hydro officials, charging they longed to get Orillia to join the Ontario Hydro grid. Ontario Hydro looked at the OWLP as a rival because its low rates sparked Ontario Hydro customers to question their own rates, said Hale. Sir Adam Beck, the founder of Ontario Hydro, had failed in 1916 to persuade Orillia voters to join Ontario Hydro. The provincial utility had a better chance in the 1950s, when Orillia faced building a plant at Horseshoe Falls.

The Centre a Community Built

Until the late 1940s, a natural ice rink inside a corrugated metal shed on West Street at Coldwater served as Orillia's arena. In 1947, just about the time the Orillia Water, Light, and Power Commission (OWLP) bought the site of the natural rink for a new building, a small group of service club representatives led by lawyer and Y's Men Club member Mac Carter started talking about building a modern arena. The town had little money to spare, as it was paying for two school projects and a new sewage plant. So, it was left up to the service clubs in town to initiate and pay for the $150,000 project.

A young Mac Carter, centre, led the dignitaries on a tour of the new community centre on January 28, 1952. Following Carter is Maple Leaf goalie Turk Broda.

But interest in the centre appeared flat after the first four months of campaigning. Looking for a way to heighten interest in a new arena, Carter came up with an unusual solution — shut the old one down. Without a rink in the winter of 1948, town residents might better appreciate the need for a new one, he figured. The media and many civic leaders cried foul. Carter explained how Orillia would lose out if it didn't act fast. The OWLP had promised $15,000 from the sale of the old, corrugated-sided rink to the new arena committee, said Carter. If no buyers were found soon, the OWLP would have to move the rink to build its new headquarters, and subtract the costs of that move from the money handed over to the new arena committee. His arguments won the day, and the town shut down the old rink for the duration of the campaign. Skaters and hockey players had to settle for outdoor rinks.

It took longer than expected to begin building, but once the sod was turned in 1950, the arena became a community centre even before it was built. Local contractors and manufacturers donated materials and services valued at around $48,000. About 3,000 volunteers hammered, nailed, sawed, and helped lay bricks over the two-year construction. Service clubs provided teams of twenty or more, one night a week, with as many as 100 volunteers working at a time, eventually contributing more than 10,000 hours of labour. That was worth about $85,000 then and cut labour costs in half. Government inspectors and contractors praised the work. Fundraising brought in $110,000, and the province gave $10,000, leaving the city with only $25,000 to borrow, one of the lowest loans for a municipal arena in the province at the time.

The opening-night gala on January 28, 1952, featured Toronto Maple Leafs goalie Turk Broda and champion figure skaters from Toronto. About 2,400 people watched Premier Leslie Frost, a native Orillian, cut the ribbon. The OHA Junior A Barrie Flyers and Galt Black Hawks put on an exhibition game, with Barrie winning 5-1. Touring the new arena that night, George Dudley, secretary-manager of the Canadian Amateur Hockey Association, told reporters, "If more beautiful arenas like this one are built, hockey would be brought up to an even higher standard than it already enjoys in Canada."

unexpected sides. Mayor Cramp, a constant critic of the OWLP, argued against joining Ontario Hydro. The confusing question came to voters September 14, 1953, and even though the OWLP won the vote, it lost the war. Orillians voted 996 to 911 for the new plant, but that did not come close to the 60 percent needed. The new plant was lost, and affiliation with Ontario Hydro came soon after.

Newspaper writers at the time wondered why the town was willing to give up its independence so easily. It's likely the huge debt remaining from the building of the Matthias plant in 1950 and the fact that household rates differed little from Ontario Hydro rates dampened the enthusiasm for a new plant, wrote the *Orillia Newsletter*.

"It has been a heartbreak of my old age to see … Orillia's future as an industrial centre thrown away," wrote C.H. Hale in his book *Reminiscences*. The result of that decision was clear, he wrote. After forty-five years of the lowest electrical rates in Canada, it took only ten years of affiliation with Ontario Hydro to put Orillia's rates above those in Barrie, Midland, Coldwater, and Gravenhurst, said Hale.

Hale saw the vote over the OWLP as a battle between old Orillians with pride in their power plant and newcomers who had no such loyalty and were backed by Ontario Hydro's Barrie office. It was likely not that simple, for in the shifting debate over Orillia's future, it has often been newcomers who try to maintain the community's link to the past. It was a newcomer, young radio announcer Pete McGarvey, who led the fight to buy and restore Stephen

Premier Leslie Frost, left, and Pete Garvey celebrated the unveiling of a bust of Orillia great Charles Harold (C.H.) Hale, right, at the Orillia Public Library. Orillia native Elizabeth Wyn Wood sculpted the bronze bust. Hale died in 1963 at the age of eighty-eight.

Leacock's summer home on Old Brewery Bay (see McGarvey's book *The Old Brewery Bay: A Leacockian Tale*). The ending of the OWLP's independence symbolized the end of the trust in industrial leadership of the early 1900s, but it hardly marked the end of a spirit determined to make Orillia unique.

CHAPTER SEVEN
Some Dreams Just Won't Die

Flat on her back with the flu in 1961, Orillia housewife and mother of four Ruth Jones had nothing else to do but think: about Orillia, her home of the past five years; about the notion espoused recently by a tourism expert that each community should have something unique to draw people; about how she loved to get away now and then to Toronto and listen to the rising young folk musicians. By the time the flu bug had worked its way through Ruth Jones that winter, she had worked out an idea that would marry her love of folk music and her love of Orillia — the first-ever Canadian folk festival, held, of course, in Orillia. Six months later, hundreds of teenagers from across the country and hundreds of bewildered Orillians heard the opening songs of the first Mariposa Folk Festival. On that peaceful night, when Jones's dream had come true, no one could predict the rocky ride Mariposa and the 1960s would take, with Orillia just barely hanging on.

The Mariposa Folk Festival began like many of Orillia's dreams that decade, with naiveté and energy. Ruth Jones sent letters to major folk stars such as Pete Seeger to invite them to this as-yet-non-existent event. Few replied, but it did not matter to Jones. Within weeks she had a committee working for her. Alderman Pete McGarvey, fresh from his Leacock home victory, liked the idea and dubbed it the Mariposa Folk Festival. Jones and her volunteers roamed the province, trying to gain support and publicity. The festival committee found strong acceptance in Orillia. A folk festival was a nice, clean way to promote Orillia and bring thousands of tourists into town. In 1961, folk music was riding a crest of popularity, attracting both clean-cut college students still many years away from Woodstock and the hippest of their middle-aged, middle-class parents. The organizers' aims were simple and noble. The Mariposa Folk Festival would teach Canadians about their own national folk songs, give

The first Mariposa Folk Festival drew from 6,000 to 8,000 people with an all-Canadian lineup that included Ian Tyson and Sylvia Fricker.

rising musicians the publicity they needed to attract record contracts, allow Canadian singers a chance to earn a successful living at home, and promote Canada's folk music to the world.

The first festival accomplished all that. On a warm August night at the Lions Oval in 1961, about 2,000 people sat before a stage that looked like a medieval jousting tent and listened to rising stars Ian Tyson and partner Sylvia Fricker, later known as Ian and Sylvia Tyson. So good was the music, some Orillians even moved out of their chairs to sit on the grass near the stage, reported the *Packet & Times*. That was as wild as things got. After the Friday night performance, hundreds enjoyed a square dance on Mississaga Street and throughout the festival watched films about folk music. In true folk festival fashion, it rained the Saturday evening. About 4,000 people crowded into the community centre to watch newcomers such as Bonny Dobson and seasoned folksingers The Travellers. Afterward, Traveller Jerry Goodis proclaimed, "This could be another Stratford." The *Packet & Times* agreed. It called on any suspicious Orillians to accept the eccentric folk musicians and their fans, just as Stratford residents finally accepted the strange theatre people who descended on their town each year. Mariposa was just the thing to give Orillia an extra edge in the tourism industry.

The second year proved just as successful, with a bit of hometown pride thrown in, too. Orillia native Gordon Lightfoot, starting to make a name as a folksinger in Toronto, brought fellow Orillian Terry Whelan to the festival and they performed as the Two Tones.

In 1961, the Two Tones — a young Gordon Lightfoot, right, and Terry Whelan — sounded too commercial for organizers of the first Mariposa Folk Festival.

The second festival featured workshops on folk music, including a serious look at the art form with critics from the *New York Times* and the Folklore Center of New York.

The 1963 lineup was even more impressive, with a midnight jamboree and hootenanny, tempered by lectures from Edith Fowke, an acknowledged expert on folk music and host of many CBC folk music programs. Festival organizers expected 25,000 people to congregate in the town of 15,000 and pleaded with homeowners to rent out their rooms. People from across the United States and Canada were phoning for accommodations and the motels were full. A businessman in Severn Bridge cleared some land and created the Silver Sleeve camp ground to handle the overflow. Homeowners responded by opening their doors, and the police, worried about traffic, asked the OPP for extra officers. About 5,500 people watched the Friday night performance on August 10. That was twice as high as the year before and convinced the show's producer, Jack Wall, earlier worried about Orillia's interest in the event, to keep the festival in the town. Wall had taken over organizing the festival from Jones. The third festival gained Orillia international recognition, with crews from CBC television, NBC, and CHUM radio recording the event. The crowd that first night listened quietly to the songs of Ian Tyson and Sylvia Fricker and veteran folksinger Alan Mills. The only trouble for the fifteen town police and ten OPP officers were the traffic jams downtown and up the highway to Severn Bridge. The party that night centred

on Silver Sleeve, where a jamboree and impromptu bonfire sing-alongs kept teenagers up most of the night.

Saturday turned rowdy in Orillia itself. According to press reports, more than 23,000 people, including members of the Black Lancers motorcycle gang, streamed into Orillia. About 11,500 of them turned up at the Oval for the concert. Men armed with baseball bats tried to keep out gate crashers. The field was so jammed with people, organizers warned concert-goers if they left at intermission, they would not be allowed back in. That sparked trouble and hundreds tried to get back in by climbing over the fence. One girl fell from the fence and landed on a beer bottle, breaking her arm. The crowd settled down when The Travellers took to the stage, but people were still restless and a post-concert singalong drew little interest. The teenagers in the crowd poured downtown, where they joined thousands of others who had come into Orillia just for a party. They took over the main street. Silver Sleeve had closed its gates to the crowd at 8 p.m. because it was full. Police on duty there reported seeing thirteen- and fourteen-year-olds drunk, and campers using neighbouring lawns for toilets because there weren't enough washrooms in the park.

"The morals at Silver Sleeve were deplorable. It was disgusting," OPP Sargent Ken Chalmers later told the press.

Things were worse, or at least felt that way because they were closer to home, in Orillia. Gangs of youths drank and fought in the streets, said newspaper reports. Doorways became toilets. Teenagers swarmed around a police officer as he tried to arrest a youth, and the youth escaped into the crowd. One officer checked a man in a sleeping bag on the street and came face to face with a gun. Teenagers rolled pints of beer down the Mississaga Street hill to friends at the bottom. They showered and bathed each other and the Champlain monument in the park with beer. Drunken girls of thirteen and fourteen who consistently showed up in eyewitness accounts of rowdy times in Orillia — last seen in bootlegger hangouts in the 1930s — turned up again in newspaper reports. This time they were seen roaming the streets on the arms of older men. There were reports that at least one ended up in a sleeping bag with a biker. According to police and newspaper accounts, one mob of teenagers broke into a University of Toronto bus and smashed all the camera equipment and scattered clothes onto the street. A hundred youths held up a police cruiser on the main street, refusing to let it pass for several minutes. Parked cars were ransacked and thieves stole anything inside. Police arrested hundreds, but a thousand officers could not have handled the crowd, they said.

"Bloody noses and black eyes" greeted police officers everywhere, said Chief E.W. McIntyre. The forty town, OPP, and RCMP officers could not handle the mobs. Not even the worst brawls of the lumber days sparked such outrage in the town.

"It is obvious there cannot be another festival here," Alderman McGarvey, one of the festival's founders and biggest supporters, said the next day. There was no doubt the festival made money — restaurants reported triple the business. "We need the money, but not at the expense of the town's good name," said Alderman Murray Robinson.

The kids were all right, as long as they were square dancing in the street. But rowdy crowds of young people prompted Orillia to kick out the Mariposa Folk Festival in 1963. All grown up and a bit battered by age, the festival returned home for good in 2000. (For more on this, see *The Mariposa Folk Festival: A History*, by Michael Hill.)

An estimated 23,000 people, mostly teenagers, descended on Orillia for the Mariposa Folk Festival in 1963, swarming the Champlain monument and sleeping in Couchiching Beach Park.

Not everyone found the Mariposa Folk Festival the nightmare reported in the press. The Orillia establishment overreacted to a few small problems and the sight of so many young people in the streets, maintains Frank Gold, who owned a clothing store in the middle of the fracas downtown.

"The old-timers couldn't believe the young people," he recalled in an interview for this book. "It was the Woodstock generation, and this town wasn't ready for it. The stories were exaggerated."

Ruth Jones agrees. *The Globe and Mail* sent a reporter just to do a story on the riots before the festival even started, she said in an interview. Festival organizers conspired to get the reporter drunk, and he missed his deadline. But the image of the town had been tarnished, and city leaders felt any threat to Orillia's good name, and year-round family tourism, had to be quashed.

Council and organizers told the producers to go somewhere else, preventing the festival from being held near the town in 1964. The festival moved on, looking for a permanent home on the Toronto Islands, Barrie's Molson Park, and a few other places in between. It would take Orillia thirty-six years to get its festival back.

Another dream of the 1960s met a similar fate, and refused to die into the 1990s. Just as the Mariposa Folk Festival packed up its tent stakes, Orillia embarked on an even more ambitious plan to please its youth, while making money and boosting the town's image at the same time. The way to do that seemed simple — build a university. Universities do more than keep young people at home and bring in students and their money. They give a community an intellectual centre, and a focus for arts and entertainment, from varsity sports teams to better pubs. And Orillia came agonizingly close to achieving the cachet of a university town a half dozen times during the stormy rise and fall of Simcoe College. For the first few

heady years in the 1960s, it appeared certain the town would get its university. Enrolment at existing universities was rising and the Orillia area was growing. A group of educators and residents formed a university committee in 1964. In a report of that year, the committee proposed building a university called Simcoe College that would cost $1.25 million, to be built in three stages. Besides a 35,000-square-foot teaching centre, Simcoe College would have a library, student residence, and gymnasium/auditorium. Waterloo Lutheran University was interested in operating the satellite campus until someday, perhaps, the university would achieve independence. The first stage would enrol 600 students, with another 600 enrolled when completed.

The campaign to raise the construction money started with the largest banquet held in Orillia. About 700 people sat down to a fundraising dinner in the community centre June 4, 1966. Excitement gripped Orillia, the county, and Muskoka, for the university was to serve a large area. The eighteen campaign leaders themselves pledged $41,400. The Simcoe College Foundation hoped to raise the $1.25 million by September, so the buildings would be complete the year after in 1967. In the fall of 1966, the Simcoe College Foundation paid $115,300 for 228 acres of wooded land on the west side of Highway 11. So optimistic was the foundation, it bought more land than originally planned, in order to allow for college expansion. The site seemed ideal for a university, with a stream, pond, and rolling hills that gave a view of lakes

Couchiching and Simcoe, and frontage on Highway 11. Stephen Leacock himself had used the pond as a secret fishing retreat and wrote about it. But fundraising slowed after the initial kickstart, and the September 1967 opening was delayed. Meanwhile, the foundation had to bump its goal up to $1.8 million to cover the extra land purchased.

Foundation chairman Sue Mulcahy appealed for the public's help. A sod-turning ceremony a year after the dinner may have been a sign of the public's waning interest. Thirty-five people working in shifts called 9,796 residents by phone to personally invite them to the June 17, 1967, sod turning. About 200 turned up to stand in the rain that day for the dedication ceremony by the Hon. Earl Rowe, then the lieutenant governor of Ontario and honorary patron of Simcoe College. That same year, the federal government announced a shift in funding that saw Waterloo Lutheran lose some grants. The university pulled back on its commitment to Orillia. At the same time, the province announced it would offer grants only to universities in existence in 1967. Although the Simcoe College Foundation had been incorporated in 1965, the province refused to offer it any grants.

For the next thirty years, the foundation and its supporters rode a roller coaster of hopes lifted and dashed. Each time the province announced a new direction in post-secondary education, the foundation grew hopeful money would finally come. The Conservative provincial government alternatively warned there would be no

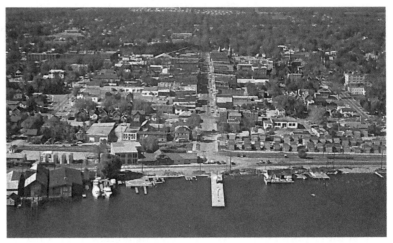

By 1964, when this photograph was taken, time, ice, and fires had knocked down most of the large boat works on Orillia's waterfront. Hunter Boats remained to the south of the Orillia Air Dock. Canada Wood used the waterfront area for storing wood piles. In 1966, the town began clearing the waterfront and adding fill north of the dock to create Centennial Park, which opened on July 1, 1967.

money for universities and promised Orillia it would be the first to get one when money was available. In 1974, Premier William Davis fanned the dying embers of the dream by suggesting university enrolment was rising again and Simcoe College would get permission to build. No free-standing universities would be approved, said Davis at an Orillia fundraising dinner, but Simcoe College was affiliated with the University of Wilfrid Laurier (formerly Waterloo Lutheran University), and that meant it could go ahead.

That promise was broken and, as the years went by with no construction in sight, the pledges of service clubs and businesses died natural deaths. Meanwhile, the foundation had to endure charges about the mishandling of funds and wasting everyone's time. In 1981, Orillia council took back about $284,000 raised in taxes for the university. That money was for bricks and mortar, and nothing else, council members said. For much of the 1980s, the remaining foundation members held on to the slimmest of hopes for a university in the face of demands it put the land and assets to another use, whether for a recreation centre or a new hospital. Volunteers cleaned up the property from time to time, as hikers, mountain bikers, and cross-country skiers became the only visitors to the site. The foundation continued to help students taking York University courses at Georgian College and gave $10,000 for a college library. The pressure to sell grew heavier when Richmond Hill, Ontario, developer Lou Orsi started buying land around Orillia in the late 1980s. He offered the foundation from $1 million to $1.5 million for the land. Long-time college backer Sue Mulcahy and other board members refused. Meanwhile, the province told the foundation to forget any idea of a new university for a long time.

By 1989, the foundation had had enough of the pressures and asked the province for help in dissolving the foundation and dividing up its assets. Under its charter, the foundation's assets had to go to charities, but there was little charitable about the scrabble for the 228 acres of land and the $77,000 in the bank. The Supreme

Isabel Post was Orillia's first female mayor, serving six terms in the 1960s. She was joined at a civic holiday program at Aqua Theatre in August 1965 by Miss Canada 1964 and the Orillia Silver Band.

Court of Ontario announced it would hear from groups interested in the assets, sparking a bizarre battle between a range of non-profit groups. Local service clubs, the hospital, the Orillia Naturalists Club, Georgian College, the St. James Court Non-Profit Housing Corporation, the Orillia Heritage Centre, city council itself, and a new-age church called the Fellowship of White Light all claimed to have the best plan for the land and $77,000 in assets. The proposals ranged from the prosaic to the poetic.

The Orillia Lions, Rotary, Kinsmen, and Quota Clubs joined forces to push for a nature and recreation park that would attract tourists and help residents. The Naturalists Club had a similar idea but favoured a wilderness area. Hospital officials would not say why they wanted the park, but it was likely for a new facility or to resell and pay for one. The Orillia Heritage Centre wanted some money to help build a museum in Tudhope Park. Georgian College wanted some money to pay for scholarships and capital works projects. The non-profit housing group wanted to build non-profit housing. The new-age Fellowship of White Light wanted to build a "mystery school." That's how leader Stephen Ginsberg described his proposal. The group had 1,500 members devoted to health, peace, and "focusing on the white light." The Fellowship's conference centre, restaurant, dormitories, and nature trails would offer adults a place to learn how to eat better, relax, and regain their spirituality, said Ginsberg. "We believe we can change the world," he said.

Just to make things even more confusing, some of the previous owners of the land claimed they should get the land back. The owners said they had been forced into selling their land by the threat of expropriation for a university. If there was going to be no university, the land should return to them, they argued. Each group lobbied council and the public before a Supreme Court hearing into the assets. The fighting grew so intense Mayor John Palmer, often the cause of controversy, pleaded for calm. "We're looking like a bunch of little pigs," he told the *Packet & Times*. "It seems a little unseemly, like someone threw a loaf of bread into a crowd of starving people."

In the midst of this interesting little battle, council, the service clubs, and the Naturalists Club got together to propose — what else? — a university. The roller coaster headed up the track again. Former education minister Bette Stephenson, heading a group trying to build a private university, gave initial support. The Ontario Public Trustee's Office, which supervised charities in Ontario, thought that was a great idea.

A district judge delayed the hearing on the assets to give the university backers time to prepare a proposal. Most of the other city groups fell in behind the idea, although the property owners and the non-profit housing corporation continued to make a plea for some of the assets. Meanwhile, yet another government study came out, giving Orillia new hope. The Institutional Policy Committee of the Ontario Council on University Affairs suggested the province consider ways to help fund proposals such as Simcoe College. In February 1990, the dream of a university received official rekindling. A Barrie court decided the Simcoe College Foundation should expand its board of directors and work toward getting a university in Orillia. Mulcahy and other foundation members could hardly believe that in less than a year they had bounced from a bitter dissolution to an optimistic expansion. Ironically, the legal battle over the foundation drained all but $13,000 of the assets that had tempted so many groups.

For most of the next five years, the new Simcoe College Foundation tried to establish a centre for environmental studies, offering graduate students and professors a place to conduct research. The centre would not have to gain any university accreditation, but would get the status of university research in exchange for supplying a facility, technical equipment, and support staff. Orillia's unique location between the urban and agricultural south and wilderness north provided an ideal setting for studying a range of environmental issues, said supporters. With $3 billion available in the federal government's Green Plan, Conservative MP Doug Lewis in Cabinet, and a local Conservative leader, Jack Stewart, heading the foundation, it appeared finally that Orillia would get something. The federal government financed two of three studies into the centre's development, which outlined not only what the centre would do, but in what buildings and how. The foundation pressed the federal government for $500,000 to prepare site plans and architectural drawings. But in May 1993, the government balked, perhaps because any more help would put it on the line for the rest of the $15 million needed for the centre. A $50-million government cut had turned the vibrant Green Plan pale. A few months after the federal government's rejection, foundation president Jack Stewart died. The Tories themselves lost the election a year later.

With the February 1995 deadline approaching, the foundation disappeared from public view. Behind the scenes, foundation members lobbied the Ontario Public Trustee and anyone who might object to a further extension. A Barrie court order, issued on February 2, 1995, gave the foundation three more years to make substantial progress in setting up an environmental research centre. The foundation also made an agreement with Georgian College, the occasional burr in its side, to let college students use the 228 acres in Scout Valley for environmental studies. In three years' time, the foundation had to get another $50,000 for its final report and hire someone to get a commitment to the plan from Ontario universities.

Three years later, in 1998, the exhaustive and exhausting effort to create Simcoe College finally ran out of breath. The foundation sold the 228-acre Scout Valley to the city for about $180,000 and donated the proceeds to Georgian College, which uses the money for scholarships.

Despite the failure of the college and the departure of the Mariposa Festival, the 1960s ended with optimism in the city. For one reason, Orillia could finally be called a city by the end of the decade. There had been several attempts to turn the town into a city, usually tied to annexing some land. So optimistic were city fathers in 1917, they named the Opera House the Orillia City Hall. Progress never seemed so certain after those years. Mayor Ben Johnston tried in the 1930s to expand the town's borders to include 10,000 people, enough for a city, but failed. Other attempts in the 1940s and 1950s failed for the same reasons, fear over costs and fear over a loss of small-town identity. From 1915 to 1952, the town did not expand at all. The 1950s saw a series of annexations. In

In the 1960s, progress often meant tearing down or hiding Orillia's older buildings. The Andrew Carnegie public library had its facade covered by angular additions in the 1960s and again in the 1980s.

1952, about 109 acres north of Brant Street and west of West Street was annexed. Much of that land had been a farm owned by Reeve James Quinn of Orillia. He had used his influence for years to keep the farm safe from annexation so he could pay the township's lower tax rate. The town annexed two more parcels in 1956, including the land where Orillia Secondary School sits today, and a small parcel in 1959.

By 1965, more people were moving into Orillia Township on the town's borders, taxing the town's facilities, without giving the town taxes. The western edge of the town was Westmount Drive and West Street, its northern border a zig-zag of streets below the curve of Highway 11. Across Westmount especially, hundreds of new homes were springing up. They weren't tied to city services and there was fear the septic tanks couldn't handle all the sewage. Council commissioned a study of the problem and the consultants recommended the town annex 3,000 acres of Orillia Township. With the typical optimism of consultants, the report predicted the town would grow to 30,500 people by 1985 and needed the room. Growth had been stalled since 1951 by lack of space, while the township had been booming. But all those people used city facilities, and the city needed to get something in return, concluded the report.

At first the town and township played down any potential animosity over the recommendations. Mayor Isabel Post suggested the township hand over the land quietly, without a fight. Township Reeve Tom Joslin said his taxpayers would not approve of that, and suggested the township and town consider uniting. That and other compromises failed, so the town took its annexation plans to the Ontario Municipal Board (OMB) in 1966. Orillia Township opposed the move. Town lawyers argued that by 1985, without annexation, Orillia would have only seventy-five acres left for residential development. There were only twenty-five acres of industrial land left in town, and two industries, Dominion Rubber of

The Long Wait for a Drink

It took almost a hundred years, but Orillia finally got a drink.

The colourful Wilbur Cramp and a group of merchants led the vote in 1950 to allow a beer and liquor store in Orillia, but residents still had to drive across The Narrows to Atherley for a drink in a tavern. The first bar across the bridge was nicknamed "The First" and the next in line, "The Second." Between trips to Atherley and dipping into the cooler at the curling club or other private clubs, Orillians could get a drink. But it still galled many that residents or tourists could not buy a drink with a meal in as modern a time as the 1960s. Focusing on the benefits to the tourist trade, a group of seventy-two residents signed a petition in early 1967, asking council for a plebiscite on the issue. Council agreed to the vote, and the last great liquor fight began.

The Orillia Yes Committee included doctors and developers, and they hired a professional manager to help bring bars and lounges to town. The committee stressed that opening lounges and beverage rooms would please tourists but have no effect on Orillians' drinking habits. Opposing the committee were the Concerned Parents Movement and some local churches. The churches became the rallying point for the No side, when radio station CFOR cut short the weekly broadcast of a Sunday service. Station management had asked the churches not to bring up the liquor vote in the weekly shows. One minister told his audience about the restriction, then joked that he planned a long dissertation on the demon rum. The radio station cut him off the air, playing

In 1966, there wasn't a tree or patch of cobblestone to be found or a place to get a drink In downtown Orillia. The Shangri-La Gardens was the first of the main street restaurants to get a liquor licence after a plebiscite on April 24, 1967, reversed decades of a dry Orillia.

a few records and returning only when the minister began his sermon. The churches and Temperance supporters cried censorship. The Concerned Parents stepped up their advertising, which claimed lounges and taverns increase alcoholism.

The *Packet & Times* reversed a century of editorial policy and endorsed the vote for lounges, concluding Orillia needed lounges and licensed dining rooms to attract tourists. Temperance officially ended on April 24, 1967, when slightly more than the required 60 percent of voters approved licensed lounges. A few months later, the first tavern sign went up on Jin Seta's Shangri-La Gardens. The licensed Terrace Room attracted a steady stream of businessmen enjoying the first public drink in Orillia since 1908, and the end of a long, dry season.

Kitchener and CCM Bicycles, had rejected Orillia because there were no suitable industrial sites, argued town lawyers.

The spectre of the town's leading industrialists opposing new industry rose again during the hearings. S.F. Saunders, the president of Dorr-Oliver-Long, the town's biggest industry, and chairman of the Orillia Industrial Associates, told reporters he was against annexation because it would increase taxes. His point was well taken. Orillia's taxes were already higher than average for towns its size, and higher than Barrie's. The town's debt per capita was the fourth highest for municipalities that size.

The township lawyer argued that the annexation was piece-meal and would destroy the township's tax base, pointing out that a previous annexation attempt in 1957 was turned down by the OMB. The hearings turned nasty several times, such as when the township officials suggested Orillia clean up its "slums" in the south ward before worrying about getting more land.

"You'd think you were a criminal on the stand," Mayor Isabel Post recalled years later. "… You had to stand through all this, through all this cross questioning. I remember someone saying, that the lady ought to be offered a chair. And I remember retorting quite caustically, 'She's quite able to stand'. It was a sort of bitter business."

The Ontario Municipal Board ruled in September 1966 that Orillia could annex about 3,000 acres of township land, because the built-up areas around Orillia should come under an urban administration. The annexation doubled the size of Orillia and raised the population from about 15,000 to 20,000. That was enough for a city, but no one was rushing to become a city, at least officially.

"I don't see any city status for Orillia in the near future," said Mayor Isabel Post shortly after the annexation victory.

The next year, 1967, Orillia was incorporated. The relationship between the municipality and the county was beginning to sour. The county refused to give large municipalities such as Orillia more voting power, prompting Mayor Post to do a preliminary study in the fall of 1967 on becoming a city. Her figures showed that Orillia was paying more for county services than Barrie, which loosened its relationship with the county when it became a city in 1958. Post wanted to delay doing anything for a year because there was no money budgeted for an official study, but council pushed ahead. Council members said they were tired of fighting the county over money, and feared the province would force regional government on them. The next spring, in 1968, a chartered accounting firm from Toronto decided that leaving the county would cut taxes in Orillia. No one objected to the proposal when the city applied to the Ontario Municipal Board. The board took about two minutes on May 6, 1968, to decide Orillia could finally become a city. Interviews with residents after the decision revealed the struggle to reconcile the desire to grow, but not to grow too big.

"We'll start acting big," declared resident Reg Irwin.

"I wouldn't like to see Orillia get too big though," said resident Violet Mintz.

When fireworks, speeches, and the ringing of church bells proclaimed the birth of the city January 1, 1969, civic leaders offered the same optimism, and caution.

"Our day is tomorrow," proclaimed Mayor Burt McIsaac.

"Look, We Are a City! But We're Still Orillia," proclaimed the *Packet & Times*. How true that was. For the next twenty years, residents struggled to reconcile Orillia the City with Orillia the Sunshine Town. The Orillia Spirit was splintered by internal division and bashed about by external forces, leaving the entire city with a splitting headache.

CHAPTER EIGHT
Big City Dreams, Small Town Reality

If everything had gone according to plan, by 1990 Orillia would have had a new community centre, a new hospital, one of several waterfront plazas, a big downtown mall, a huge Highway 11 mall, a lot more jobs, and a lot more people.

So much for plans. Instead, throughout the 1970s and 1980s, Orillia suffered through bitter arguments, failed or derailed projects, fewer industrial jobs, stagnant population growth, and an undeveloped waterfront where the only thing expanding was a scrap yard. But things weren't all that bad. The city gained a new college facility, some new companies, and a much-improved downtown that has become key to tourism. The local hockey club brought the city to its feet with two championships. But all the failed plans, hollow hoopla, and missed projections of greatness left Orillia with a hangover of cynicism about new ideas and projects, which lingered into the 1990s. The only constant in the years from 1970 to 1990 was the desire to grow out of being a small town, yet avoid growing into a city. That mixed-up wish left the city… mixed up.

The first sign of trouble came at the start of the decade in a provincial plan for the growth of southern Ontario. The Toronto Centred Plan, released June 5, 1970, after months of discussion, focused on the roles of Toronto and the communities around it. The plan suggested communities such as Barrie and Midland grow as industrial centres. Orillia? It was best suited for recreation and parkland; as one government spokesperson said, a place for horseback riding and snowmobiling. "For Orillia, it's a blueprint of doom," the *Packet & Times* declared. "The plan sentences Orillia to a lifetime as the centre of a playground for the idle rich from Metro…." An infuriated Mayor David Brown vowed, "We will fight like hell." In public meetings, local politicians reminded provincial bureaucrats and Cabinet ministers that Orillia had already proven itself a successful

industrial city. The city sent off an official response to the Toronto Centred Plan, calling its conclusions false and its implications for Orillia dangerous. Orillia had proved through hard work, imagination, and determination that industry could and would locate here, said the city report. Angry city officials said retailers and professionals in the city were suddenly reluctant to expand because of the stigma the report gave Orillia. Reports come and go, and in the 1970s and 1980s especially, one report was hardly printed before another put it out of date. Yet in Orillia there is a suspicion the Toronto Centred Plan did hurt the city, at least for a while. Developers and company owners looking to expand likely did consult the plan, an important one in Queen's Park. And that plan certainly discouraged them from moving to Orillia. The plan proved so controversial, its recommendations were dropped. But Orillians suddenly had a bad feeling about their standing in the rest of the province.

It would get worse. In 1975, a CBC television crew filmed a documentary called *Orillia, Our Town*. The CBC focused on fifteen people in Orillia, basing their look at small-town life on the Thorton Wilder play *Our Town*. The ninety-minute documentary accented Orillia's quaintness and manufactured some of its own. The soundtrack ambled along on barbershop quartets, Movietone music, and ragtime, and the camera focused mainly on old salts and the salt of the earth. Old home movies were cut into shots of empty streets. The documentary focused on old cars, old factories, old people, and the old theme of a nervous bride and groom approaching their wedding

When the 1970s began, Orillia was still considered to be an industrial city, with the Big Three — Dorr-Oliver Long, Fahralloy Canada, and Otaco. Otaco made its mark on the world in a range of ways, from its twenty-ton "Deep Freeze Sleds" for Antarctica expeditions to the amphibious all-terrain vehicle called the Bazoo. The decline of the Big Three reflected the city's struggles for the next two decades.

day. As a look at ordinary people's hopes and dreams, "Orillia, Our Town" worked fine. As a mirror held to a nervous, young city hoping to attract suitors, it was a distorted disaster.

The show was first aired to a crowd at the Opera House, which gave it fair reviews. But when *Orillia, Our Town* was shown on television coast to coast March 19, other Orillians getting a first look at it were horrified. Hundreds called the mayor's office, the *Packet & Times*, radio station CFOR, and Conservative MP Dr. P.B. Rynard's office. None were too happy, and many echoed the comments of CFOR announcer Rusty Draper: "We've been made fools of in the eyes of Canadians." Letters to the editor in the *Packet & Times* carried Orillians' complaints: The documentary showed nothing of Orillia's growth or energy. Orillia was depicted as Dullsville with a capital D. Where were the new buildings, the prominent people, the heroes, people under forty-five? How could anyone think Orillia was still Mariposa?

Actually, all anyone had to do was look around. While some Orillians were complaining that outsiders were making the city look like Mariposa, others were invoking the myth of Mariposa to make sure Orillia didn't look too much like a city. Their fears focused on high-rises and they made the choice clear to Orillia: the city could have Homes or High Rise. The group by that name forced the city into a rollicking and mud-slinging debate on the future of Orillia. Members of the group take credit for the preservation of the city's church spire and municipal tower skyline.

Development-hungry city politicians in the early 1970s had opened the door to builders. The planning board and council had approved a few seven- and eight-storey apartment buildings without much opposition. But in 1973, a handful of influential and wary north ward residents heard rumours an apartment complex proposed for their neighbourhood, on the southwest corner of Laclie Street and Fitton's Road, was going to be eight and twelve storeys high. After a bit of a tangle with the city's planning department, which appeared reluctant to give out too much information, the residents learned that the buildings were indeed going to reach the 120-foot mark. The residents happened to be leading members of the Orillia Historical Society and the Orillia Chapter of the Ontario Architectural Conservancy. Jay Cody, president of the Historical Society, made a short but controversial presentation to council January 15, 1973. He suggested the planning department did not want residents to know about the height of the new buildings and that council members should declare any interests they had in building developments. Cody raised several questions about the effects of high-rises on sewage, traffic, and the health of residents. Several Toronto urban planners were claiming that high-rises led to crime and a breakdown of community, and did not make much money for landlords. Supporters of development argued that the city needed more housing. After all, the population was expected to reach 40,000 people by 1985. But the debate really centred on one issue: Orillia's image.

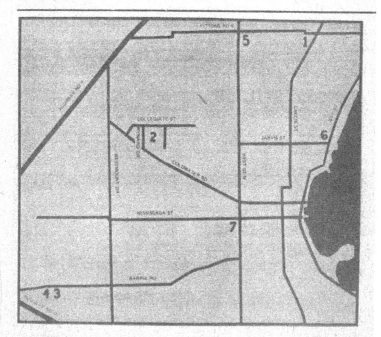

Golden Dragon
(1)
TOPACE Ltd.

OPEN DAILY UNTIL 2 A.M.
Take Out Service
Phone 325-2229

Page
11
Friday,
May 11, 1973

Daily Packe

High Rise Directory

The above map shows the location of high-rise projects either simply proposed by developers, at one of the various stages leading toward final approval and under construction.

ment agreement and site plan bylaws passed by council and all residents within 400 feet of the site are now being notified. If there are objections it will go before an Ontario Municipal Board hearing. Reject-

council it is not subject to the city's new site plan zoning in the annexed area. The developer has now asked for permission to apply for a building permit. Under the terms of the development agreement construc-

(5) APPROVED IN PRINCIPLE — Six-storey, 60-unit block on West St. at Fittons Road. Approved in principle by city council. Development agreement and site plan zoning now being drawn up.

(Above) Jay Cody, right, battled both high-rises and development near the Stephen Leacock home, to keep Orillia's Sunshine Town flavour. The former councillor and director of the Stephen Leacock Museum died in 2011 at the age of eighty-eight.

(Left) Battles over development and the identity of Orillia raged throughout the 1970s and 1980s. The *Packet & Times* counted up all the proposals for readers in May 1973.

"I'm here on a bigger mission … to keep this place like Mariposa," stated Doug Sneyd, leader of Homes or High Rise.

The north warders took their worries to the streets, and in no time had 2,500 names on a petition against the high-rises. The city had a bylaw restricting buildings to thirty-five feet in height, passed many years earlier when firefighting equipment could only reach that high. But that bylaw did not cover the area annexed by the city in 1967.

Supporters of the high-rises argued Orillia needed more rental units, and that the well-off Homes or High Rise members living in the north ward were simply worried about their property values declining if apartment buildings were erected in the neighbourhood. Sitting before council were five plans for apartment buildings, and aldermen were not keen on turning down developers or their tax dollars. Even doctors for the Simcoe County Health Unit joined the fray, telling the city's planning board that high-density apartment buildings caused an increase in mental problems and offered little space or imagination for children.

The two-year fight over the high-rises raised all the questions and prejudices that surfaced when Orillians tangled over their future. Who had the right to speak for Orillians? The longer one's family had lived in Orillia, the more credence one's arguments received. Many of the opponents to high-rises had moved here from Toronto to escape city life. A lot of them had settled in the peaceful north ward. That gave supporters a couple of weapons. How dare outsiders, rich outsiders, tell us how to run their city? "It amazes me all the people who move here from the big city and retired ones who move here don't think we should think like a city but like Stephen Leacock's so-called little sunshine town," wrote one resident to the editor of the *Packet & Times*. Then Stephen Lewis, leader of the Ontario New Democratic Party, publicly stated his opposition to high-rise development in Orillia. That sent high-rise supporters into a frenzy. Not only was Lewis from Toronto, but he was a politician. And not only was he a politician, but he was with the New Democrats. "Who does Stephen Lewis think he is trying to tell us how to live in Orillia?" asked one letter to the editor.

Homes or High Rise, though, had gained support throughout the city. The petition of 2,500 names had several hundred from the south and west wards. "It just happens that I live in an $8,000 home in the South Ward and I am sure that it is as dear to me as those lodgings are to the folks over on the lakeshore. I don't want a high-rise next to my home!" read one letter to the editor, signed by an "Old Low-Downer."

As the debate continued throughout 1973, the two sides became more determined. Homes or High Rise spelled out its fears in a letter to Ontario treasurer John White. Because there was no official plan for the annexed land, residents had no right to appeal a development to the Ontario Municipal Board, said Homes or High Rise. A few days later, White's ministry sent a letter to the city planning board suggesting the city put interim planning controls on the annexed land, or the province might. Homes or High Rise threatened to take the issue to the Ontario Municipal Board if council did not act quickly. In March, council agreed to make developers wishing to build over the thirty-five-foot limit in the annexed area apply for a site zoning bylaw. That meant residents had the right to appeal any development to the Ontario Municipal Board.

Homes or High Rise did not stop there, and throughout 1973 won and lost several battles. Council refused to limit development

in the annexed area to single-family dwellings under thirty-five feet, but turned down one application for an eight-storey apartment. As opposition grew, few high-rises were built.

Council finally got its official plan back from the province, and began considering an overall zoning bylaw for the annexed land. Opposition to high-rises mounted, and five other ratepayer groups joined Homes or High Rise in calling for height restrictions. But council voted 6 to 2 on May 18, 1974, against putting a limit on building height in its zoning bylaw. Homes or High Rise had one chance left. The final vote on the zoning bylaw would not take place until June. By then, eight ratepayer groups, including Homes or High Rise, had joined in one association to fight the high-rises. The groups warned aldermen to change their votes or face defeat in the next election. A poll conducted by the *Packet & Times* showed 60.4 percent in favour of height restrictions. "Orillia's a sunshine town, keep it that way," said one resident polled by the newspaper. The pressure worked. In July, the planning board recommended the thirty-five-foot height restriction be placed on development throughout the city. Council agreed, and put the restriction in its new zoning by-law. But the zoning bylaw still gave council the flexibility to ignore the height restriction if it pleased. That flexibility in the bylaw encouraged developers to continue planning taller buildings. That forced Homes or High Rise into Ontario Municipal Board battles on individual developments. Although they won only a partial battle politically, few high-rises went up over the next few years.

But the issue did not go away. In August 1978, council lifted the restriction in the downtown core to approve plans for a ten-storey, ninety-four-unit apartment building behind City Hall on the site of a former creamery. The proposal was backed by influential Toronto developers Mike Huang and Bela Danczky. But in Orillia, visions of glass and steel boxes competing for space with the city's spires, treetops, and church steeples arose. And so did another opposition group, this time called Save Our City. At eighty-nine-feet high, the ten-storey apartment building would be a foot higher than the Opera House spires, said opponents. They marched in front of the Opera House on Saturdays, hanging a balloon in the sky above the heritage building to show how high the apartment building would be. That debate landed in front of the Ontario Municipal Board. The board ruled in 1979 that council had the right to develop the downtown as it saw fit, despite the thirty-five-foot height restriction. Rising vacancy and interest rates did what the protesters could not, forcing the developer to limit the apartment to seven storeys.

The battle and the furore over the CBC documentary highlighted the city's split personality: half the time looking to shed its Mariposa image and move on, half the time running back to it. Ironically, the city's biggest success in the 1970s came when Orillians returned to the past, in order to get ahead.

By the 1970s, Orillia's downtown was suffering a little from age and the attraction of suburban malls in neighbouring centres, such as Barrie. Downtown was hardly dying, and you could still

Core designer dislikes apartment plan

BY DENNIS SMITH
Packet Staff Reporter

A core redesigner doesn't like the idea of a 10-storey apartment behind the Market Square, even though several of his clients, members of the Downtown Management Board (DMB), favor the proposal.

"An apartment building at the Creamery building site would be like a little CN Tower in the downtown area," said Gary Morrison of Inducon Ltd., designers of a $3.8 million redevelopment plan for the downtown area.

"That site is better-suited for a retail business like a department store, which would be ideal because it would be near the civic square we've proposed. The apartment has merits, but a lot more thought has to go into it."

The apartment proposal and the final redevelopment plan were made public almost simultaneously last week, but DMB members say the two are not connected.

The rental building would have a height of up to 102 feet, several feet taller than the Opera House, which would be the centre of a civic square proposed as part of the redevelopment plan.

MORE PEOPLE DOWNTOWN

DMB members favor the apartment proposal because it will bring more people to the downtown core and improve business on the main street.

"The board favors more residential projects in the downtown area and the upcoming secondary plan will likely encourage this," said Frank Gold, DMB chairman. "Whatever the downtown core can stand, we'll take."

Two others on the board, Gerry Tompkins and Jim Simpson, also said they liked the proposal.

Alderman Dave Macdonald, a planning board member, said the building could fill a need for senior citizens who wanted to live downtown.

"A lot of retired people ask us 'Why don't we have a good apartment building downtown?'" Macdonald said. "They'd prefer a convenient apartment to looking after a house."

Ald. Macdonald isn't worried about added traffic, because he feels most residents would walk to the core area.

Parking would have to be looked at further, he admitted, but he likes the developers' plans for underground parking.

"I think the apartment would fit in well with the civic square proposal," he said. "With the administration building just up from the Opera House, we've already got a mixture of old and new architecture in that area."

The alderman's opinion is not shared by Ken Switzer, a citizen who was involved with the "Homes or Highrise" group in 1974.

TOO TALL

"I'm not opposed to highrises in certain places, but at this height, the apartment would make the Opera House disappear," said Switzer. "I think the proposed building should at least be kept below the top of the Opera House."

Maureen Scott, a director of the Opera House Restoration Foundation agreed the building was too tall for the centre of town. "Maybe the developers will come up with another idea that will benefit the community," she said.

Ken Brown, chairman of the foundation, could not be reached for comment Saturday.

The apartment proposal will be discussed further with city officials. Parking and density of the building will likely be the plan's two main stumbling blocks.

A change in zoning to multiple residential from commercial would be needed, and the city's 35-foot height restriction would have to be waived.

The changes must first go through planning board, and then gain final approval by city council.

Opponents of a plan to build a high-rise apartment building behind the Orillia Opera House in 1978 showed how high cranes and construction would go.

buy everything from hardware to women's clothing within a few blocks. But downtown merchants and professionals figured they had better do something before a mall moved into the city. Former Conservative Cabinet minister Doug Lewis, then a lawyer looking for ways to make his mark, started promoting the Norwich Plan, based on the Norwich Insurance Company of England. That plan called for the painting of brick buildings in a variety of colours to brighten up a city's downtown. With the help of some downtown merchants and professionals, Lewis convinced landlords and tenants to go along with the idea.

The Norwich Plan gave birth to another proposal, with the typically 1970s boosterish name Operation Pride. So proud were downtowners, they closed off the main street, Mississaga, from Peter to West, for two months in the summer to give shoppers time to stroll

under canopies and by flower boxes and, of course, storefronts. It was called the Mariposa Mall and was all very pleasant for two years, 1974 and 1975. But merchants soon learned shoppers wanted parking more than flower boxes. A shopper heading to a mall will park a kilometre away from the entrance without a thought. However, a shopper heading downtown wants to park in front of his or her chosen store, or at least within sight of it. Operation Pride ended when too many people complained about merchants messing with their main street and too many merchants complained about losing their customers.

But the downtown boosters weren't through yet. A few of them discovered a little used part of Ontario's Municipal Act that allowed municipal councils to appoint a board to manage downtowns and provide provincial money for capital projects. Toronto's Bloor Street West had already received money, and Orillia decided to follow that lead. The downtowners set up a management board in 1975, created a business improvement area, and hired a consultant to draw up plans. About thirty members of the Downtown Management Board gave unanimous approval for a $3.8-million, five-year revitalization. The money came from downtown landlords and the province. Over the next two decades, Orillia's downtown changed from the typical cement and concrete, straight and square fashion of the 1950s to a more comfortable-looking blend of cobblestones, benches, flowers, planters, and decorative lighting. Left behind because of dwindling finances was a proposed civic centre stretching from City Hall to the Opera House, which would have included an amphitheatre and public plaza.

The redevelopment occurred just in time. The Orillia Square Mall opened in November 1975, and the economy of the downtown began to hurt soon after. From 1977 to 1978, retail sales in the downtown dropped $20 million as several stores closed. Even some of the old-time stores began to close. Yet, throughout the recession of the early 1980s, downtown redevelopment continued. And the mall was about the only major development in the 1970s that worked.

For a brief, heady period in the middle of the decade, Orillia had two suitors romancing it with promises of giant commercial developments. By playing its cards right, the city managed to lose both of them. The first proposal came from a Toronto development group, Willmore-Trizec, in May 1974. Trizec had built the Yorkdale shopping mall and had plans to put up a 300,000-square-foot shopping centre and 558-unit housing subdivision on a site southwest of Highway 11 and the Coldwater Road. The developers promised the mall would create 400 to 500 new jobs. At the first council meeting on the proposal, spectators crowded into the packed council chambers cheered for the development and booed anyone speaking against it. Twenty years later, city council did back flips to get a developer to build a mall on the same site, but in the 1970s, council held a little more tightly to the dream that industry would someday come to its senses and move to Orillia. The land Willmore-Trizec owned was zoned industrial. And some council members thought it should stay industrial to entice new firms to the city.

Waterfront and downtown renewal moved slowly in the 1970s, '80s, and '90s, but even failed or short-lived efforts saw some changes that led to far bigger successes later. With a push from MP Doug Lewis, the federal government provided $800,000 in 1984 for the breakwater. It never did protect a hotel, as planned, but remained a valuable addition to the waterfront.

A few days after the Trizec proposal, the real estate arm of Canadian Pacific, Marathon Realty, unveiled its plan to build an enclosed mall, hotel, marina, and community civic centre on twelve acres of downtown waterfront. That project would create a minimum of 300 jobs, the developers promised. At the first council meeting on the proposal, spectators crowded into the packed council chambers cheered for this development too, and booed anyone speaking against it.

Each proposal promised a major department store. It appeared Orillia was finally going to boom. The trouble was, with the Orillia Square Mall going up, there was room in town for only one more big player. Marathon immediately asked council to oppose any other large retail projects — in other words, Trizec. As a new council began to consider the two proposals in January 1975, the *Packet & Times* released a poll showing most Orillians favoured the Marathon development on the waterfront. The Trizec plan would pull shoppers away from the downtown, while the Marathon plan would draw them into the core. In the spring, the Chamber of Commerce voted 31 to 5 in favour of Marathon, partly to keep the Trizec land industrial. Yet another newly formed citizens' group, Heart of Orillia, also backed the Marathon proposal.

But Mayor Frank Dolcort suggested Marathon wanted a monopoly and, in what some aldermen called a last-minute surprise vote, council approved an amendment to its official plan to allow the Trizec proposal to go ahead. Marathon asked for at least a hold on development until it completed a feasibility study on the proposal. At the same June 1975 meeting, council turned down the Marathon request and hired a consultant to prepare its official plan amendment for the Trizec development. A month later, Marathon said so long to Orillia. Council continued with the plan to develop the land across Highway 11 with Trizec. But after a year of study, the consultant concluded Orillia could not support another commercial mall such as Trizec's, and the city should concentrate on

A Smaller Dream

Sometimes the smaller dreams have a better chance of coming true.

While the campaign for an Orillia university sputtered throughout the 1970s, a small adult training centre grew into Georgian College's Orillia campus. Under Mayor Isabel Post, the town and school board began adult training in 1963 to help the unemployed and those without proper business and industrial skills. Classes were held in the evenings at Orillia District Collegiate and Vocational Institute. The program grew and, in 1968, was moved to the town's Armoury on West Street, which was renamed the Adult Education Centre.

A year later, Georgian College of Applied Arts and Technology in Barrie took over the 22 courses and 400 students. As the program grew even more, the health classes had to be held in a storefront on Mississaga Street. By the 1970s, courses were taught at five locations in Orillia. The college's quest for a larger, permanent site ran into several barriers, including a city council reluctant to support the college at the expense of the proposed university. But in 1977, the province declared two parcels of land at the Huronia Regional Centre surplus. That cleared the way for Georgian to buy the land, and with a $3.6 million grant from the province, build a $2.6 million facility on Memorial Avenue. Mayor Frank Dolcourt turned the first sod at a November 3, 1978, ceremony, and Premier William Davis opened the campus on April 18, 1980.

developing — what else? — the downtown core. The city kept that study secret for a month or two, but it could not stop the inevitable. After the study became public, Trizec said so long, too.

That was the way it went in the 1970s and 1980s in Orillia. Huge development plans drew huge headlines and, after a few years of excitement, nothing happened. In 1972 and again in 1980, two different developers announced plans to put up commercial complexes on the Tudhope Block. Primesite Developments' 1980 plan was stunning in its immensity. Wiping out twenty-six businesses, including three major industrial employers, five residential units, a church, a bus terminal, and three vacant offices, the commercial plaza would have taken in two blocks bounded by Mississaga Street West, Barrie Road, Andrew Street, and West Street. Only the new Canadian Imperial Bank of Commerce at the corner of Mississaga and West streets would have survived. Such was the optimism only months before the recession hit. Two years later, that proposal too was dead. Primesite could not find a major department store for a tenant and scaled down the plan to a $7.7-million mall. Council refused to allow a small commercial plaza that would compete with, rather than enhance, existing stores downtown.

The failure of the huge commercial ventures grabbed the headlines, but none of the proposals were solid or realistic. And there was worse news, which didn't get the same attention. The city's industrial base was shrinking, especially in relation to the population. In 1966, there were seven Orillia companies with more

than one hundred employees. By 1982, there were five companies with more than one hundred employees, showing a decline in the best-paying, unionized factory jobs. Some of the companies, such as Dorr-Oliver-Long (once the E. Long Ltd.) and Fahramet (formerly Fahralloy), peaked in workforce strength in the late 1970s. But the mining industry, which gave business to Orillia foundries, went flat, and the foundry jobs began to disappear. The recessions of the 1980s and 1990s did even worse damage. By 1995, membership in the United Steelworkers union had dropped so far that the union sold its hall on Gill Street. The population growth of the city also slowed to a crawl, moving up only 2.16 percent from 1971 to 1976.

But in Orillia, you can't keep a good scheme down for long. Once the recession of the early 1980s was over, a flotilla of proposals to make Orillia unique and wonderful again jostled for the public and politicians' favour. With the downtown being redeveloped, and malls out of the question for years, attention turned again to the waterfront. Many residents were angry the city had let Marathon slip away and wanted the mess of old boathouses and a scrapyard owned by the irascible Max Schachter cleaned up. Conservative MPP Al McLean announced the province would hand over $3 million to Orillia for a waterfront marina, on the condition the city assemble the land and the private sector build a hotel. City business leader Ralph Cipolla and his partners in a company called Oldco owned some of the land, and the city encouraged them to work on a proposed convention centre/hotel. The city and the company signed a deal in 1984 to sell their separate parcels of property to a parent company called Newco. That company was made up of Oldco partners, city officials, the city's Economic Development Commission, and immigrant investors grouped together in the Orillia Development Corporation. The Orillia Development Corporation, working with the federal government, had attracted seventeen foreign investors to Canada, offering each one landed immigrant status for a $100,000 investment. "In forty years in business I don't think I've ever seen a project so complicated and complex," said Orillia alderman Jack Andre. "It's a consultants', lawyers', and accountants' paradise." The province handed over half the money, which the city used for a 130-slip marina. The other half was to come with the construction of the hotel. The federal government jumped in with its $800,000 worth in 1984, building a breakwater to protect the slips and the proposed hotel. That was as straightforward as things got. The deal between the city and the developers began to fall apart. Newco, the parent company, hired a consulting firm to look at waterfront development and concluded the costs of developing the land were too high to make any project feasible. City officials and the immigrant investors balked at giving Cipolla and his partners $800,000 in cash and twenty-eight shares in Newco, worth another $700,000, for their property. The remaining members of Newco tried to buy the city's land, but that deal fell apart, too.

The sun, the lake, the Opera House, and, of course, Samuel de Champlain in a plume-feathered cap playing a bagpipe shaped like a perch. The 133 entries for the design of Orillia's flag in a 1984 contest covered all the city's symbols and landmarks. Orillia resident Don Tunstall won the contest with his design, with the waves meeting the sun, symbolizing the city's location on two lakes.

Nothing seemed easy in Orillia in the 1980s. Even championships in sports seemed to draw trouble. The Orillia Terriers won the Senior A Allan Cup in 1972, and the Orillia Travelways won the Centennial Cup in 1985. But the sudden closure of the city's community centre in 1986 disrupted the season of the defending champions, and sparked a fight that still left a bitter taste in opponents' mouths ten years later. And it became a defining round between those in Orillia who resist spending tax dollars and those who encourage it.

Concern surfaced in the mid-1980s that the community centre, the pride of volunteers and a symbol of community, was falling apart. Building and fire codes had changed since the 1950s and since renovations to the building in 1970. A study in the late 1970s gave the arena another five years. It seemed likely in 1985 that the arena needed work. The city hired consulting firm Proctor & Redfern to examine the arena in the fall of 1985. By March the next year, Mayor Ted Emond began warning the public that the arena might have to be shut down, and worried aloud that Orillia might have to build a new one.

Emond had already been meeting privately with investors about building a new arena, and his warnings may have been testing the public for support of a new building. Yet, no one expected the dramatic announcement that came March 12, 1986. Travelways coach Gary Marsh arrived at the arena at 4:30 p.m. to prepare for a playoff game only to find the doors locked. The first look at the consultant's report the night before had prompted council to close the centre immediately. The report concluded the arena was safer than it ever was, but it still failed to meet building and fire codes. Nervous about the building's safety and fearing potential lawsuits, council locked the doors. It was not a popular decision among council members, and Orillia's sports fans couldn't believe it. The closure forced the Travelways to play home games in Gravenhurst and put hundreds of minor hockey players on the bench. Summer lacrosse and ball hockey leagues had nowhere to go. Community groups that used the centre for fundraisers had to look elsewhere. Angriest

of all were the volunteers who built the centre. How could an arena last thirty-five years without any problems then be shut down in a day? they wondered. If it was so unsafe, why did city staff let the report sit on the shelf for a week before council saw it, a week in which 600 people attended a Travelways game?

Council began considering building a new arena. But Alderman Clayt French, who had voted against the closure, insisted a committee be set up to look into the arena issue. French told council in May his own survey showed Orillians favoured rebuilding the old arena by nine to one. He persuaded council to shelve fledgling plans for a new community centre and rebuild the old one for $500,000, with an opening expected in October.

Mayor Ted Emond and Alderman Jerry Wink argued council should build a new centre instead, calling the $500,000 estimate ridiculously low. They were right. The only company that bid for the repairs would have charged $970,000. The city approached three firms to see if they could at least repair the arena's trusses for about $500,000. As fall approached, angry residents pressured council members for a solution. A slight majority of arena users favoured a quick fix instead of a new building, but they all criticized council's lack of direction. The big players, the Junior A club, and Doug Leigh's Mariposa School of Skating called for a new arena. But minor hockey and lacrosse officials wanted the old one repaired. A group of residents calling themselves the Friends of the Community Centre volunteered their time to rebuild the old arena.

The new estimates for the repair work, about $700,000, solved nothing. A report from a second council arena committee said it would cost $1.3 million to fix the old arena properly and about $3.5 million to build a new one on the same site, with government grants available for either project. A third proposal would tear down the walls and roof of the centre and put up a temporary bubble for about $160,000.

The high costs of fixing the old building persuaded council to reverse its earlier decision and build a new centre. Meanwhile the roof of the old one would be torn off and a temporary bubble roof installed. The decision was hardly unanimous. Barely a week after the vote, supporters of the new arena and supporters of the old were caught by the press swearing at each other just after a council meeting ended. The normally quiet Emond and French had a profanity-filled shouting match that prompted an alderman to suggest they carry on in a more appropriate setting, such as the washroom. Council was hardly a year into its term and already bitterly divided.

Things would get worse before they got better. Although council had approved the bubble plan in September, supporters of the old arena continued to lobby aldermen. The $160,000 price tag of the bubble turned out to be unrealistic and now stood at $300,000. Council reversed itself again — residents needed a scorecard by now to keep track of the game — and voted to repair the old arena with $800,000 of city money and $200,000 from the province. French led the fight again for the repairs, promising the arena would need no major renovations for many more years.

The Mariposa School of Skating and the Travelways Junior A team immediately announced they would look elsewhere to set up shop. The news rocked sports-hungry and image-sensitive Orillia. To small communities, Junior A hockey is the pinnacle of big-time sports. The Mariposa School of Skating, eighteen years in Orillia, and its star student Brian Orser, were making Orillia famous. Coach Doug Leigh complained that the city's second ice surface, the Brian Orser arena, was too small for his expanding school. He needed an Olympic-sized ice surface. With a new arena now ten to fifteen years away, it was time to move. He opened negotiations with Barrie, the worst possible news for Orillians.

Travelways president Bob McFadden said he was counting on a new arena to attract more fans and pay off the team's operating deficit. The Travelways played in the lower tier of Junior A, but their success inspired hopes of a major Junior A club in the city. Those hints were enough to get council to set up yet another arena committee, this one to examine building a new arena even while the old one was being repaired. Time was running out. Soldiers' Memorial Hospital was about to launch a major fundraising campaign and no one believed the city would support both at the same time. Alderman French opposed spending $20,000 on the new arena study, saying the city could not afford a new arena, given its high debt. But by the time the old arena opened in February 1987, the momentum for a new arena had risen again. The Chamber of Commerce and Downtown Management Board backed the efforts to build a new arena. Business owners said Leigh and his skating school brought about $1 million a year into the community, the same amount a new arena would likely cost taxpayers.

Several business owners offered to renew pledges, made a year ago, for a new centre. Faced with that kind of pressure, council backed a new, $5 million centre, which would have an Olympic-sized ice rink, 3,000 seats, and meeting and training rooms. The city would have to put up $1 million, a public fundraising campaign another $1.6 million to $2.6 million, and the provincial and federal governments the rest. So unified was council, Alderman French introduced the motion for the new arena. The enemy now was Barrie. The federal and provincial governments suggested only one of the two cities would get substantial funding for an arena that year. Federal sports minister Otto Jelinek sweetened the pot, saying his government wanted to establish a national skating school in the Simcoe County city that offered the best proposal. Barrie had the early edge. While Orillia council waffled about a new arena, Barrie's parks and recreation department wooed Doug Leigh and his skating school. Orillia's parks and recreation department took its direction from council, whereas Barrie's more aggressive city hall staff had been working behind the scenes for four months with Leigh.

Still, Orillia's eleventh-hour fundraising campaign got off to a grand start, with business leaders committing their resources to the effort. Long-time hockey backer Bill Smith began negotiations with the Ontario Hockey League to bring a major Junior A team to Orillia.

Leigh continued to negotiate with Barrie, or as some angry Orillia residents claimed, continued to play the two cities against each other for the best deal. Through 1987, the competing arena campaigns riveted the city. In May, Leigh delivered the bad news — he was taking his school to Barrie. Orillia moaned. Barrie celebrated. It seemed to Orillians once again that Barrie got everything. In the gnashing of teeth and pointing of fingers, a few people suggested that Leigh had never had any real intention of staying in Orillia. Shortly after sparking the campaign for a new arena in Orillia, Leigh had privately signed a letter of intent with Barrie. The Orillia arena would have been larger than Barrie's, but the bigger city to the south offered Leigh a better financial incentive and proximity to Toronto and national media.

Leigh's decision damaged Orillia's pride. Residents believed they had done what Leigh wanted — agreed to build a new arena — yet he still spurned his family of the past eighteen years. Mayor Emond criticized Barrie for spending $1 million in taxpayers' money to lure an industry from a neighbour. Leigh's move to Barrie guaranteed that that city received the federal government's designation of its proposed rink as the national training centre. Watching Leigh build the most successful figure skating school in the country, with Elvis Stojko following Orser's success, was difficult for Orillia sports fans and businessmen. Leigh's departure and official signing with Barrie in July 1987 threw the new Orillia arena into question again. The province contributed about $900,000 to the arena in July, but opposition to a new centre, led again by French, resurfaced.

Brian Orser set off a celebration in Orillia when he won the World Figure Skating Championships in Cincinnati on March 16, 1987. A month later, his coach, Doug Leigh, announced he was moving the Mariposa School of Skating to Barrie.

The bad news for arena supporters came in March 1988, almost two years after the day the old arena was closed. A consultant's study determined Orillia could not raise the $3.5 million for an arena in a fundraising drive, mainly because the hospital campaign had begun. The good news was the city might be able to raise $2 million, and get the rest from the federal government, the report concluded. That was good enough for deputy

mayor Jerry Wink, the biggest supporter of a new arena. But the consultant's recommendations sparked a whole new debate. The report concluded the arena had a lot of support, but French argued an influential minority had biased the consultants. A 5 to 4 council vote kept the arena project on track. Alderman Geoff Hewett, French's ally up to now, voted for the arena. Mayor Emond cast the deciding vote, but made it clear any new arena depended on getting $1.5 million from the federal government. The city applied for the money through the local community futures board, which determined which city projects should get federal money. Two other groups were looking for money, the Orillia Heritage Centre, which hoped to build a huge museum on the waterfront, and the CN Station committee, looking to renovate the old station on Front Street. The board turned the arena down. After three years of nasty arguments and several reversals, a new arena was dead. For his efforts in defeating the new arena proposals, Alderman French had the old community centre unofficially named after him. Residents who shivered in the cold seats called the arena French's folly. That moniker would fade in the next century when a new round of city politicians performed even greater recreation centre follies.

The arena debate set up a battle for the next election between those who wanted to cut spending and those who wanted to spend to spur development. In 1988, Ontario's economy was still booming and Orillia seemed ready to bust out of its long economic hibernation. The city was moving to annex about 3,000 acres of land from Orillia Township, much of it for industrial expansion. Richmond Hill developer Lou Orsi was buying up thousands of acres around the city, obviously optimistic that Orillia would grow. A pro-development faction remained strong on city council. It was led by Mayor Ted Emond, architect behind many of the deals over the past few years. When Emond announced in 1988 he would not run for re-election, his hand-picked successor, Jerry Wink, appeared ready to walk into the mayor's office. Instead, Wink found the doorway blocked by a six-foot, eleven-inch giant with a gravelly voice and his own large hands on the doorknob.

CHAPTER NINE
The Spirit Returns

The handwritten label on the file of newspaper photographs showing John Palmer stepping into the mayor's office said, "Palmer takes charge," and underneath, in parentheses, "God help us all."

The world's tallest free-standing mayor, as a campaigner once called him, struck fear into friends and foe alike. Everything about Palmer was big — his voice, his stomping walk, his clothes, his furniture, his whimsy, his mistakes. His friends worried about the trouble he would get into and the pressure he would bring on himself as mayor. His foes worried about his mercurial temper and occasional blindness to persuasion.

Some wondered how he got elected. The bitterness over the community centre and development in the 1980s had driven city leaders apart. It seemed likely the split between those who favoured large-scale, city-backed growth and those who favoured things staying pretty much the same would carry over into the 1988 election.

Mayor Ted Emond stepped down late in the term to give deputy mayor Jerry Wink a better chance of winning. A city businessman, Wink was in favour of spending money to make money. Council watchers picked him as the early favourite to win. When his opponent for mayor lumbered onto the stage at the first all-candidates' debate in the election, life in Orillia turned into a Leacock story. A former teacher and a newspaper columnist with a loyal following, Palmer had run for council in 1985 but pulled out because of heart problems. Two years later, he led a doomed battle against opening the city landfill site to waste from townships. But as a mayoralty candidate in 1988, he remained an unknown element. Palmer changed that in his first public speech, accusing a shocked Wink of lying, of running the city with an elitist clique, and of drawing grandiose schemes out of a hatful of expensive consultants' studies. Palmer agreed the city needed more industry, but argued it first needed to

protect the 1,500 jobs at the Huronia Regional Centre, which was under pressure to close. It was Ben Johnston and Wib Cramp all over again. His bombastic attacks on the past administration captured the favour of voters sick of the fights over a new arena and bitter over failed development plans. No one really expected Palmer to win, because it was hard to figure out whom he was trying to represent. In some ways he represented what has been called the old guard of the city, those who favour the status quo. Talk surfaced that he and other candidates had gained the support of some Legion members in return for ensuring nothing be built on the land between the Legion and the shoreline of Lake Couchiching. But Palmer played on his style more than his substance. His own promises of a new style of open government took on less importance than his own personal style. He was big but vulnerable, temperamental but generous. Growing up as the biggest kid in the class made him the centre of attention, not all of it good, Palmer once recalled. Everyone wanted to take a shot at the big kid, so he was unwillingly thrust into many schoolyard fights. As big as he was, he knew vulnerability too, Palmer said. And he also knew how to defend himself.

That combination of strength and vulnerability helped get Palmer elected in 1988 and quickly into trouble. The fun began in the winter of 1989, appropriately enough, at the Stephen Leacock home. The home was surrounded by bush and fields, part of Leacock's original property. Only part of the author's property had been obtained by the group that saved the home in the 1950s.

Orillia's seven-foot-tall mayor, John Palmer, strode into all kinds of debates with residents, including a bitter one over a proposed incinerator.

In 1977, Lou Ruby had sold the rest, about twenty-eight acres, to the city. Ten years later, the city asked developers for proposals to build a seniors' village on about eighteen acres of that property. The remaining ten acres would go to the Leacock home. Not a peep of opposition was raised as council announced in the spring of 1988 that Versa-Care Ltd. of Cambridge had won the contract to develop the Leacock property. The development would provide $500,000 in taxes a year, $1 million in construction wages, $350,000 in improvements and services to the Leacock home, and best of all, an

immediate $1.5 million in city coffers. Versa-Care, an experienced developer and operator of seniors' complexes, planned to build a full-service seniors' community, with condos, apartment units, a lodge, and a nursing home. Palmer inherited this plum that seemed to please everyone. Days after he was elected, the first uneasy questions about the development arose. How close would the condos be to the Leacock home? Would the complex destroy the peaceful nature of the grounds? Still confused by the answers, the Leacock home board waited until January 1989 to express worries about the development's borders. It appeared the development would cut through the back of the Leacock home property and destroy the line of cedars Leacock had planted to separate the formal backyard from the farm fields, and keep the servants out of sight of his guests. Suddenly, six city residents started a campaign to stop the development. Palmer was furious. "The deal is made. When I say it's a deal, it's a deal," he told reporters. He called the opponents, the Committee to Protect the Leacock home, a dishonest "self-appointed collection of grand-standers" whose objections were "totally stupid."

The fledgling committee refused to back down. "The land is beyond price," said leader Gwen Richardson, a transplanted Torontonian and teacher. Before long the city was split into two camps over the development and Leacock himself. All the bitterness about Leacock resurfaced. He was nothing but a drunk and a nuisance, said some old-timers. He was a genius, argued others. Palmer's bombast reached new heights as he accused the home's board and

its curator of working with the committee and threatened to cut off their funding. The committee came under fire for refusing to make the names of all its members public. One member, weekly newspaper columnist Rick Webster, charged city council with nothing less than a cover-up over the shady deal. "Two city councils seem to have left their brains in bed," he wrote.

As winter turned to spring, and an appeal of the development headed to an Ontario Municipal Board hearing, the plot's twists and turns filled the front pages of the local newspapers and the letters to the editor. One Leacock board member quit to join the committee to save the home, charging the board was nothing more than a social club that did not have the courage to bite the hand that fed it. Alderman Fayne Bullen's wife, Vera, was chairman of the home board, complicating matters even more. Simcoe North MP Doug Lewis entered the fray and made a point of publicly refusing to help save the property. The board had done nothing to promote itself in twenty years and would not get his help now, said Lewis. Curator Jay Cody arranged a meeting with Lewis to talk about the federal government taking over the home, sparking another tempest at council. National media figures joined the fight. Humourist Gary Lautens, writer Lloyd Dennis, and McClelland & Stewart editor David Staines backed the Committee to Save the Home. Even an exasperated Palmer and an amused Richardson had to admit the battle was one of the craziest things they'd ever seen. "I wish Leacock was here to write about it," Richardson told reporters.

The Ontario Municipal Board hearing maintained the high emotions of the battle. Versa-Care planners called the Leacock property scrubby and garbage-filled. An emigrant from Europe testified that as children, she and her sisters had huddled under the bed covers reading Leacock's *Sunshine Sketches of a Little Town* and dreamed of someday living in Canada. Consultants and planners played down the significance of Leacock and the home. Writers and editors testified Leacock was the most popular Canadian writer in history. One resident presented his dog, named after a Leacock character, as evidence. The Ontario Municipal Board chairman took the rare step of visiting the home, where an angry planner assailed a photographer for taking pictures of the group.

Each day's hearing in the council chambers of the Opera House drew a packed house, which booed their villains and applauded their heroes. Crusty city lawyer Wharton "Rusty" Russell and Terry Hunter, lawyer for the Committee to Save the Home, attacked opposing witnesses with glee, rolling their eyes in scepticism at some remarks, playing the crowd, putting everything into a performance that had much fewer constraints than a courtroom proceeding. At stake were Leacock's archives, 100-year-old trees, and one of the few waterfront parks left in the city, argued committee witnesses, including editor Staines. At stake were hundreds of thousands of dollars and the city's credibility, argued city and Versa-Care witnesses. Despite the emotional appeals, the issue came down to planning, and the Ontario Municipal Board

ruled the city had followed its tangle of land-use plans correctly in allowing the development. Versa-Care was allowed to build.

As fierce as it was, the battle over the Versa-Care development was quickly overwhelmed by other controversies during Palmer's term as mayor. Over the next two years, council and Orillia grew even more divided. The budget-conscious council members, especially deputy mayor Clayt French, favoured slow growth and the maintenance of Orillia's small-town appeal, although not necessarily promoting that appeal to tourists. French opposed putting city money into an airport, and letting a developer build on the waterfront. More aggressive businessmen on council, led by Alderman Geoff Hewett, tried in vain to persuade council to put more city money into projects. Palmer generally favoured slow growth, but one could never tell where he stood. Reporters learned to put down their pens when they made their first call to the mayor in the morning. Often they woke him up and in his gravelling voice, Palmer made little sense. Only when an alarmed Palmer called back to find out what he had said did reporters take notes. Throughout council's term, French gathered more power. His biggest weapon against spending was the city's huge debt. French made a visit to the *Packet*'s publisher each spring at budget time with the latest dire figures, just to make sure the newspaper understood the necessity of making cuts in spending. Tracing the city's debt is a difficult task. Several times in its history, the province had warned Orillia that its debt was too high. The city was faced with the costs of servicing the land annexed in 1967,

and upgrading water treatment and waste water plants. At the same time, the industrial tax base had shrunk, making it harder for the city to keep up its infrastructure without borrowing more money.

Given the economic squeeze, city council was pleased to announce in April 1990 that it had agreed in principle to let a New Jersey waste company, Ogden Martin Systems Ltd., build a $500-million incinerator in the Sunshine City. Few controversies in Orillia's history raised as much anger, craziness, and bitterness as the proposed incinerator. It may have claimed the life of the mayor; it certainly wounded whatever trust the public had in its politicians.

Nothing prepared Orillia for the impact of the fight that first day. City council members had met Ogden Martin officials only three times before secretly approving the proposal. When they unanimously passed the public resolution welcoming the waste giant, aldermen from all camps praised the plan. The energy-from-waste plant would provide $1.5 million a year in business and property taxes and create 150 jobs. The plant's production of 75,000 kilowatts of electricity could quench the entire city's thirst for electricity. Businessmen and other community leaders applauded the plan. A few environmentalists condemned incineration, saying it produced toxic by-products and discouraged recycling, but their voices were smothered by a chorus of approval. In those days in Orillia, finding a local environmentalist to comment taxed the resources of the *Packet & Times* newsroom. There just weren't many around. Besides, company pamphlets assured everyone that incineration was so safe, a person had a greater risk of getting sick from eating peanut butter sandwiches each day than living near an incinerator. The emissions would be cleaner than the air around the plant, they said. And for a couple of weeks, at least, Orillia residents took Ogden Martin at its word. At a public meeting and in letters to the editor, most people, even members of a group fighting a dump in a nearby quarry, backed the incinerator. It was easy to understand why. Orillia's landfill site sits on Lake Simcoe, and there were fears that contaminants might leak into the lake. An incinerator seemed to solve the worries over burying garbage.

Then, quietly, almost unnoticed by the media, a few city residents began questioning incineration. A *Packet* reporter attended a meeting on incinerators in Toronto and reported the fears of environmentalists there. A few more letters to the editor appeared, and the group opposed to the quarry landfill, Citizens Against Metro Garbage, announced it was against incineration as well. If Palmer figured incineration would be an easy sell, he got a bit of a shock at a May luncheon of the Kiwanis Club, hardly the place where revolutions usually begin. Several Kiwanis Club members, business people mainly, pressed Palmer for assurances the incinerator would be clean and safe. In a typical Palmer reply, the mayor waved away opposition with his big hands and bigger statements.

"In a year, you'll forget it is there. From the outside, it will look like the local high schools. It is the way of the future."

From that day in May 1990, the smouldering opposition to the incinerator began to catch fire. A day later, both the Economic

Development Commission and Citizens Against Metro Garbage hosted separate public information meetings on the incinerator. About 130 people listened with scepticism to Ogden Martin officials pitch their plant, while 200 people listened attentively to Toronto environmentalists sound warnings about incineration. A new group, Stop Incineration Now, sprang up and drew 400 people to its inaugural meeting. One mother vowed, to thunderous applause, she would not let incineration ruin the health of city children. Palmer showed up briefly to tell the crowd he was hurt by talk that he wanted to harm children. The mayor was heading into this battle the same way he did in the Versa-Care issue, with his heart on his rolled-up sleeves and his reputation on the line.

As opposition grew over the spring and summer, council dug in its heels. For the first time in a long time, council stuck together. At first, council members argued residents should wait for more information before making up their minds. But the more information and questions that arose, the more insistent council members became that they knew what was best. The city faced a garbage crisis, and a minority of rabble-rousers, with no better ideas, were making trouble, insisted council members.

In an unusual move for a tight-fisted Thomson newspaper, the *Packet & Times* sent two reporters to Indianapolis, Indiana, for a week to examine an Ogden Martin incinerator. In all the numbers, comments, descriptions, and photographs they brought back, a simple photograph and a typographical error sent a chilling message to

The author was photographed by fellow *Packet & Times* reporter Mark Bisset on a tour of Ogden Martin's incinerator in Indianapolis, Indiana. The burn was supposed to be so clean that nothing but ash was left, but images of grass and other items at the plant preyed on the minds of Orillians worried about their health.

Orillians. After five days of negotiating, the two reporters had managed to get a tour of the ash site, where waste from the incineration was stored. Ogden Martin officials had claimed that incineration burns so cleanly that nothing is left but ash. Evidence of an incomplete burn could mean dioxins and other pollutants were released during incineration. At the ash site, reporter Mark Bisset and this author noticed a lot more than ash left over — grass, pieces of carpet, even bits of newspaper. With an official busy elsewhere, Bisset snapped a photograph of his colleague holding a clump of grass found in the ash. When the photograph appeared on the front page, it carried a sentence that was supposed to end in a question mark.

Instead, in no uncertain terms, the photograph's caption officially proclaimed the grass was "a link between incineration and dioxins." Environmentalists seized the photograph as proof of their fears.

Still, dozens of protests and meetings with so-called experts on either side could not persuade a wary public that incineration was either totally bad or totally good. Tempers flared throughout June and July. About eighty high school students left their classes and persuaded Mayor Palmer to meet them in front of City Hall by pretending they wanted a civics lesson. Instead they greeted the mayor with chants and protest signs. An angry Palmer suggested he would shoot every one of them if they had skipped his class for such a protest, prompting a protest over his protest of their protest. Orillia had not seen this many demonstrations since the Homes or High Rise protests in the 1970s. Council members said they were called names, harassed, and phoned in the middle of the night with threats. Yet aldermen insisted only a minority opposed the incinerator, and planned a public forum in August to present all the facts. Their train was derailed in mid-June, when rookie alderman Josephine Martensson suddenly announced she was opposed to the incinerator because of the health risks. Her fellow council members charged Martensson with grandstanding and said she hadn't thought it through. At a council meeting a few weeks later, deputy mayor Clayt French told an alderman that Martensson should be kept out of all future meetings on the incinerator. Television microphones picked up the comment, sparking another uproar.

Then came the worst news of all for council. The Orillia Medical Society released a twenty-page report calling incineration harmful and dangerous. Council members sputtered that the doctors were using scare tactics, and their arguments began to border on the hysterical, not to mention racist: the incinerator would promote health because of the parks the tax money would buy; the Japanese have lots of incinerators and they are more intelligent than Canadians. About 600 people gave Dr. Donald Philpott a standing ovation when he presented the report to the public on June 27 at a high school gym. For the next week, doctors and nurses told their patients incineration was unhealthy.

At a Monday, July 9, council meeting, a volunteer group of pollsters presented council with the results of a random phone survey. About 75 percent of 4,300 residents called were opposed to the incinerator, 10 percent supported it and 15 percent were undecided. The same night, Stop Incineration Now handed over a petition signed by 8,870 people against the incinerator. For the first time, council admitted there was no silent majority supporting the incinerator. Four days later, council voted to reject a deal with Ogden Martin. Council did not reject incineration as a way of dealing with city garbage, just the handling of Toronto's waste. Behind the scenes, Alderman Hewett had told council he was ready to publicly oppose incineration because of the overwhelming opposition to it. Faced with crumbling support within their own ranks, council members decided to save some face and kill the proposal. It was hardly a unanimous decision.

"I'm so damn fed up with what they did," Palmer said. "They get someone yelling at them and they bend over and surrender."

Some Orillians say Palmer never got over the incinerator debate. "I could find far more attractive ways to fall on my face," he told a reporter. A month later, Orillia's giant complained about pains in his leg and had to undergo surgery for two aneurysms, a weakening and ballooning of the arteries that can be fatal. His lungs collapsed once and congestion sent him back to hospital, but Palmer managed to make it home to Orillia in September, and showed some progress. But his body never recovered from the strain of the operations. The city woke up Friday, September 28, to learn Palmer, 65, had died at 4 a.m. that morning. His heart had given out. Palmer's death shocked his friends and adversaries alike. The rumbling and rambling giant mayor seemed as if he would go on forever, and no one doubted his sincerity. Many still blame the stress of his two years as mayor as the main reason for his illness and death. Palmer took every argument, off-hand remark, and news report to heart, and it was his heart that finally gave up.

The incinerator debate influenced Orillia in several other ways. The environmental movement born of the fight refused to fade away. Some Stop Incineration Now members formed Citizens Acting Now, a group that helped force the city to adopt a waste management advisory council and a waste management plan that made Orillia a leading recycler in Ontario. The life of the landfill site on Lake Simcoe was extended, thanks to the diversion of waste.

Palmer's death also cleared the arena for a full-scale battle over the shape of Orillia. Palmer was closer to deputy mayor French in philosophy, but his changing moods made it difficult for French, already in charge of the budget, to win every battle. When Palmer died, it was as if a distraction had been removed for the two most popular aldermen in the city — French and Hewett. They immediately clashed over the waterfront. With Palmer as mayor, council had agreed to expropriate about two acres of the land owned by business person Ralph Cipolla and his partners for a park. Cipolla was bitterly opposed to the expropriation. Hewett disagreed with expropriation and fought for a mixed development, with a privately run hotel on one half of the waterfront and a park on the other, with a public boardwalk in front of both. French and Hewett tangled over the waterfront all term, even as the slow process of expropriation continued. Hewett made halting the expropriation the key platform of his run for mayor in 1991. French wore the mantle of the saviour of the waterfront for the public, although he had previously supported the Versa-Care development on the Leacock waterfront and expropriation ran counter to his chief platform, cutting city expenses. It was a nasty campaign, with each candidate throwing mud at the other, then complaining about it to the press. Each accused the other of representing — what else? — those old "special interests," and, in a sense, they were right. A member of the old guard and a conservative, French had the support of many seniors opposed to waterfront development and spending of any

kind. A member of a group of business people that met frequently to discuss city issues, Hewett had the support of younger leaders impatient to get on with expansion. Hewett lost mainly because his timing was bad, and people in Orillia trusted a business leader less than the grandfatherly French. By 1991, the city's brief economic boom had died, and taxpayers no longer liked the idea of high spending. As it had been for many years, the average household income in Orillia was low, far behind those of Barrie, Simcoe County, and Orillia Township (now the Township of Severn). The lower-than-average income was due in part to a large population of seniors on fixed incomes, but 60 percent of the workforce had jobs in the two lowest paying sectors: tourism and retail, and trades. In a 1991 survey, residents put affordable housing and poverty at the top of a list of serious problems in the city. In the twelve months leading up to the 1991 fall election, about 800 Orillians had lost their jobs. With that kind of outlook, and a recession deepening, residents gave French and his promise to cut taxes an overwhelming election win in 1991. Staying the course and ruffling few feathers earned French and many of his incumbent aldermen another win in 1994.

Several aldermen on those councils had been through the incinerator wars together, and the longer they served together, the more cohesive they became. With a powerful mayor at the head of council, a loyal core of aldermen, and a public nervous of spending, city council turned into a homogeneous group that did most of its business in private sessions. The debates in Orillia in the mid-1990s did

The opening of the OPP headquarters in 1995 provided secure and high-paying jobs to a city that had seen manufacturing decline.

not come from within council but from the public and media. Those debates lacked the ferocity of the incinerator battle, and, without a business leader on council, the intensity of the waterfront fights.

For example, council decided in 1995 to disband the local police force and negotiate a contract with the Ontario Provincial Police to take over city policing. It wasn't the first time that council had considered disbanding the force. In 1949, the town had briefly entertained the idea of having the Ontario Provincial Police take over policing to save money. This time, French's oft-repeated promise that the move

would save the city $800,000 persuaded the police board and council to disband the city force. A brief flare-up of public opposition fizzled under council's determination to save money. A small burst of public resentment over a new waterfront park fizzled just as quickly. Council had promised to hold a meeting on the proposed design of the park after expropriation was approved. The city began building the park without holding that meeting. When a meeting was finally held in the fall of 1995, months after an amphitheatre and trail had been built, it was too late for critics to have much of an impact.

Neither the city's leaders nor its ordinary citizens had much to do with the start of the two largest developments of the 1990s — the building of the OPP headquarters and the Native casino in Rama. The province decided in May 1990 to move the OPP headquarters and the administration department for the ministry of the solicitor general from several buildings throughout Metro Toronto to Orillia. The city's location at the junction of Highways 11 and 12 and the large property already owned by the province at the Huronia Regional Centre helped Orillia get the OPP headquarters. Orillia's leaders had little to do with the decision, besides welcoming the 900 employees and the more than $35-million-a-year payroll.

City council had even less to do with the province's decision to allow the Chippewas of Rama First Nation to build and operate a casino and resort. In fact, many council members first opposed the casino, finally approving it in a private session just before the province chose which band would get permission.

Council made some moves in the late 1990s that helped the city; for example, persuading one of the city's largest industries, Hunter Enterprises, to build a new factory instead of moving elsewhere. The deal included the city's purchase of the Hunter plant — the old Tudhope car factory — for $1 million.

None of these issues — the mall, the park on the waterfront — greatly captured the public's interest or imagination. It left some to wonder what had happened to the Orillia Spirit that had inspired great accomplishments and wild debates for the past 150 years. Was it dying? The answer came from two sources, with irony attached to each: that old eccentric Stephen Leacock and the Chippewa who were forced to leave Orillia more than 150 years earlier.

Leacock inspired one of the most unified moments in Orillia's history, in a typically simple way. C.H. Hale., J.B. Tudhope, Pete McGarvey, Ruth Jones, Sue Mulcahy, Mac Carter — they all launched their quests with a simple question: "Why don't we…?" So did Jim Dykes in 1994. Trying to sell his canteen service to the Leacock Museum, a naive Dykes asked to see the boathouse he had admired in Karsh photographs of Leacock at his Orillia summer home. He was told the boathouse had fallen into disrepair after Leacock's death and efforts to convince the politicians to help fix it had failed.

"Why don't we do it ourselves?" Dykes asked Leacock Museum curator Daphne Mainprize. He soon forgot he had asked, until several months later, when Mainprize told him the museum board was ready to hear his proposal. Dykes quickly put together a presentation for a

January 1995 board meeting. His idea received the board's approval. Dykes then went to city council. He stressed that no politicians would have to be involved and no public money spent. Council approved the plan. For the next nine months, Dykes and contractor Jim Storey signed up volunteers and construction companies, pressed the flesh at dozens of city functions, and cajoled the media into making the campaign a priority. The idea snowballed. Perhaps because few had seen it, the boathouse had always held a certain mystery for Orillians. Leacock often sought the quiet of his two-storey boathouse to write early in the morning. The image of the writer at his large table on the second floor, writing sentences that would delight the world, gave the small building more cachet than any ordinary boathouse.

And the reconstruction would be nothing ordinary. Organizers insisted the reconstruction be an old-fashioned barn raising, with entertainment, food, and the entire city invited out to lend a hand. More groups and donations came on board throughout the summer. Typically, a little doubt and scepticism arose. How could they build a boathouse in one weekend? Where was all the money going? Dykes dismissed the rumours as last-minute nervousness on the part of Orillians. In the weeks before September 9 and 10, 1995, construction crews readied the site. When the sun rose on Saturday, September 9, a flat, concrete pad welcomed the first set of sleepy workers. When the sun set on Sunday, the boathouse was up. The sunny, two-day "barn raising" drew about 5,000 adults and children to help, watch, and celebrate. What made the accomplishment

About 5,000 people spent a weekend in September 1995 raising a replica of Stephen Leacock's boathouse, a remarkable achievement and a modern-day example of the Orillia Spirit.

even greater was that it took place on Leacock's property. It was the first time since the home was bought that Orillians of all stripes shared the same opinion about the old drunk/genius — he was worth something. For many Orillians, it was the first time they had stepped on the Leacock property. The barn raising may have given Orillians a sense they own and are responsible for the home of their most famous citizen. It certainly gave them, for a weekend at least, a sense they own and have a responsibility for the Orillia Spirit.

That spirit was shown again the next year. Months after the Chippewas of Rama First Nation and Carnival Casinos began building a temporary casino, the Conservative provincial government ordered construction to stop. The government said it was nervous about proceeding without certain agreements signed, but the real reason behind the shut-down was the government's desire to change the financial arrangement. The previous NDP government had decided not to take a percentage of the revenues, to give Ontario's First Nations more of the pot they would share. The Conservatives decided to change the deal and demanded a 20 percent share of gross revenues.

The provincial Conservatives had received nothing but the blessings of Orillians for the past sixty years. But shocked business leaders, would-be casino workers, merchants, and municipal politicians all cried foul. About 700 showed up to a news conference at the casino site to show their support, and dozens wrote letters to Conservative Cabinet ministers in protest. About a month after the shut-down, the province and casino officials signed the outstanding agreements, and the province agreed to let construction resume while negotiating the stickier issue of revenue sharing. It was likely the first time since white settlers forced the Chippewa out of Orillia in 1836 that the two communities had united in such strength.

In the show of strength across The Narrows at Rama, and in the boathouse building, the Orillia Spirit seemed alive and well. It took only a couple of years for the rambunctious, and occasionally damaging, side of that spirit to show itself. A veteran of many political battles, Clayt French was thinking of not running for re-election in the 1997 mayoral election. He almost changed his mind when he saw who was running, the chair of the Orillia Water, Light, and Power Commission, Ken McCann.

The two had clashed over the future of the OWLP, which had to change under new provincial rules deregulating electrical production in Ontario. There was a personality clash as well, expressed by French in his typically understated manner: "I don't subscribe to his management style."

McCann was well known to Orillians as the contractor who inspired more than 500 skilled volunteers to build a home for a burn victim, Joe Philion, in 1989. Popular and a populist, McCann rallied ordinary Orillians to kick out the special interest groups and the old guard running the city.

"The majority of this town feel they're being muzzled to death," McCann said, echoing the platforms of Wib Cramp and Ben Johnson before him.

"After two terms you should be out. You don't have new ideas and the vision we need to carry on." McCann expressed special disgust at the Mayor's Action Group, a group of business leaders who met privately with the mayor. "I need a completely open council accountable to all the people," he declared.

As they had done occasionally in the past, Orillians decided a housecleaning was due, and gave McCann 40 percent of their vote in a five-way race that included two council members. Only two incumbents

on council returned, and defeated and successful candidates agreed the election was a resounding rejection of the previous council.

"It's going to be a fun ride. Buckle up," the fifty-three-year-old McCann said on election night.

It was a ride. Within days of taking office, McCann moved the mayor's office to the ground floor of city hall to be closer to the people. Over the next three years McCann took it upon himself to bring jobs to the city. He had council approve the Mayor's Initiative fund so he had money to travel and pitch Orillia to companies. He had the city put up a ten- by thirty-two-foot billboard on Highway 11, showing his smiling face and the words "Mayor Ken McCann wants industry for Orillia." His micromanaging and interference prompted the manager and three employees of the independent Economic Development Commission to resign. His aggressive style offended several council members and some senior staff. He threatened to have council members who didn't treat him with respect expelled from meetings. He declared himself the city's chief executive officer and that all council members worked for him.

"As far as I'm concerned, he declared himself dictator and we might as well pack up and go," Alderman Mary Lou Kirby said.

As McCann's term neared an end, he declared he would not run again, then hinted he would, prompting a *Packet & Times* reporter to present the mayor with a Bible on which to swear he wasn't running. McCann declined, saying it would be sacrilegious. He did end up leaving in September 2000 for a job with the Ontario Energy Board. McCann was credited for bringing jobs to the city and opening up city hall. But he left a bitterly divided, shell-shocked council and an economic development commission in tatters. His strain of the Orillia Spirit — some would call it straightforward and enthusiastic, others bullheaded to the point of recklessness — also seemed to leave Orillians a little bored or maybe discouraged about civic politics. Although five people ran for mayor in the 2000 election, voter turnout — about 40 percent — was the lowest in twenty years. Ron Stevens, an eighteen-year-veteran of politics in Severn Township, including service as mayor, won the election with a measured, managerial, and courteous approach to politics. With a council made up largely of veteran politicians and a few newcomers, it seemed Orillia was ready for a few relaxing years. Dull even. Then that old spirit rose again.

CHAPTER TEN

Haunting Dreams

A dream for a dollar. Not just any dream, but *the* dream.

The long unfulfilled, tortuous desire to finally, finally shed the humiliation and frustration of being lesser than others and put Orillia on an equal footing with dozens of other bigger and smaller communities. For $1, Molson Canada would sell thirty-six acres of land close to downtown to the city. After decades of waiting, Orillia could get a recreation centre.

So the new century and new millennium began.

The effort to build what became known by its acronym, MURF, (multi-use recreation facility) defined much of what happened in Orillia and its enduring spirit in the first decade and a half of the 2000s. In sixteen years, the city shed many of its past disappointments and realized many of its other long-sought dreams: a university, the return and success of the Mariposa Folk Festival, an expanded hospital, a new public library, and a renovated art gallery and museum.

Development on the west side of Highway 11 exploded with houses and big-box stores, but the 320-acre Scout Valley forest was saved from having a sewer line go through it, and placed under ninety-nine years of protection through the Couchiching Conservancy.

The downtown continued to attract restaurants and boutique stores. Condos sprang up on the waterfront and the Millennium Trail — a 9.5-kilometre, paved trail along the waterfront built by volunteers and volunteer donations — was completed.

Balancing all that positive news was the MURF. The story of the MURF touched upon almost every new and old story of Orillia: the divide between east and west, and north and south; the location of Lakehead University; the ghosts of the industrial past and the prize still to be taken — the 151 acres of land along Lake Simcoe where the Huronia Regional Centre stood. Anger, absurdity, determination, frustration, councils elected and rejected, rallies for and

against, and rivers of ink and bytes used: the battle of the MURF reflected every aspect of the Orillia Spirit, the best and the worst.

As a Stephen Leacock tale, the skeleton of the narrative would be this: Orillia decided in 2000 to build its MURF on an old factory site without knowing too much about the site, spent eight years and millions of dollars on that site to get clearance to build on its dangerous chemical debris, and, as soon as it got clearance, rejected that site, and chose a second site. Then it rejected the second site and chose a third across the road from the contaminated first site. Then the city rejected that third site and fifteen years after choosing the first site, chose it again. Fifteen years to go around in a circle.

If a numbers crunchers told the story, it would include the figure 1,740. That is the number of times the acronym was mentioned in the *Packet & Times* from 2000 to 2016, according to the archives service Infomart. The by-the-numbers account would include the rising cost estimates that flew so alarmingly high that city hall simply stopped looking up. It would include the countless premature proclamations of success. It would include the 5,044 days (thirteen full years, three of them leap years, and two partial years) from the December 2, 2002, announcement that Molson was donating the land to the September 28, 2016, groundbreaking ceremony.

The story starts with an example of the Orillia Spirit. The idea to build a recreation centre on a brownfield came from an ordinary citizen wondering, why not? Glen Connor came from a long line of ground-level political scientists. For decades, the Connor tire garage on Memorial Avenue hosted regular gatherings of customers and employees who discussed the politics of the day. A popular topic among Orillians had always been the old community centre, patched up several times since it was saved in the 1990s and a new recreation centre proposal rejected. Nothing much had changed as the century turned, except a curling club was built in Tudhope Park after one had closed ten years earlier. The community centre still needed patching up and people still talked about the need to replace it.

That talk grew more focused in 2001 when it became clear the centre needed about $2.6 million in repairs over the next few years, after sucking up almost the same amount over the past twenty. Connor floated the idea of building a recreation centre on the former Otaco iron foundry on West Street, close to downtown and on a major road with transit service.

The city planning department gave initial support, noting there was "a minor issue of contamination" in one spot of the brownfield where Otaco had built everything from Mosquito Bomber undercarriages and farm implements to stoves and toys from 1910 to 1990. Molson conducted its own soil tests in March 2002, and officially announced in December 2002 that it was transferring the site to the city, for $1, for a future recreation centre. All Molson wanted in return was naming rights, special consideration for selling beer, and a $500,000 tax receipt. Orillia's leaders celebrated.

"This is an important and exciting day for Orillia," Mayor Ron Stevens told the *Packet & Times*. "It's the most positive day

for Orillia in a long, long time," downtown business person Ralph Cipolla, who helped broker the deal, exulted. "It's a great day for Orillia and area. There is no downside to the announcement," the *Packet & Times* stated, listing the benefits of the site. "For the first time in almost two decades, a full-scale rec centre seems to be not just a far off dream, but a certainty."

In retrospect, on the one hand, it's easy to smile at the early optimism. On the other hand, without that Orillia optimism, the dream wouldn't have survived the next troubling decade. "Even the sole problem with the site — contaminated soil left by the foundry that once occupied the land — appears to be easily resolved," the *Packet & Times* editorial said.

Before building could start, the city had to conduct an environmental assessment and present a plan for managing contaminants from the foundry to the province's Ministry of the Environment. That assessment, city officials figured, would cost about $250,000.

It didn't take long for the two streams of contaminants — money and dirt — to ooze into and weaken the dream. Less than a year after that first celebration, the price tag had risen dramatically, from an estimated $18.7 million in 2002 to $47 million a year later. Rumours began surfacing about what was in an environmental assessment report Molson had commissioned in 2002. None of that seemed too troubling. In spring 2004, council made a few cuts to the budget to bring the price tag down to about $45.5 million. The bulk of the money would pay for the eight-lane pool, double gym, twin-pad arena, indoor track, multi-purpose space, and outdoor tennis courts, baseball diamonds, playground, splash pad, and basketball court. About $4.5 million would cover environmental management. As for the contamination in the soil, Molson released its report to the public. The soil contained heavy metals, PCBs, and hydrocarbons, but an environmental consultant told council the contaminants could be capped with a woven plastic barrier topped with clay, granular material, and soil.

Orillia's strong environmental community wasn't so sure about that. The rallies began small in summer 2004, protesting a plan to ship 40,000 tonnes of contaminated soil from the site to the city's landfill on Lake Simcoe, and raising questions about the extent of the chemicals on the site.

Council more or less ignored the concerns. Much more initial effort was expended on debating the fate of a wetland on the site and a nesting grounds for turtles. The wetland was eventually filled in but conservationists saved about fifty turtles.

But questions grew. By the time the issue was raised in the Ontario legislature in fall 2004, the *Packet & Times* was already labelling it a "controversial recreation project." The battles over the costs and the environment waged for the next several years. A group called the Citizens' Coalition battled the city in court over the right to test the soil heading to the landfill and the need for a full environmental assessment of the project, a far more costly,

exhaustive, and time-consuming evaluation than the city's plan to do a risk assessment and risk management plan for the site. By early 2005, Mayor Stevens was so concerned about the environmental challenges that he penned an open letter, published on the front page of the *Packet & Times*, reassuring citizens the city was "taking every precaution to ensure the MURF site will be safe."

Tests on the site weren't as reassuring. An electromagnetic geophysical survey found evidence of metallic objects. Further tests, including drilling boreholes, were ordered. Ontario's Ministry of the Environment gave an early warning sign of what was to come in March 2005 when it suggested more tests and more safeguards were necessary, based on the city's initial risk assessment plans. Still, council members remained confident in the West Street site. There seemed to be a truce in the works when council, under obligation from the province's new rules for public involvement in brownfield development, invited environmentalists to a twelve-person committee overseeing cleanup of the site.

But every time council seemed to put a lid on contamination concerns, a new one leached out. A hot spot of vinyl chloride at levels 40,000 times the provincial guidelines was found exactly where the swimming pool, arena, and gymnasium were to be built. In August 2005, the Ministry of the Environment ordered the city to submit a revised plan for dealing with contaminants and more testing to assess the extent of the vinyl chloride, which was not so much a hot spot as a plume drifting beyond the site's boundaries.

The problems prompted two council members to suggest the city look at an entirely new site, acreage recently purchased on the other side of Highway 11 — the 134-acre Horne farm. The news kept getting worse for supporters of the downtown area site. Ontario's environmental commissioner slammed the city for its treatment of the public. "The perceived lack of information and lack of consultation has generated concern and suspicion within the community," commissioner Gord Miller wrote in his 2005 annual report.

And the battle continued into 2006, and 2007, and right through to 2012. (Readers are free to skip several pages, but here's a spoiler alert: nothing much changes.) Downtown business owners banded together in 2006 to push for the MURF near the city core. On display in their stores were signs that read "MURF … coming in 2008." About the same time, even higher concentrations of tetrachloroethylene (TCE) and its derivative, the vinyl chloride, all considered volatile organic compounds (VOC), were found. The war was turning into a battle of acronyms and science that was getting more difficult for people to follow.

The Ministry of the Environment continued to make life difficult for the city, telling officials in spring 2006 that they had to resubmit a risk assessment because the information was out of date or inadequate. "How many times do we need to do this? We're trying to do everything physically and honestly possible," MURF booster and councillor Ralph Cipolla said.

Meanwhile, through all the turmoil, a fundraising campaign called Your Community in Motion, Building our MURF, continued to raise money. It might have been more suitably called Your MURF in Motion. To allay some concerns, council decided to shift the complex away from the most contaminated spot on the property, at a cost of about $1.5 million. The municipal election in 2006 changed nothing, including the continued ambiguous feelings about the MURF. The mayor who supported the West Street MURF site, Ron Stevens, was elected a third straight time. A councillor who led the charge against the MURF was defeated and replaced by a councillor who supported the MURF. The biggest vote-getter among councillors was one who supported the MURF. But none of the four newcomers were totally sold on the project.

And so 2007 continued on the same way as 2006. In successive stories, the estimated price tag went up again, to $55 million, then $57 million, then $58 million. And again, the Ministry of the Environment sent the city's risk assessment back for revisions, saying there were still some issues to be addressed. And again, proponents expressed optimism it wouldn't be much longer before construction would begin. "I'm a lot more confident now than I was before," councillor Ralph Cipolla said after council voted 7 to 2 in July 2007 to send a revised risk assessment back to the province. Council was hoping the project would go to tender in January 2008. That time rolled around and politicians were still arguing about the ever-growing price tag, now up to $64.3 million.

At times, the estimates seemed picked out of the sky. Only a few months later, opponents were saying the price was $77.5 million. More than 200 alarmed Orillia taxpayers gathered at a meeting in March to express their dismay and try to get answers.

Then, the inevitable happened. In March 2008, the Ministry of the Environment sent Orillia's third submission of its risk assessment back with requests for changes. That was simply too much to handle. City hall staff presented politicians with several options, including looking at property near the future site of Lakehead University's campus across Highway 11, and replacing the plan for one big multi-use facility with several smaller centres. The *Packet & Times*, a staunch supporter of the MURF, reversed its stand and in a front-page editorial in April said it was time to abandon the West Street site. Aside from the millions of dollars already spent and the contamination complications, the project could be delayed by environmental challenges even after the province gave its approval, the newspaper noted. In a surprising change of the paper's long-time support of downtown, the newspaper suggested the MURF be built across the highway. Perhaps the paper's best suggestion: change the name of the project. MURF had become a synonym for failure, a bad joke, greeted by a roll of the eyes, a sinking feeling in the stomach, and a symbol of everything that ever went wrong with Orillia.

City hall began hedging its bets. Council continued to support the West Street site but also gave a new ad hoc committee $5,000 to start exploring alternatives, just in case. As for the rising costs,

council came up with a brilliant new strategy, perhaps a Canadian first, perhaps another example of the never-say-die Orillia Spirit. How do you stop the estimated cost from rising? You stop estimating. At a meeting in October 2008, council decided to no longer calculate for the public the rising costs of the project due to inflation. "When the numbers are floating, people get upset," Councillor Joe Fecht was quoted in the newspaper.

Putting a spin on the numbers aside, everything else spun out of council's control. In January 2009, the city had to suddenly shut down the Orillia Community Centre after engineers had found structural problems in the fifty-eight-year-old building. The closure did more than throw 700 hockey players off the ice and anger hockey parents — a formidable force fearful to politicians in any Canadian community. The closure also symbolized to Orillians how bungled the quest for a new recreation centre had become. No words were spared in skewering politicians for merrily chasing a dream while allowing the community centre to fall apart. "Given an infinite number of dollars, an infinite number of consultants, an infinite number of years and an infinite level of stubbornness on the part of those politicians who have tied their reputations to the outcome, the MURF would have indeed been built on the contaminated brownfield so 'generously' donated to the city by Molson. But to do so in any reasonable time frame? Forget it," a *Packet & Times* editorial concluded. Columnist Colin McKim captured the essence of the absurdity in three short words:

"Only in Orillia," he wrote. "I can't remember how many times I've started a column with those three, long-suffering words."

Angry Orillians demanded action and councillors quickly agreed to build a twin-pad arena across Highway 11 in West Ridge on the former Horne farmland. Things started to look up at West Street. The Ministry of the Environment finally approved the city's risk assessment of the West Street site in January 2010. That prompted the standard celebratory comments among MURF supporters, tempered by the knowledge that some of the MURF was already being built across the highway.

The decision launched another year of discussion over what the new MURF should include that ran straight into another municipal election.

The voters spoke, although it wasn't totally clear what they were saying. After ten years in office, Mayor Ron Stevens decided not to run again, leaving the mayoralty race open. Running for mayor were veteran councillor Ralph Cipolla, a strong supporter of the MURF on West Street; another veteran councillor Tim Lauer, who raised questions about the MURF; and the city's largest developer, with no council experience, Angelo Orsi. Orsi vowed during his campaign to get rid of the consultants and reassign city hall staff responsible for the MURF mess. He suggested the West Street site wasn't the best for the centre. There were other issues in the campaign and incumbents could point to the other accomplishments. But it's unlikely other issues resulted in the highest voter turnout,

more than 50 percent, since 1988. Orsi won easily and only two incumbents were returned, but it wasn't clear yet how the new council would move on the MURF.

This council got a gift no previous council had received: final clearance from the Ministry of the Environment to build a recreation centre on the former factory site on West Street. All Orsi and council had to do was wait out the fifteen-day appeal period and, if no one launched one, they were clear. No one launched the appeal, but council had had enough of the West Street site. In September 2011, council voted 5 to 3 to reject 255 West Street as the site of the MURF. By then, the city had spent about $6 million in consulting fees and environmental assessments for what was basically going to become a park.

With the MURF on West Street finally dead, the stage was set for quick decisions and decisive action on a new recreation centre elsewhere. But downtown Orillia wasn't done with a recreation centre yet. Again, a group of merchants, calling themselves West Street Makes Sense, pushed council in the spring of 2012 to build on West Street. Council pushed back, deciding in fall 2012 to narrow the potential locations to three sites: the property of a closed elementary school, David H. Church, on James Street in the city's lower income south ward; McKinnell Square Park, just east of the core; and the FL Smidth site at 174 West Street. The West Street site, where the foundry of the FL Smidth mining and cement service company stood, was across the road from the original site at 255 West Street, just to keep matters confusing. At a public meeting that drew 150 residents,

most Orillians voted for the new 174 West Street site. Council was set to pick a site on November 4, 2012. Finally, a decision would be made and a new recreation centre could be built.

Of course, it didn't work out that way. Council agreed on November 14, 2012, to build on the David H. Church site. The 5 to 4 decision came after a raucous council meeting with politicians clashing and residents shouting. "You guys have just ruined Orillia," one woman shouted, according to media reports of the meeting. In reality, nothing was ruined or settled. Downtown boosters, backed by a consultant's report calling for brownfield redevelopment in the core, kept pushing for the recreation centre on the new West Street site. Council members opposed to the school site complained that the site was too small for a recreation centre and parking. On and on the debate went over the winter and into the spring and summer of 2013.

Council stayed firm, despite opposition to building on the school site on James Street. Until something new came along. In fall 2013, a company called Tribal Partners unveiled a proposal to build a $65-million recreation centre, at a cost of $30 million to the city, on the FL Smidth site at 174 West Street. The company had an offer in on the land, its president Lance Trumble said. The oddly named company, Tribal Partners, had no affiliation with any First Nations communities, which might have caused scepticism about the feasibility of the plan, or at least concern about optics, from the start.

It's hard to believe, but the recreation file was about to become even messier. By the time this West Street proposal ran its course,

the city's chief administrative officer resigned over ethical concerns, members of a deeply split council found new mud to throw at each other, an investigation found some council members were too cozy with the developer (although well intentioned), and dismayed voters threw an entire council out of office. Much of it could have been avoided had one question been asked at the beginning.

The Tribal Partners' proposal had its attractions. The company proposed to build a $100-million complex that included a recreation complex and wellness centre. The size of the recreation centre would be up to council. The basic option would have a pool, gymnasium, and 20,000 square feet of operating space to generate revenue. The luxury option would have a fifty-metre pool, recreation and therapeutic pools, a twin-pad arena with seating for 1,000, a double gymnasium, a full fitness centre with studios, a walking and running track, a sports hall of fame, multi-purpose meeting rooms, public space, change rooms, storage space, and a 120,000-square-foot wellness centre that would house offices and healthcare clinics. At the time, Tribal Partners was negotiating a conditional offer with FL Smidth for the site, and would provide office space for the company.

The proposal received immediate support from several council members, downtown business owners, and many members of the public. "With the proposal by Tribal Partners and supporters of its plan, Orillians have been shown a golden vision for recreation," the *Packet & Times* opined.

Not that golden, yet, city hall bureaucrats said. They asked Tribal Partners how it was going to persuade senior levels of government to hand over many of the millions of dollars needed to build in a tight construction time frame. Who would pay for costs of environmental cleanup? How could the city sole source, with public dollars, such a huge project? (To avoid corruption, conflict of interest, and perceptions of both, large projects using tax dollars are usually awarded after a competitive bidding process.)

In February 2014, only a week before Tribal Partners made a formal pitch to council, Orillia's chief administrative officer (CAO), a thirty-year veteran in municipal operations, resigned over ethical concerns. The CAO, Roman Martiuk, did not say what those concerns were but revealed that he'd been troubled for several months. At least one councillor revealed that the ethical concerns were related to the recreation centre. Despite a small cloud hovering over the proposal, Tribal Partners made its official pitch to the city February 26, 2014, and council agreed 6 to 3 to further investigate building at 174 West Street and hire consultants to work with Tribal Partners on the proposal. The James Street plan, which had already cost $1.4 million and had architects working on the design, was put on hold.

Tribal Partners told the council that the complex at 174 West Street had other potential partners, including Lakehead University, Orillia Soldiers' Memorial Hospital, Georgian College, and the Ontario Provincial Police. Building a new Orillia OPP

detachment on site, to replace the over-crowded current detachment is "a critical piece to this," company president Trumble said. The 10,000-square-foot Orillia OPP detachment on Peter Street, built in the 1970s, was an outdated, unsafe, and crowded workplace. In 2009, the city bought and tore down the adjacent Oddfellows Hall on Colborne Street and had designs created for an expanded 30,000-square-foot detachment office. The new council, led by Orsi, had put that plan on hold to look at other options, and in 2011 they had put an option to buy some of 174 West Street for the detachment. The site now seemed a perfect place for both a new recreation centre and OPP station. But Tribal Partners did not have an agreement with the OPP to build a station. Someone might have asked then about how likely it would be for the OPP to deal with one company without going to tender in a bidding competition for a project worth $10.6 million. Apparently no one did. The business plan presented to council was incomplete, without operating costs or financing details, noted CAO Martiuk, who was still working for the city before his resignation took effect.

A month later, his ethical concerns about the project came to light after council agreed to release a previously confidential report on his resignation. In that report, Martiuk expressed concern that the city would have to sole source for the project to go ahead and that members of council made decisions without seeking staff advice. But his biggest problem was the fact that some members of council had worked with Tribal Partners to help the company obtain a contract with the city. That gave Tribal Partners an unfair advantage in working with city staff, who would be pressured to compromise on their concerns, and gave Tribal Partners an edge in trying to get what it wanted from the city, Martiuk believed. City staff should be the negotiator in procurements and council should be the decision maker, Martiuk said.

After the confidential report was released, some councillors accused Martiuk of acting inappropriately and being biased from the start against the Tribal Partners' proposal. Others said they had few concerns about sole-sourcing a $35 million project. Boosters of the new West Street site, naturally enough, backed those council members. The group that supported the earlier site across the road, West Street Makes Sense, now called themselves 174 is So Much More. Restaurant owner and group spokesperson Steve Clarke said Martiuk and some council members had blocked the idea from the beginning. But another group worried about the new West Street site also sprang up, with many of the same concerns about the possible contamination of a site across the road from the first site.

Most Orillians were likely just tired of waiting. "Stop bickering and get something built," volleyball coach Kris Parnham wrote to the daily paper.

Meanwhile, residents in the city's south ward near the school property could see the political writing on the wall; the city would once again neglect the lower income area and build a new recreation centre somewhere else. Their instincts were right, although the numbers

suggested otherwise. PricewaterhouseCoopers reported in May 2014 that, just as the now gone CAO Martiuk had warned, the proposal lacked financing details. As well, the city wasn't going to see the economic return from the project that Tribal Partners had predicted.

But nothing seemed to stop the politicians, backed by many members of the public, from going with the Tribal Partners plan at 174 West Street. At a June 2, 2014, meeting, council considered a new, complicated proposal: Tribal Partners would sell a portion of the land to the city. The city would then lease the land back to Tribal Partners and Tribal Partners would build the recreation centre. Then the company would lease the centre back to the city, and the city would operate the centre. Then, much later on, the lease between the two parties would expire and Tribal Partners would give the centre back to the city. It didn't matter how much sense that made because none of it would start for another two years. Council voted 6 to 3 in favour of the proposal — prompting a verbal explosion from Mayor Orsi, frustrated nothing would be done in his term of office — and the James Street site was abandoned for good. "Let's end this term of council. Get something done. Stop dragging our poor community through the mud. Up and down and all around. Killing this council. What is this all about? We're friends. Now, we're enemies. Our community loves us and hates us? Is this what it's all about?" Orsi was quoted in the *Packet & Times*. Standing up from his seat and pointing at the city's coat of arms, which reads "Progress," Orsi said, "Is this progress? I say not. It's a joke."

And a long one. In August 2014, a report from the city's integrity commissioner, Suzanne Craig, concluded that three council members, Pete Bowen, Patrick Kehoe, and Tony Madden, had contravened Orillia's code of conduct by getting too close to the negotiations with Tribal Partners. The code prohibits council members from doing anything that might grant, or appear to grant, advantages or special treatment to a group. But all three acted with the best interests of the community and didn't deserve punishment, the report concluded. As could be expected, the council meeting where the report was released turned nasty at times, with accusations of wrongdoing flying from many sides. By the time the election came that fall, Orillia voters had had enough. Orsi didn't run. Steve Clarke, the West Street booster and downtown restaurant owner, won as mayor with 90 percent of the vote. Every incumbent on council was defeated, the first time anyone could remember that happening. Five rookies and three former councillors were elected. Clarke vowed to make a decision on a recreation centre within six months of taking office. He and the new council committed in February 2015 to negotiating with Tribal Partners to build a recreation centre at the site at 174 West Street. A month later, the proposal was near death. It turned out that Infrastructure Ontario and the OPP would not negotiate directly or solely with Tribal Partners to put a new OPP detachment at the site. Tribal Partners pulled out of the deal.

City council had no choice left but to cast its eye toward the brownfield across the road at 255 West Street that was bought for $1 so long

ago. Before making a final decision, the city held an open house to discuss the plan. As if there hadn't been enough talking already.

"I don't see anything new at all. They didn't tell me anything I didn't already know or anybody who's followed it for 15 years didn't know," Betsy Gross told a reporter. "That we're still talking about it — that's what's annoying. It really is annoying."

On June 1, 2015, council voted 6 to 3 to build a recreation centre at 255 West Street South. The same decision about the same site drew the same reactions from the same groups as the first time around. The price tag rose over the next year, just as it always did. A fundraising group was formed with determination to raise millions, just as one did before. But this time around, a contract was signed and ground was broken. In August 2016, council awarded the job to a Toronto-based contractor for $48.45 million, slightly above the $45 million target. In September 2016, ground was broken for a multi-use recreation facility that will include an eight-lane lap pool, gymnasium, and fitness centre.

The ceremony, wrote the *Packet & Times*, "signals new life for a tired, weary part of town struggling to thrive in the aftermath of a proud industrial heritage that scarred and tainted the land. But the most important thing Wednesday's ceremony heralded, hopefully, was a new beginning for the city. This issue has hung like a black cloud over the city for 40 years; it has pervaded into our culture, tainted a generation and planted seeds of doubt and dissonance in our collective experience as Orillians. It's been a failure we've all worn."

That was no exaggeration. During the fifteen years of the MURF debate, other city projects had been contemplated, debated, and completed. Each time those debates went awry, Orillians expressed concern another MURF was about to happen. That fear reached its peak perhaps during debate over another great unfulfilled dream, a university for Orillia.

The story of that dream's revival has the ring of Orillia's past triumphs. A newspaper man playing poker with his friends raises the dream of something big for the city, nothing less than a university. At first his friends shrug him off but he keeps talking about it. They create a committee and the committee pushes the idea and a university comes to the city. The story sounds like a typical venture of Charles Harold Hale, the *Packet & Times* publisher who coined the phrase "Orillia Spirit." This story, though, happened in the new millennium and involved another newspaper man, the former publisher of the weekly *Orillia Sun*, Anderson Charters. When the topic of a university came up at the monthly nickel-ante poker games early in the 2000s, the dream of building Simcoe College had been dead for years. But Ontario universities were looking to grow by putting satellite campuses in the downtowns of their home cities or in entirely different cities.

The group of dreamers became the Orillia University Committee, chaired by Charters. He persuaded a friend and professor at Wilfrid Laurier University in Waterloo to look at the Huronia Regional Centre (HRC) site. By the time the story broke publicly in 2003,

several of the university's officials, including its president, had visited the site, and city and provincial politicians and officials had been brought into a behind-the-scenes effort.

"It's difficult to think of any other possible development that could be more significant to Orillia or that could make this community a more vibrant place in which to live," Charters wrote in the *Packet & Times*, sounding very C.H. Hale-ish. "No bureaucrat in Queen's Park is going to wake up one morning and dictate that a university should appear in Orillia. It will only happen if the community pulls together to make it happen."

The community didn't appear to be pulling together, at first. With a campus close to the HRC lands and its own plans of offering university courses in Orillia, Georgian College served notice it should get first crack at buying the HRC site, as had been promised in the past. A few months after the news about the university effort broke, in March 2004, Georgian signed a deal with Laurentian University out of Sudbury to offer two university programs at the Orillia campus, beginning that fall. "Nothing's changed," Charters responded in the *Packet & Times*. "For the community, the long-term vision should be to have 5,000 community college students and 5,000 university students."

In summer 2004, the effort for a university grew. City council asked the province to designate part of the HRC land for a post-secondary education facility; initial meetings with provincial officials went well and a mayor's task force was created to boost efforts. At some point in the fall, plans to draw Wilfrid Laurier University to Orillia faded. But there was a new suitor. In 2004, Simcoe North MPP Garfield Dunlop set up a meeting with the Ontario Minister of Training, Colleges and Universities, Mary Anne Chambers. At that meeting, Chambers told Dunlop that Lakehead University was looking to expand. Lakehead faced a declining population in northern Ontario and the perception that it was too far away for many potential students in southern Ontario. It had recently lost a bid to build a campus in Burlington.

The campaign to bring a university to Orillia switched to courting Lakehead, and that flexibility was just one of several ways this initiative was different from the MURF. Even council moved quickly on the matter, deciding in January 2005 to begin talks with Lakehead University and to support a partnership between that university and Georgian College, a smart bit of peace brokering. It may have been that city council finally had the luxury of reflecting a common and powerful sentiment in Orillia. Urged by city leaders to show support, about 200 people squeezed into the 140-seat council chambers for a meeting in March 2005 to listen to Lakehead University president Fred Gilbert. In December 2005, Orillia announced that Lakehead University would open a campus at the former J.B. Tudhope factory downtown, adjacent to city hall, the next fall. That building had been converted to city hall and condos in the 1990s.

The interim campus opened in 15,000 square feet of leased space in the building, Heritage Place, in September 2006 with 104

Lakehead University's downtown Orillia campus opened in September 2006 with 104 students.

Delay and confusion, as it turned out, were more fitting. The province gave no word. Even though it would cost less, an estimated $27 million less, to renovate and build on the HRC site, Lakehead University gave up waiting. President Gilbert announced in fall 2007 that the university would build a campus west of Highway 11 on the Horne farm. Council agreed to give Lakehead eighty-five acres of land on the farm and $10 million in support.

Orillians have a habit, for better or worse, of never taking an initial decision as the last decision on a matter. City councillor Ralph Cipolla vowed to push the provincial Liberal government to quickly free up space at the HRC. The Simcoe North Progressive Conservative MPP and the Liberal candidate, Laura Domsy, who ran against him in the October 2007 election, joined forces to try to do the same. Lakehead president Fred Gilbert took to the daily newspaper in February 2008 to explain the decision. The university needed more space for its 5,000 to 10,000 students than the twelve to fifteen acres first available at the HRC, and had already delayed the expected 2009 opening of a permanent campus, he wrote. "What Orillia should be concentrating on is the positive aspects of having a modern, environmentally sustainable, medium-sized university campus within its city boundaries — boundaries that have been established by the provincial government for the city's future growth," Gilbert wrote. Don't tell us what to do, former federal Cabinet minister Doug Lewis responded in the newspaper the next day. "Your approach is wrong-headed," wrote Lewis, still an influential figure in

students. It seemed only a matter of time before the province, seeing the potential, would arrange to sell or donate some of the property and already empty buildings at the HRC — set to close completely in 2009. Lakehead University on Lake Simcoe. What could be more fitting?

the city and a supporter of the HRC site for the university. "Orillia has a sense of history and where we want to be in the future. You need our support. So don't warm us up by telling us how it is going to be. Mr. Gilbert is really saying, 'I'm from Thunder Bay and I'm here to tell you how it is going to be in Orillia.' I know it has been cold up there this winter, but is everything frozen? "

As if the push for the HRC and the occasional harsh letter to the editor weren't enough, in May 2009, a citizens group formed with a good acronym and self-explanatory name, Build Orillia Lakehead Downtown (BOLD). Mayor Ron Stevens sounded the alarm at a meeting with that group. "If we keep fooling around with this, we are going to lose Lakehead University. That would be an absolute catastrophe for this city."

Even studying a downtown campus could delay the expected September 2010 opening, Orillia campus dean Kim Fedderson told the *Packet & Times*. Trying to actually build a campus downtown, with years added to buy and rezone properties, could end the project, he warned. "There's simply no time to consider a naive, ill-informed proposal," Fedderson said.

Opposition to the Horne farm site faded quickly after that. Lakehead opened its West Ridge university campus in 2010, and with the downtown campus still operating, had 1,450 total students enrolled and 200 full- and part-time employees in 2014. The opening of the eighty-five-acre campus across Highway 11 from the core of Orillia gave West Ridge a cultural legitimacy and identity.

The university's main campus opened west of Highway 11 in 2010.

No longer was the new part of the city only big box stores, an arena, and houses. The opening also gave Orillians much needed faith, while the MURF saga continued, in their ability to get somewhere no matter how winding the path. "Today is a defining day in the history of a city that was built with ingenuity and innovation," *Packet & Times* columnist David Dawson wrote when ground broke on the new campus in June 2009. At that groundbreaking ceremony was original Simcoe College Foundation head Rusty Russell, who described his feelings, shared by many Orillians: "Satisfaction and joy and comfort."

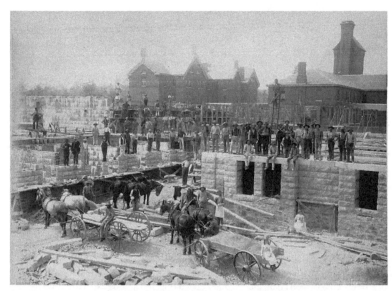

Ontario began building its new Idiot Asylum on Lake Simcoe in 1885, opening with about 550 patients. Construction of the administration building, shown here, was completed in 1891.

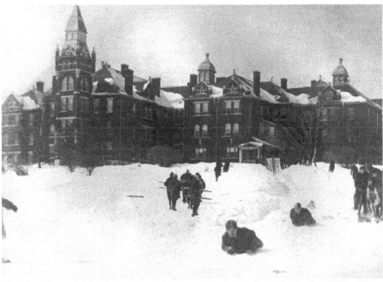

The clock tower of the imposing asylum was removed after a fire in the 1900s. From the beginning, the expansive grounds provided a space for playing hockey, tobogganing, and fishing for patients and staff.

The opening of Lakehead University also left Orillia with a long lingering question. What to do with the Huronia Regional Centre? The place has haunted the edge of the city for decades. The town within the town, people called it. The HRC had provided good paying and secure jobs for thousands of Orillians over the years, but it also housed thousands of children suffering from loneliness, abuse, abandonment, overcrowding, and deteriorating conditions.

By the 1960s, the former asylum buildings on Lake Simcoe were called the Ontario Hospital School with a peak of close to 3,000 residents and hundreds of employees — electricians, plumbers, painters, carpenters, dietitians, food service workers, machinists, farm helpers, landscapers, recreation workers, pharmacists, laundry personnel, transportation workers, and clerical, security, switchboard, and canteen staff. The jobs were among the highest paying in the city

and provided long-term security. Naturally enough, astute politicians recognized the bigger-picture benefits of the facility. Applicants for jobs at the Ontario Hospital School needed to get an endorsement from a local Tory official to apply, recalled Pete McGarvey, an historian and Liberal party supporter in the 1960s. The local Tory official would then pass the name on to the Tory MPP, Lloyd Letherby. He would provide a letter to the applicant for the job interview, and if a job was granted, the applicant would then sign on as a Tory party member. "The system assured a hefty balance for the party's local coffers and a winning vote in Orillia on election day," McGarvey wrote.

About that same time, in 1960, Pierre Berton wrote a column for the *Toronto Daily Star* about a visit with a friend and his son, a resident at the Ontario Hospital School. Berton described an overcrowded, decaying, and disturbing institution, in which a dedicated staff fought an uphill battle "against despairing conditions." There were 2,808 residents jammed together in largely unsafe and unhealthy quarters, Berton wrote. "The paint peels in great curling patches from the wooden ceilings and doors. Gaping holes in the worn plaster walls show the lath behind. The roofs leak. The floors are pitted with holes and patched with ply. The planks have spread and split, leaving gaps and crevices that cannot be filled," he wrote. "The beds are crammed together, head to head, sometimes less than a foot apart."

It took time, but the province took notice. In 1971, a government-commissioned report by Walston B. Williston described overcrowding, inadequate staffing, and forced labour of

By the 1960s, the name of the asylum had changed to the Ontario Hospital School, but the new name couldn't hide the crowded conditions and inadequate care. The resident population neared 3,000 in 1968.

residents at provincial institutions, including Orillia's. In 1976, after complaints about assaults at the institution, the province commissioned a report from Dr. Joseph Willard on what was by then called the Huronia Regional Centre. Willard's report led to the departure of the centre's administrator and described an institution with not enough staff or supervision, inadequate training of staff, and questionable use of drugs in treatment of residents. In the 1980s, the province began downsizing its large institutions and moving residents into community care.

In Orillia, counsellors and other workers at HRC argued that there was no way everyone could be moved out into a community setting. The HRC provided all kinds of services in one spot, they argued. They also pointed out that salaries provided by community agencies were not as high as at the institution and the city's economy would suffer if the HRC closed. By 2000, there were about 350 residents and 650 staff at the HRC, and the province's closing date of 2012 seemed far away and hardly practical.

The Liberal government shattered that notion by announcing in September 2004 that the HRC would close in five years. The battle to keep the centre open began immediately. The Ontario Public Service Employees Union, representing employees, and local politicians and parents of residents waged the battle on economic and humanitarian grounds. The closing of the HRC would mean the loss of 729 jobs and $30 million a year in payroll in Orillia, politicians noted. Community agencies weren't prepared or funded properly to handle the remaining residents, the union argued. Their children or brothers or sisters were happy at HRC, a coalition of family members and supporters called the Huronia Helpers insisted.

Yet it took only days after the announcement for talk about what to do with the HRC site to begin. "Far from being a tragedy, the looming closure of the Huronia Regional Centre (HRC) and the potential loss of 700 jobs may be one of the greatest economic and social opportunities this community has ever seen," the *Packet & Times* exulted. "The closure of the HRC may not be a meteor hurtling toward us, but a star leading us into thrilling possibilities." Among those possibilities, an expansion of Georgian College, a specialized care and training centre, and nothing less than the long-denied dream of a university campus on the shores of Lake Simcoe. That lake can be tricky to sail, with quick wind changes and choppy water making it difficult to stay on course. Orillians were buffeted by the looming loss of jobs in one direction and the renewed stories of the abuse at the HRC in the other, by the hope of saving the HRC and the hope of reclaiming it for a new use.

The families of residents at the HRC and Rideau Regional Centre in Smith Falls launched a legal appeal of the province's decision to close the facilities, arguing the province did not have the authority to move residents out. In January 2006, a court ruled the province had the legal right but that the government had to obtain consent from families before transferring residents to community settings.

That set the final transfers in motion for closings by March 31, 2009.

As the closing approached, the *Packet & Times* invited people to share their stories about the HRC. Former employees wrote about the sense of family at the centre.

"Residents provided Christmas concerts for the staff and Orillia residents. Most enjoyed going to town on shopping trips, to hockey games and various town events. The sandy beach on Lake Simcoe provided many hours of swimming as well as fishing outings," wrote Jack Kean, for thirty years an employee, who also described with affection and respect many of his residents.

And the Spirit Looks Like What?

971.317 RIC. That's the Dewey decimal code for the earlier version of this history book at the Orillia Public Library. The one you're reading is the new one. The first one had a few different stories and a different look. Which one is better. Does the Orillia Spirit mean honouring the past or embracing the future?

When the phrase was coined in the 1900s, it was easy to state that embracing the future was the sole definition. Now, however, the phrase needs to honour both the heritage that arose from the first round of city building and the future.

Take the experience of building the new Orillia Public Library, for example. It opened in 1911, at a cost of $11,710, one of thousands across North America funded by the Andrew Carnegie Foundation.

In the 1960s, when heritage was far less prized than now, Orillia began ruining the look of the Carnegie library, adding a rear extension and front extension, which covered the facade. Additions continued in the 1980s until only the old east and west walls remained visible. The roof of the Carnegie section collapsed under snow in January 1992, but it was a lack of space that started efforts in 1999 to build a new facility, with a formal report on the feasibility completed the next year, *Outgrowing Our Building*. More studies followed in the first part of the new millennium, and it became clear the old part of the building would be too costly to restore.

The heritage of the building was long gone by the time architects unveiled plans for the new library in 2008. Shaped like an *L*,

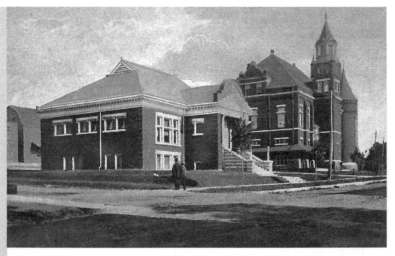

Orillia's public library began as a stately Andrew Carnegie library in 1911.

with a modern facade, the design surprised Orillians who thought the new library would have more of a heritage look. Council and the public were taken aback. There were complaints the building would not fit in with the rest of downtown's heritage look. Mayor Angelo Orsi suggested the 47,000-square-foot building was too big and suggested that one floor be allocated for city administrative staff.

But when the spacious, light-filled, airy, and contemporary Orillia Public Library opened in 2012, Orsi had nothing but praise. Despite the obstacles, he threw up for the library, or perhaps

More than 3,000 people attended the grand opening of the new library on June 2, 2012.

because of them, he was the perfect person in the perfect place to invoke a version of a spirit that balances old and new, progress and obstruction. One of the most successful business leaders in the city's history, he was finding success as a mayor difficult to achieve. In two years, he would not run again, but, instead, would return to the family development company largely responsible for expanding Orillia beyond its traditional boundaries and appearance. In his address opening the new library, Orsi referenced the first version of this book, which was on the library shelves, and the leaders of the past who filled its pages. The modern new library, he said, embodied that old Orillia Spirit.

"Hay rides both in the summer and winter months were enjoyed by both staff and residents. I will never forget the jovial laughter and singing that emanated from the staff and residents as they went by," wrote twenty-five-year employee Nancy Rowell.

Former residents and their parents wrote in as well.

"Retiring to Orillia 17 years ago, I have purposely never driven through these grounds. Finally, spurred by The Packet's articles, I did so last week. I was moved to tears with memories that are almost 50 years old," Jack Gourlie wrote to begin a heartbreaking account of leaving his five-year-old daughter Diane at the HRC on May 31, 1959. "The buildings seemed so cold looking and foreboding. It seemed deathly silent. I took Diane by the hand and we managed to navigate the crumbling staircase. Dressed in her best pink dress, she was excited about visiting this unknown place, bouncing with happiness, trusting that her dad's hand would never be parted from her." Gourlie was not allowed to say goodbye or visit for at least 30 days. " I retreated to my car and sobbed uncontrollably," he recalled.

He brought his three other children, ages three, seven, and nine, with him to visit in August of the same year, and found a "chaotic din" and overwhelmed staff. "The reunion was tense, traumatic and brief. The goodbyes were tearful and solemn. Driving back to Toronto, there was an unaccustomed silence, broken only by muffled sobs." Diana eventually moved to a group home and is happy, Gourlie wrote.

A former resident, Harold Dougall, described the facility in the 1960s as a prison where employees would hit residents with a strap

or a shoe at random and the residents were too frightened to speak out. He was eventually transferred to a better facility and gained his independence at twenty-seven. With a job and a wife and still living in Orillia, Dougall told the *Packet & Times* he hoped the place would be demolished. "I'll go out to watch them tear it down. I'll have a big smile on my face."

Soon after the HRC was closed, the institution and the Province of Ontario were named in a $2 billion class action suit claiming residents were subjected to sexual abuse, physical violence, and the use of drugs as punishment. The statement of claim also alleged residents lacked adequate medical care, worked without proper compensation, and were tended to by unqualified caregivers. The lawsuit cast the eyes of millions of Ontario residents to the HRC and similar institutions in Chatham and Smith Falls, Ontario. In September 2013, the government of Ontario and the Toronto law firm Koskie Minsky announced a tentative settlement over the HRC had been reached. The settlement included a $35-million fund for former residents and a formal apology from the government.

Six years after closing and three years after the political apologies, the Huronia Regional Centre site remained in the province's hands. The province collected ideas for the site in an online survey in fall 2016, with the intent of reporting back the results in the spring of 2017.

In response to the survey, Community Living Ontario, a province-wide confederation of agencies and groups helping intellectually disabled people, declared its opposition to the site being given to any level of government, any other special interest group, or any corporation. Nor does the group want existing government bodies, using buildings declared surplus many years ago, to expand or continue operating on the site. "It is the position of Community Living Ontario, that any future use of these lands should benefit survivors of the institution and the First Nations who were the original stewards of the land," the organization stated in August 2016. "The Province of Ontario has no moral authority to do anything else."

In Orillia, the ideas for the site ranged: a media centre for innovation and research, a showpiece hotel, or a First Nations pavilion. Led by artist Charles Pachter, a new group, Huronia Cultural Campus Foundation, proposed the creation of a southern Ontario version of the Banff Centre in Orillia. The cultural campus would include workshops, studios, residences for artists, an outdoor amphitheatre, and a sculpture park. That idea took root and flight. The foundation received start-up funding from the city and the Trillium Foundation and some of the same people who led the effort to bring a university to Orillia began working on the project. Lending support were author Margaret Atwood, business leaders Don Tapscott and Bonnie Brooks, and Anne Golden, a former president of the Conference Board of Canada and still active in public policy. The group promised to recognize the sensitive past of the HRC, to use the arts to heal, and to include a memorial to those who lived at the site.

The proposal to turn the grounds of an imposing and troubled institution into a world-renowned arts festival like the one in Banff

spoke well of the continued desire in Orillia to make the city stand out. As expressed in arts and culture, the desire hasn't always had much support from politicians.

In fits and starts, with council support, then withdrawal of that support, many arts institutions managed nonetheless in the first decades of the 2000s to expand and renovate.

It took the Orillia Museum of Art and History more than ten years, some political wrangling, and $3.3 million to turn the crowded and crumbling Sir Sam Steele Memorial Building on Peter Street into an open and elegant gallery, winning a 2013 Architectural Conservancy of Ontario award.

The city's relationship with the Stephen Leacock Museum remained strained, with an unclear picture of how deeply the politicians of the day valued the author's home or legacy. The city rejected expansion plans in 2000, but did provide $800,000 for a $1.2-million upgrade finished in 2014. In 2016, a proposal to build a microbrewery at the Leacock site briefly surfaced, then sank. Even so, museum supporters were advised that the Leacock site might have to include a commercial element to help pay culture's way. Nowhere was the city's mixed view of Leacock more apparent than at the author's boathouse. The community's careful replication of the boathouse in 1995 was officially celebrated in Orillia twenty years later. But the condition of the boathouse had suffered and it was used largely for storage on the second floor and, briefly, a children's activity area on the first. Gone were dreams of using the boathouse for a

(Top Left) Orillia's post office has changed inside and out since it was first built on Peter Street in 1894 at a cost of $14,000.

(Top Right) In 1916, the bell tower and clock face were added, and the building was decorated for the city's and Canada's fiftieth birthday in 1927. The building served as the police station from 1956 to 1977, then a variety of purposes until art lovers opened a gallery in 1994 in what was by then called the Sir Samuel Steele Building.

(Bottom Left) It took ten years and $3.3 million to clean up, shore up, and open up the building for the Orillia Museum of Art and History.

writer-in-residence. In the fall of 2014, with support from Mayor Orsi and original boathouse builder Jim Dykes, the boathouse was painted and the bottom floor cleared for meeting space just in time for the twentieth anniversary. Two years earlier, a more metaphysical cleaning up of the Mariposa legend had begun. Supporters of the Leacock Museum, and Orillia's heritage in general, began developing a kind of a think-tank, eventually called the Mariposa Roundtable, to define the city's identity and build on that identity to help the city succeed, economically as well as artistically. Their focus on storytelling and a sense of place, displayed in an exhibit at the Orillia museum and art gallery in the city's sesquicentennial year, paralleled the efforts of the Huronia Cultural Foundation, the hundreds of other smaller cultural events that have arisen and faded over the centuries, as well as the those that have endured or, like the Mariposa Festival, returned.

A sense of place and the accompanying desire to shape that place's story defined much of what happened the past 5,000 years in what became Orillia, first expressed by the Huron, then the Chippewa, the first white settlers, lumber barons, industrialists, developers, dreamers, politicians of all styles, artists, writers, and everyday citizens. Through division and moments of unity, that sense of place and story grew. All it took in 1866 for the Village of Orillia to become the Incorporated Village of Orillia the next year was, according to the original bylaw, the "requisite number of individuals." What it took to become the Orillia of 150 years later was something else — the requisite number of individuals with the right spirit.

ACKNOWLEDGEMENTS

Updating *The Orillia Spirit* required the help of dozens of people, some involved in the first edition and some new. This edition would have been impossible to produce without several key people and their organizations.

Jennifer Murrant, at the Orillia Public Library, did more than provide access to the library's collection, she put in hours of work resizing and scanning dozens and dozens of images, and helping me learn more about those images.

Orillia historian Marcel Rosseau generously provided images from his postcard collection and his own wonderful book of Orillia postcards, and information from his own research. The other members of Orillia Heritage Centre provided key information as well.

At the Orillia Museum of Art and History, Hope McGilly Mitchell combed through archives to find rare images and supplied valuable information.

Will McGarvey and Greg Pauk also provided key images. The generosity of the Stephen Leacock Museum must also be noted.

Once again, the journalists at *The Packet and Times* must be acknowledged for the daily collection of stories that make up a community's history. There are too many to mention from the past twenty years, but be assured I am grateful to you all for continuing the legacy of C.H. Hale and a commitment to Orillia.

One of those journalists was Mark Bisset, who guided the *Packet* for many years and, along with Sandi Bisset, provided me a road map into the past twenty years. Also providing good guidance were Orillia Sports Hall of Fame member and friend Elaine Thompson, and Daphne Mainprize, another friend and curator emeritus of the Stephen Leacock Museum.

Four times now, Dundurn Press has published histories that I have written or to which I have contributed, and each time I have been impressed by the professionalism and care of their editors, from president and founder Kirk Howard to the people who worked hard on this edition: managing editor Kathryn Lane, production editor Cheryl Hawley, copy editor Marg Anne Morrison, and publicist Kendra Martin.

Of course, this edition would not have been possible without the many who assisted on the first. Thank you again.

Finally, the greatest thanks to my wife Janice, and children, Rebecca, Sawyer, and Molly, for their love and support, and by a marriage and three births giving me a link to the city of Orillia forever.

SOURCES

GENERAL

Bisset, Mark. "125 Years in Orillia," A special edition of the *Packet & Times*, June 27, 1992.

Brillinger, Isabel. *The Orillia Hall of Fame, 25th Anniversary Booklet.* Orillia: The Orillia Hall of Fame Committee, 1989.

Hale, C.H. *Notes on General History of Orillia, 1957.* Orilliana Collection, Orillia Public Library.

Ireton, Norah, Ruth Thomson, and Grace Crooks, eds. *Orillia Portraits*, Vol. 1. The Orillia Historical Society, 1966.

Ironside, Allan. *Anecdotes of Olde Orillia.* J.C. Grossmith, ed. The Orillia Historical Society, 1984.

———. "Around Lake Couchiching Tour." Unpublished, 1979, revised 1981.

"It Happened in Orillia." 125th anniversary edition *Packet & Times*, November 1995.

Leitch, Adelaide. *The Visible Past: The Pictorial History of Simcoe County.* The County of Simcoe, 1967.

The Newsletter.

Orillia Expositor.

Orillia Packet.

Packet & Times.

Rizzo, Dennis. *A Brief History of Orillia: Ontario's Sunshine City.* Charleston, SC: The History Press, 2014.

Rizzo, Dennis and Ross Greenwood, eds. *Mariposa Extended: Stories for the Sesquicentennial.* Le Temps H&S Times, 2016.

Rosseau, Marcel. *Post Card Memories: Orillia.* Orillia: Rose Printing, 2013.

Rushton, Ted. *Outline of an Orillia History.* Copy 7, 1966.

The Times.

The William Sword Frost Scrapbook, Volumes I, II, III. Appendices and Explanatory Notes by Leslie M. Frost, Orillia Public Library.

The Jesuit Relations and Allied Documents, Vols. XXXIV and XXXV. Rueben Thwaited, ed. New York: Pageant Book Company, 1959.

GENERAL SOURCE INTERVIEWS
Bisset, Mark, November 2016.
Bisset, Sandi, November 2016.
French, Clayt, March 1995.
Hunter, Don, April, September 1995.
Jenkins, Don, March 1995.
Mainprize, Daphne, November 2016.
McGarvey, Pete, July 1995.
Mulcahy, Sue, March 1995.

CHAPTER ONE: A MEETING
Cahiague 1961 Public Lecture Series. University of Toronto Archaeological Field School, June 15–August 15, 1961.

Champlain, Samuel de. *The Journals of Samuel de Champlain*. Vol. III, *1615–18*. H.P. Biggar, ed. Toronto: University of Toronto Press, 1971.

Drury, E.C. *All for a Beaver Hat: A History of Early Simcoe County*. Toronto: The Ryerson Press, 1959.

Hayes, John. *Wilderness Mission: The Story of Sainte-Marie-Among the-Hurons*. Toronto: The Ryerson Press, 1969.

CHAPTER TWO: AN INEVITABLE CLASH
Anderson, Thomas G. Letter to Colonel J. Givons, December 28, 1830, respecting Mr. Alley and his school at The Narrow. National Archives of Canada.

Douglas, Mark. Interview on history of the Chippewa in Rama, May, 1995.

Douglas, Mark. "Mnjikaning: The Fish Fence at The Narrows." Personal written account.

Drinkwater, Jack. The Drinkwater Family, interviewed by Jay Cody and Dr. Luke Irwin, Feb. 19, 1964.

Gaudaur, Jake. "My Orillia Heritage." Meeting of the Orillia Historical Society, April 21, 1977.

Hale, C.H. "The Moffatt Family." Paper presented to a meeting of the Orillia Historical Society, date unknown.

Jameson, Anna Brown. *Winter Studies and Summer Rambles in Canada: Selections*. Toronto: McClelland & Stewart, 1965.

"The Report on Indian Affairs" by the Commissioners W. Rawson, John Davidson, and William Hepburn. January 22, 1844. National Archives of Canada.

Rogers, Sean. "Ancient Fishing Weirs." Essay, March 1994. Orilliana Collection, Orillia Public Library.

Steele, Millicent Pollock, and Ellen Frances, "Diary of a Voyage from London to Upper Canada in 1833." Ontario Historical Society's Papers and Records, Vol. XXIII, 1926.

Thomson, Captain John. "Extracts from His Diary." Simcoe County Archives.

Tiller, John, and Ian Winchester. "Modelling a City with a Village, Orillia and Hamilton, 1850–1870." Department of History and Philosophy, Ontario Institute for Studies in Education, May 1977.

Ware, Titus Herbert. "The Titus Ware Diary of a Journal from Liverpool England to Orillia, 1844." Simcoe County Archives.

Village of Orillia, Statement of Receipts and Expenditures for the Year 1868.

CHAPTER THREE: THE LUMBER BOOM

Annis, Charles, Elinor Bingham, Allan Ironside, and Monty Leigh. "Lumbering in Simcoe County." Panel discussion for Orillia Historical Society Meeting, March 19, 1970.

Groen, Allan C. "Image and Economic Development Within Orillia."

Heels, Charles H. "A Brief Summary of the Background of the Railways that Served Orillia." Presented at the meeting of the Orillia Historical Society, January 8, 1970.

Illustrated Atlas of the County of Simcoe. Toronto: H. Belden and Co., 1881.

Long, Clare. *Longview: The Story of an Orillia Pioneer Enterprise,* 1995.

Mulcahy, Teefy. "Reminiscences of Teefy Mulcahy." Handwritten notes. Courtesy of Sue Mulcahy.

Noble, E.J. "Barrie and Orillia: The Market Town and the Manufacturing Centre, 1860–1911." *The Country Town in Rural Ontario's Past.* A.A. Brookes, ed. Guelph, ON: University of Guelph, 1981.

Noble, E.J. "Entrepreneurship and Nineteenth Century Urban Growth: A Case Study of Orillia, Ontario, 1867–1898." *Urban History Review* 9, no. 1 (June 1980).

Tudhope, M.B. "Personal Reminiscences Sent to Mrs. George Blackstone." Orilliana Collection, Orillia Public Library, 1938.

Washington, Whitney. "The Start of the Portage." Letter to Orillia Public Library, 1952.

Wilson, Mrs. M.E. "The Steele Family." Paper read at the Annual Meeting of the Ontario Historical Society in 1940. Orillia Historical Society.

Sidebar: Canada's First Medical Plan

Daily Times: February 25, 1899; October 11, 1889; Nov. 8, 1889.

Sidebar: The Dry Days Begin

Minutes of the Orillia and Oro Division No. 122, Branch of the Order of the Sons of Temperance, 1854 to 1857. Orilliana Collection, Orillia Public Library.

Sidebar: The Finest Position in the Dominion

Lapp, D.A. "Preface to a Report for the Orillia Public School Board." Orilliana Collection, Orillia Public Library, January 28, 1967.

Skeaff, Bruce. "The Compleat Centennial History of Orillia and the Orillia District Collegiate and Vocational Institute After 100 Years." From "The Finest Position in the Dominion," paper presented in 1978.

Sidebar: Churches

Barker, Kenneth. "History of Orillia Churches." *Packet & Times*, 1987.

The First Hundred Years: The Story of St. James Parish. St. James Anglican Church, 1941.

Jubilee Sketch, Orillia Presbyterian Church, 1851–1901.

Order of Divine Service, July 17, 1932, at the Celebration of the Centenary of the Settlement of the Pioneers in this region, 1832–1932. Orillia Presbyterian Church.

Pealow, Joan. *History of the Guardian Angels Parish, Orillia, 17th to 20th Century.* Guardian Angels Church, date unknown.

Then and Now: A History of St. Paul's United Church, 1832–1972. St. Paul's United Church.

Wilson, May E. *Church of St. James, Orillia, 1841 to 1956.* St. James Anglican Church, 1956.

Sidebar: Steaming into Legend

Tatley, Richard. "Steamboating and Lumbering on the Trent-Severn Waterway." Speech to the Orillia Historical Society Meeting, October 15, 1981.

———. *Steamboating on the Trent-Severn.* Belleville, ON: Mika Publishing Company, 1978.

CHAPTER FOUR: THE ORILLIA SPIRIT

Angus, James T. *Severn River: An Illustrated History.* Orillia: Severn Publications, 1995.

Lamb, David B. "The 1912 Tudhope: The All-Canadian Car." *Driving*, July 1974, 29–31.

Lamble, Bert and W.T. Stephens. Discussion of the Smelter on Atherley Road, November 8, 1966. Interview by Allan Ironside.

Leigh, Jabez Montgomery (Monty). *Monty Leigh Remembers.* Grace Leigh and Sally Gower, eds. Simcoe County Historical Association, 1983.

McNeice, L.G., "The Story of Orillia's Three Power Plants." *Packet & Times*, October 31, 1935.

Orillia Board of Trade. Minutes, 1910 to 1928. Orillia Public Library.

Orillia Water, Light, and Power Commission. "A Centennial Look at Orillia's Power and Water Development, 1967."

Smith, Gordon E. "Automobile Manufacturing in Orillia." Speech at the Orillia Historical Society meeting, February 18, 1982.

Spencer, John Timothy Tudhope. "A Short History of Tudhope Specialties Ltd." Orilliana Collection, Orillia Public Library, 1966.

Sidebar: A Motoring Adventure

Robinson, A.W. "The First Motor Car Purchased by the Bell Telephone Co." *Bell Telephone Employee Magazine*. Courtesy of Bell Canada Historical Collection.

Sidebar: A Fairy-Tale Ending

"Phantoms of the Orillia Opera House, 1895–1995." Compiled by Don Jenkins. Orillia Opera House Management Committee, 1995.

CHAPTER FIVE: KING BEN

French, Wib. "History of French's Stand, 1920–1980." *Packet & Times*, 1980.

Ironside, Allan. "As I Remember It." From a series of articles in the *Packet & Times*, August 11, 1990.

McGarvey, Pete. "Notes on the 1950s."

Sidebar: Chasing Rum-Runners and Nazis

Clark, Gregory. "Herbert Ditchburn and the Famous Boats He Has Built at Orillia and Gravenhurst." *Toronto Star Weekly*, January, 1928. Reprinted in the *Packet & Times*, January 26, 1928.

Hunter, Don. Interviews, June 1995 to March 1996.

Weekly Times, Nov. 21, 1929. Interview with Herbert Ditchburn.

CHAPTER SIX: ANYTHING WAS POSSIBLE

Barons, Harry. Interview, September 1995.

Carter, Mac. Interview, July 1995.

Cohn, Barry. Interview, July 17, 1995.

Facts and Figures. Department of Industries, Orillia, 1965.

Howes, Kenneth. Interview, June 1995.

Jones, Ruth. Interview, June 1995.

Lightfoot, Gordon. Interview, May 30, 1995.

Sidebar: A Leacockian Tale

McGarvey, James A. "Pete." *The Old Brewery Bay: A Leacockian Tale*. Toronto: Dundurn Press, 1994.

CHAPTER SEVEN: SOME DREAMS JUST WON'T DIE

"City Status Report." Glendinning, Gould & Co., Chartered Accountants, Town of Orillia, January 26, 1968.

"Phase Two Development Plan, Final Report." Environmental Consulting Services Limited, Centre for Environmental Studies, Orillia, Ontario, October 30, 1991.

Post, Isabel. Interviewed by Sally Gower, April 11, 1975.

CHAPTER EIGHT: BIG CITY DREAMS, SMALL TOWN REALITY

Coates, D.E. "A Demographic Model of Simcoe County, Ontario, for the Purposes of Projecting Demand for Post-Secondary Education." A Report for the Simcoe County Post-Secondary Planning Committee. Revised July 1979. Toronto: York University.

"Community Profile." City of Orillia Economic Development Commission, Orillia, November, 1982.

City of Orillia Downtown Improvement Program. Inducon Consultants of Canada Limited, November 20, 1978.

City of Orillia Waterfront Concept Plan, Final Report. Moore/George Associates Inc., June 13, 1985.

Final Report of Development Strategy. Simcoe-Georgian Consultants, Simcoe-Georgian Area Task Force, July 1975.

Mayor and Members of the Orillia City Council. "The City of Orillia in the Toronto-Centred Plan." Brief to the Treasurer of Ontario and Minister of Economics, Charles S. MacNaughton. 1970.

"Orillia Master Plan for Parks, Open Space and Recreation Facilities." Balmer, Crapo and Associates, Inc., July 1978.

Orillia Tourism, Recreation and Culture Master Plan, Summary Report. Marshall Macklin Monaghan Limited. Institute of Environmental Research, John W. Prince & Co., August 1988.

Richmond, Randy. "Under the Waterfront." *Packet & Times*, December 21, 1991, 3.

CHAPTER NINE: THE SPIRIT RETURNS

Dykes, Jim. Interview, September 1995.

"List of Industries and Major Employers." City of Orillia Economic Development Commission, January 1994.

Mainprize, Daphne. Interview, September 1995.

CHAPTER TEN: HAUNTING DREAMS

Willard, Joseph W. "A Report to the Honourable James Taylor, Q.C." Inquiry into the Management and Operation of the Huronia Regional Centre, Orillia, Minister of Community and Social Services, 1976.

Williston, Walter B. "Present Arrangements for the Care and Supervision of Mentally Retarded Persons in Ontario." Ontario Department of Health, August 1971.

IMAGE CREDITS

109 Pete McGarvey Archives
111 Orillia Museum of Art and
 History
112 Courtesy of Mac Carter
116 James Pauk Photography
118 (left) *Toronto Telegram*, York
 University Archives
120 Orillia Public Library

121 Orillia Museum of Art and
 History
131 (bottom) The *Packet & Times*
134 The *Packet & Times*
139 Courtesy of Phyllis Roberts
142 Courtesy of Mike Dodd, the
 Packet & Times
145 The *Packet & Times*

149 The *Packet & Times*
152 Reproduced with permission of
 the Ontario Provincial Police
154 The *Packet & Times*
169 Lakehead University
170 Lakehead University
171 (left) Orillia Public Library,
 (right) Ontario Ministry of
 Community and Social Services

172 Ontario Ministry of
 Community and Social Services
174 Orillia Public Library
175 Orillia Public Library
177 (top left) Marcel Rosseau
 Collection, (top right) Library
 and Archives Canada, (bottom
 left) Orillia Museum of Art and
 History

INDEX

Orsi, Lou, 121, 143
Otaco, 85, 86, *87*, 92, *103*, *129*, 158

Pachter, Charles, 176
Palmer, John, 122, 144, *145*, 146–51
Park Street Collegiate Institute, 40
Patriache, P.H., 57–59, 61–62
Patrick Fogarty Secondary School, 40
Phelps, Ross W., 85
Philion, Joe, 155
Philpott, Donald, 150
Post, Isabel, *121*, 124, 126, 137
Plunkett, Albert, *71*
Plunkett, Merton, *71*
Plunkett, Morley, *71*
Primesite Developments, 137

Quetton de St. George, Laurent, 19
Quinn, James, 28, 42, 124
Quota Club, 122

Ragged Rapids, 57, *59*, 61–62, 67
Ramsay, Robert, 41–43
Red Cross Hospital and Convalescent Home, *33*

Richardson, Gwen, 146
Ritchie, Wellesley, 23
Robinson, A.W., 55
Robinson, C. Blackett, 39, 41
Robinson, Murray, 105, 107–08, 117
Rotary Club, 122
Russell, Wharton (Rusty), 147, 170
Rynard, P.B., 130

Saturday Night, 89
Save Our City, 133
Secord, J.P., 33, 57
Sheppard, Thomas H., 57
Simcoe College, 119–20, 122–23, 167
Smith, Bill, 141
Smith, Goldwin, 74
Smith, Thompson, 37
Soldiers' Memorial Hospital, 41, *70*, 71, 82, 106, 141, 164
South Ward School, 41
St. Andrew's Presbyterian Church, *44*.
St. German, Joseph, 23
St. James Anglican Church, *29*, 44, 45, 93, *94*

St. Paul's United Church, *44*, 105
Steele, Ellen France, 22, 24
Steele, Elmer, 24
Steele, Millicent Pollock, 22, 24
Stewart, Jack, 123
Stevens, Ron, 156, 158, 160, 161, 162, 170
Storey, Jim, 154
Sunshine Sketches of a Little Town, 45, 76, 147
Swift Rapids, 62, 67, 88

Tait, Andrew, 34, *35*, 39
Thomson, Captain John, 17, 20, 23, 24, 25
Thomson, John (lumberman), 35, 37, *38*, 39
Toronto Centred Plan, 128–29
Tribal Partners, 163–66
Trumble, Lance, 163, 165
Tudhope, George, 63
Tudhope, James Brockett (J.B.), 55, 56, 57–59, 61, 62–63, *64*, 65–67, 71, 72
Tudhope, William, 63

Tudhope Carriage factory, 39, *64*, *65*
Twin Lakes Secondary School, 40

Versa-Care Ltd., 145–47, 148–49, 151
Victoria Foundry and Machine Works, *39*
Victoria Park, 50, 56

Wall, Jack, 116
Ware, Titus Herbert, *24*, *26*, *27*, *29*
Webster, Rick, 146
West Street Makes Sense, 163, 165
West Ward School, 41
Willard, Joseph, 172
Williams, Thomas, 19, 23, 25, 26, 29
Williston, Walston B., 172
Wink, Jerry, 140, 143, 144

Yellowhead, Chief William, 20, 22, 25, *26*, 29
YMCA, 68, 69, 95
Your Community in Motion, 161

dundurn.com

@dundurnpress

dundurnpress

dundurnpress

dundurnpress

info@dundurn.com

FIND US ON NETGALLEY & GOODREADS TOO!

 DUNDURN